Jewish Mothers

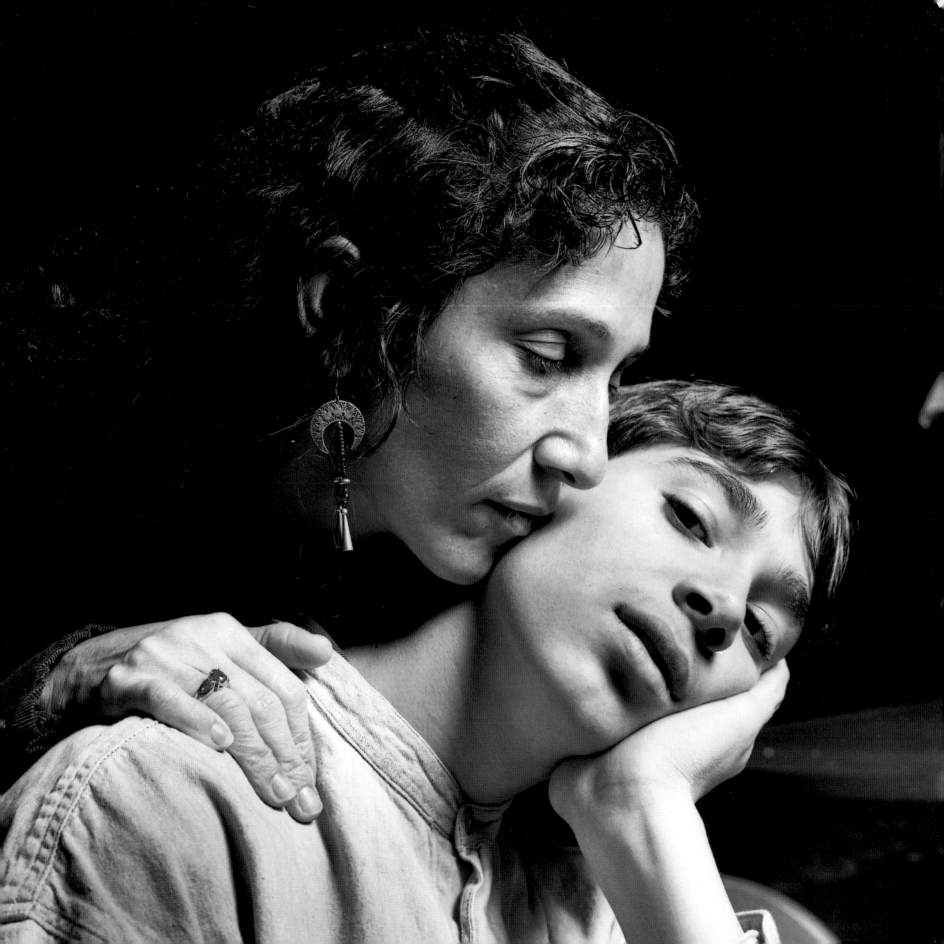

Jewish Mothers

Strength, Wisdom, Compassion

Interviews by Paula Ethel Wolfson
Photographs by Lloyd Wolf
Foreword by Anne Roiphe

CHRONICLE BOOKS
SAN FRANCISCO

Dedications

For all the caregivers in our communities, may you go from strength to strength.

Lloyd Wolf dedicates this book to his parents, Eric and Elicia Wolf, to his daughter Emma Sky Wolf, and to Dion Johnson.

Paula Ethel Wolfson dedicates this book to her parents, Harry and Rhoda Wolfson; siblings Joe and Ellen; niece Maria; extended family members Kathleen Fallon and Lilyan Frank; "Chanukah Homegirls" Deborah Thornton and Anna Helen Grafwallner. And to her Nana, Flora Shea, may her memory be a blessing.

Library of Congress Cataloging-in-Publication Data:

Jewish mothers : strength, wisdom, compassion / [compiled] by Paula Ethel Wolfson ; photographs by Lloyd Wolf ; foreword by Anne Roiphe.
 p. cm.
 ISBN 0-8118-2789-5 (hc.)
 1. Jewish women—United States—Interviews. 2. Mothers—United States—Interviews.
 3. Jewish women—United States—Social conditions—20th century. 4. Jewish women—
 Religious life—United States. 5. Motherhood—Religious aspects—Judaism. I. Wolfson,
 Paula. II. Wolf, Lloyd.
 E184.36.W64 J48 2000
 306.874'3'089924—dc21 99-044918
 CIP

Printed in Hong Kong

Design by Studio A, Alexandria, Virginia

Distributed in Canada by Raincoast Books, 8680 Cambie Street, Vancouver, British Columbia V6P 6M9

10 9 8 7 6 5 4 3 2 1

Chronicle Books, 85 Second Street, San Francisco, California 94105

www.chroniclebooks.com

VERVE
EDITIONS

Developed and produced by Verve Editions.

Acknowledgments

Many people helped us during the four-year pregnancy that gave birth to this book. We would like to thank everyone who gave us their time, trust, and advice and opened their hearts and homes.

Emma Sky Wolf, Gary Chassman of Verve Editions and his staff, especially Steven West, Euan Bear, Antonio Alcalá and the artists of Studio A, Leslie Jonath and Mikyla Bruder at Chronicle Books, our knowledgeable and encouraging friend Jeff Rubin, Rabbi Tracy Klirs, Dr. Max Ticktin, Anne Roiphe, Toby Dershowitz, Michael Greenberg, Ann Young, Jim Zachar and Mary Gratch, Mike and Mary Candel, Kevin Breen and Bette Baker, Alex and Alicia Trocker, Lisa Falk, John Moremen and Susie Racho, Jack Blecher, Peter, Judith and Rachel Intrator, Rhoda Shea Wolfson and Lilyan Frank, Lee and Eric Wolf, Dion Johnson, Gary and Kit Putnam and the great crew at Black & White, Ori Soltis, Aviva Kempner, Blu Greenberg, Amy Brookman, Phillip Brookman, Stacey Weiner, Glenn Pierce, Judith Wexler, Josh Blinder, Michael Quint and the Agudas Achim Men's Club, Ally Ger, John Wortman, Deborah Thornton, Dr. Rolf Grafwallner, Dr. Judith Hauptman, Steve Goldstein, Reena Bernards, Leah Lipman, Anita Diamant, the Anti-Defamation League, the ACLU, Hallie Gillman, Dr. Margaret Nachtigall, Carolee Rand, Betsy Salkind, Joel, Gene and Ellie Bluestein, Rabbi Deborah Orenstein, Rabbi Avis Miller, Marcia Stein, Ellen Townley, Ellen Cooper, Eileen Bellovin, Rob Goldblum, Steve Lipman, Larry Cohler, Jonathan Mark, Marilyn Silverstone, Bunny Adler, Elise Eplan, Howard Wolfson, Colleen Magliari, Susan Saxe, Marilyn Feldman, Sue Kanter, Rochelle Helzner, Terry Lowenthal, Alice Bailes, Peter von zur Muehlen, Donna Fox, Rabbi Jack Moline, Joel Carp, Linda Haase, Pamela Sumner, Jim Fussell and Susan Lauffer, Hannah Fussell-Lauffer, Dr. Charlotte Kratt, Nina Glaser, Molly Abramowitz, Ari Roth, Alice, Bracken and Galen Hendricks, Richard Kammalich, Michelle Kutler, KlezKamp West 1998, Dr. Joyce Antler, Annie Adjchanovich, Stephanie Gross, Mallory Tarcher, Rabbi Moshe Waldoks, Dr. Susannah Heschel, Yaakov and Resna Hammer, Letty Cottin Pogrebin, Jamie Chamberlin, Cyrus Khambatta, Kent Kiser, Judybeth Greene, Carol Stellings, Andrew Silo Carrol, Stacy Freed, Rita Kopin, Margie and Noah Jervis, Shanni and Penina Majeski, Shira Gottlieb, and the mythical pickle lady.

We are deeply indebted to: Carla Cohen, Vera Katz, Betty Wagner Kramer, Judith Herzig-Marx, Alicia Trocker, Ethel Goldberg, Sylvia Goffe, Anita Diamant, Rabbi Lynne Gottlieb, Lily Hayden, Dora Dimond, Karen Sobel-Bookman, Barbara Havenick, Tova Dershowitz, Liesl Lipczenko, and Marcia Stein, who graciously gave us their time and stories but were unable to be included in the space of this book.

Paula Wolfson
Lloyd Wolf

Contents

Jewish faces have a beauty all their own. It's hard to say just where it lies. Is it in the jaw, the chin, the deep-set eyes, the hooded eyes, the intense energy-filled eyes, the noses, irregular yes, but strong noses that slope or bump or jut forward? Is it revealed by the hair that tumbles forward or is pulled back, the hair that is dyed or is not? It is hard to explain how we know these women are Jewish. They are not alike, cookie-cutter women spread out across the pages. They may be young or old, orthodox or modern, mystic or skeptic. Despite the variety, doctors, scientists, blind women, rabbis, women of new ages or ancient ages, we do know that they are all Jewish. Maybe it's the hint of the Mediterranean that flows through some of these pictures, maybe it's the way the light plays against the cheeks. Maybe it's because their souls seem so open, so transparent to the photographer, to us, the viewers. Of course it's a spirit, not just appearance, that unites us. Jewish mothers in all their aching splendor, their humble everydayness, are presented here to counter the lies about us, to celebrate the strength, the poetry, the intelligence, the devotion, the mind of Jewish women.

We see the lines of age and we see the sweetness of girlhood and we see the lurking ghosts of private tragedies and public ones. We look at the mother playing with her child in the fall leaves and the women shyly smiling at the camera and we see the resilience, the power, the story of our days reflected in these faces. We see women with puppets, with scalpels, with hands on the Torah, around a baby's head, or strumming a guitar, with arms around a boy, with their young daughters or their grown daughters, with radiant smiles or sorrowful glances that could be backward or inward. What we see all together is the Jewish woman, not reserved, not hidden, not especially delicate or fragile, but slightly wild, unbeaten despite age or handicap or memories that flatten or destroy. What we see is Jewish women eager, reaching out, hands gesturing, touching, enfolding.

Back in the *shtetl* of Poland or Russia, European Jewish women worked in the marketplace for the family, they sold, they saved, they survived by wit and will. In America they were, because of the new success of their men, soon largely confined to their homes where their strength and particular beauty sometimes went unnoticed, unused. In America a different physiognomy, a different manner were considered lovely. But we were lovely too, each in our own way. Now we know it. Now we can see clearly that Jewish women were not smotherers or fortune hunters or mall rats or small-minded icy princesses. Now we know that Jewish women—like the women whose pictures are in these pages—are lit from within with the same fires that drove Miriam to dance at the far edge of the Red Sea. We both reflect and create our nation's long and continuing story, the Jewish destiny that could not and will not be fulfilled without a woman's love, a woman's mind, a woman's particular shine. Whatever the purpose of the Jewish existence, whatever we are driving toward, whatever we mean to our God and to the world, Jewish women are essential to the tale. We are the timbrel, the breath of life, the source and the power that moves us on and on.

Introduction

It began with a laugh. Sarah, the first Jewish mother, laughed when she learned that she would bear a child in her old age. It was the first woman's laugh ever recorded. And when her child was born, she named him Isaac, which means laughter.

> " … her name shall be Sarah [princess]. I will bless her; indeed, I will give you a son by her. I will bless her so that she will give rise to nations; rulers of peoples shall issue from her." (Genesis 17:15–16)

Judaism has always held the four matriarchs of the Torah, the Hebrew Bible, in great veneration. Every Friday night for millennia, on the eve of the Sabbath, Jewish girls have been blessed by their parents in the name of Sarah, Rebecca, Rachel, and Leah. These strong women gave birth to the Jewish people and sustained them at the dawn of history. Their wisdom was considered critical. At a difficult and poignant moment of decision-making, God instructed Abraham to heed Sarah. "Whatever Sarah tells you, do as she says …" (Genesis 21:12). Likewise, Rebecca's insight and actions shaped the character of the Jewish people.

It is the purpose of this book to explore the lives of contemporary American Jewish mothers. They have built on the legacy of their ancestors, successfully carrying on their traditions and heritage. We set out to listen to their concerns, struggles, and triumphs, letting them tell their own stories, to add to history. Focusing on the diverse Jewish culture that has grown up in the United States, we have chronicled women from their twenties to over one hundred years old. We wanted to know what is different or special about being a Jewish mother today: dreams, struggles, hopes, pains, pleasures, traditions, and transitions. We asked each woman about her life experiences, for her memories of her mother, for what she shares with her children, and what it is to be Jewish. We have kept in mind that an understanding of Jewish mothers is intimately linked to the status of Jewish women as a whole. A special concern was our desire to counteract the popular negative stereotype associated with American Jewish mothers. By letting mothers speak in their own words and portraying them as they are—successful, capable, caring, and wise—we hope that they can be seen in a continuum of strength and love that has extended from generation to generation.

The mother-child bond has always been held sacred in Judaism, so much so that it is used as a metaphor for God's love for the children of Israel: "As one whom a mother comforts, so will I comfort you" (Isaiah 66:13). Jewish women and their acts of leadership, compassion, and sacrifice were noted from the earliest biblical times. The Torah recounts that the midwives Shifrah and Puah saved Hebrew male babies from Pharaoh's death decree, and they and the Jewish people were rewarded by God. Yocheved, the mother of Moses, saved her baby by placing him in a basket in the Nile near where Pharaoh's daughter bathed. Her story still reverberates with chilling bravery and cunning. During the Exodus, Miriam, the sister of Moses and Aaron, was revered as a prophetess and leader in her own right. The great judge Deborah raised and led an army to victory when no one else was willing or

able. Ruth and Naomi set an early example of righteousness and caring, and Hannah's pious prayer created a model of devotion. Risking her life, Queen Esther saved the Jewish people from destruction. All of these women were activists, pillars of moral leadership within the community. Their lives have long been sewn into the weave of Jewish culture, held up as role models to each generation. Their names are still among the most common names given to Jewish girls, a living indication of the honor with which they are held.

The traditional Jewish ideal of motherhood is set forth in Proverbs 31:10–31: *"Eishet Hayil"*(Woman of Valor). It is a hymn of praise recited at the weekly Sabbath table, extolling a wife's virtues. Savvy in business and manufacturing, God-fearing and capable, she is cherished by her family. *"Who can find a woman of valor? She is precious far beyond rubies. She opens her mouth with wisdom, the teaching of lovingkindness is on her tongue … her children rise and praise her, her husband also. . . . Acclaim her for her accomplishments! Wherever people gather, her deeds speak her praise."* She is presented as an independent and righteous partner in a marriage, her primary significance deriving from her role as the virtuous, diligent manager of the household. The Fifth Commandment ("Honor your father and your mother") places mothers on an equal basis with fathers at the center of the Jewish family. The value placed on motherhood was so great that cursing or insulting one's mother is a sin punishable by death (Leviticus 20:19). The Talmud relates that when the sage Reb Joseph heard the approaching steps of his mother, he would say "I must stand up, for the *Shechinah* [God's feminine presence] enters" (Talmud:Kiddushin 31:2).

Mothers were seen as being primarily responsible for *sh'lom bayit*, keeping a peaceful home. They were to observe *Taharat HaMishpachah* (the laws of family purity including *niddah,* the ritual *mikveh* bath, and modesty in dress), maintain a kosher kitchen, light the Sabbath candles, be involved in her children's education and betrothal, attend to her husband's and family's needs, perform acts of *tzedakah* (charity), bake *challah* bread—the list is long. In return she was to be well provided for and to be honored. In old age she would become *Bubbe*, the beloved wise grandmother, the adored *Yiddishe momma* of song and story. She got *naches*, love and pride mingled with satisfaction, from her children.

Because of the great merit Judaism places on learning, in many areas of the Diaspora it was considered a *mitzvah*, a noble deed, for a woman to provide for the economic well-being of the family, freeing her hus-

band to study and pray. Jewish women often ran their own businesses while raising a family. Unlike their Christian neighbors, there was no stigma attached to women working outside the home. Many strong Jewish women were looked up to for their own accomplishments, despite their inferior legal and religious status.

There has been a long debate over the status of women in the Jewish community. Many women chafed under what they found to be restrictive attitudes and commandments that relegated them to second-class status. Marginalized from fully participating in society, they yearned to be valued for their individual humanity and talents, not just for their ability to bear children and run a household. These debates continue unabated today.

In ancient times, Jewish identity was inherited through fathers. This form of cultural transfer began to change during the Greek and Roman occupations of Israel in the last two centuries B.C.E. By the second century C.E. the sages who wrote the Mishnah determined that Jewish identity should be matrilineal, passed on from a mother to her children. A mother's role in forming her children's worldview was recognized as central to preserving Judaism. During the long centuries of oppression— ghettos, blood libel, Crusades, the Inquisition, pogroms, expulsions, and the Holocaust—Jews needed a living center of strength to continue to exist as individuals and as a people. Jewish survival through the last two thousand years rests on women's tenacity, on mothers' love.

After the destruction of the Temple in Jerusalem in 70 C.E., there are several centuries in which there are only scant records of Jewish women in public life. One of the most notable was the Kahina, the Jewish tribal queen who led the fierce resistance to the Arab invasion of Morocco in the eighth century. Beginning in the Middle Ages, some prominent Jewish mothers emerge from the darkness. They made historic contributions as teachers, writers of *techines* (prayers of supplication), religious scholars, and community leaders. Following the expulsions from Spain and Portugal in the late fifteenth century, Doña Gracia Nasi established an international underground network to rescue hundreds of Jews persecuted by the Inquisition. An influential businesswoman, she attempted to organize an economic boycott against the pope and was involved in pioneering Zionist efforts. She was lauded by an Italian poet as "Divine Mercy" in a human form. In seventeenth-century Iraq, Osnat Bat Samuel Barzani headed a *yeshivah* (religious academy) and was a renowned Torah scholar. Glueckel of Hameln, an upper-middle-class mother of

Germany of the same era, left an extensive diary that has given us a glimpse of the everyday and inner workings of a Jewish mother's life. However, it was not until the *Haskalah*, the Jewish enlightenment, that arose alongside the European enlightenment of the eighteenth and nineteenth centuries, that the roles of Jewish women began to fundamentally change.

The ideas of liberation and human rights that arose in France, Britain, and especially the revolutionary new nation of America were hailed in the Jewish world. The ghetto walls began to come down in western Europe and Jews were granted more and more freedoms. Educational, economic, political, and cultural opportunities expanded for Jews, but only a few women were able to take full advantage of them.

For the first time in history, new versions of Jewish practice emerged. Liberal Judaism (called Reform in America) sprang up in Germany and gained many adherents. Committed to adapting Judaism to the modern world, it de-emphasized traditional ritual practices. The Conservative movement was a middle path between what its members viewed as the secularized trends of Liberal Judaism and the rigidity of Orthodoxy. While many women clung to their centuries-old lifestyles, others became outspoken, active in political movements. Their passion and influence were especially felt in the budding Zionist and labor movements. Jewish women were often in the forefront of action for suffrage and for the rights of the oppressed.

While Jews were gaining more freedom in parts of Europe, there was a growing awareness of the centuries-old specter of anti-Semitism. Poverty and pogroms in Russia contributed to a rapid emigration to America. More than two million Jews came to the "Golden Land" of the United States between 1880 and 1920. Crowded into the tenements of New York's Lower East Side, the American experience nonetheless allowed many to escape the oppression that had been the fate of exiled Jews for nearly twenty centuries. Zionism, the idea of establishing a Jewish homeland in Palestine, appealed to many, but America, with its promise of prosperity, equality, and opportunity, drew most of the Jewish immigrants.

Life was hard for the first wave of immigrants. Many labored under inhumane conditions in sweatshops, peddled goods from pushcarts, or ran small businesses. Anti-Semitism existed in the U.S., but for the most part Jews were able exercise their rights as citizens. Traditional Jewish values of hard work, business skills, and education took root in American soil. Jewish men and women took advantage of the public education system as a way of improving their lot. Many entered the professions: doctors, lawyers, teachers, nurses, accountants, and engineers. Jewish mothers found the time ripe to promote education for their daughters as well as their sons. Formerly quiescent Jewish women became more assertive and they fostered this quality in their girls. Statistics from the 1920s show Jewish women working in the professions or attending college in numbers far above the national norms, helping to pave the way for other women. They were pioneers in union organizing, women's rights, social services, and community development. It is estimated that fully half of all Jewish women volunteered for such service organizations as Hadassah, the National Council of Jewish Women, ORT (Organization for Rehabilitation through Training), Mizrachi Women, and Pioneer Women.

Jewish family life, which had long been child-centered, stressing nurturance and communal duties, was challenged by American individualism. Jewish mothers faced a dilemma. The highly developed parenting skills that had enabled their families to survive under the repressive conditions in Europe often resulted in dramatic achievements by their American children. The paradox was that as they succeeded, these children often rejected many aspects of what it had once meant to be Jewish. Many young Jews, eager to embrace America, distanced themselves from their parents' Old World practices and accents. Many women discarded Orthodox disciplines that they found restrictive or demeaning. The Conservative, Reconstructionist, Reform, and Humanist movements, with their varying but less demanding rules, grew rapidly. A few women began to be bat mitzvah and called to read from the Torah as equals to the men in their congregations, but generally women were still excluded from participating in public religious rituals. Nonetheless, most mothers were honored by their families and communities. Sophie Tucker's emotional song "Mein Yiddishe Momma," a Jewish daughter's testament to her mother, voiced the popular sentiment.

The upheavals of the Second World War shook the Jewish world to its core. Hitler's Holocaust murdered six million Jews, ending Jewish civilization in Europe. Zionism became a priority, and the formation of the Jewish state in 1948 was fervently supported by American Jewry.

The war's end brought changes at home. The Depression of the 1930s was over. Jews began to fully enter American life. Many left the

ethnic enclaves of the Northeast and moved to the newly emerging suburbs. The baby boom was on. As their husbands began to move up economically, many Jewish women, following the national trend, began to stay at home with their children. Intermarriage, which had been relatively rare before the war, became more common. This created tensions and challenges within individual families and for the Jewish community as a whole. Mothers were presented with new issues of creating Jewish identity for their children. They were torn between the material and the spiritual worlds, hoping to find a way for their offspring to lead good lives as Americans and to maintain their Judaism.

This conflict became fertile ground for humor. Jewish mother jokes became popular first on the Borscht Belt circuit and then entered American consciousness via Ed Sullivan, Hollywood, and the best-seller list. From *Portnoy's Complaint* to TV sitcoms, the overwrought, neurotic, smothering Jewish mother became a stock caricature in American popular culture: a guilt-tripping, self-denying nag who would rather sit in the dark than change the lightbulb.

It is paradoxical that those perhaps most responsible for the success of the American Jewish community became the butt of a national ethnic joke. Not surprisingly, there has been a strong response from women (and many Jewish men) to the stereotype. In academia, the arts, and the synagogue there has been an outpouring from women in support of one another and in criticizing and deconstructing the myth.

Jewish women have made their mark on America. Some have become highly visible to the public through their accomplishments. Many, many others have made vital but unheralded contributions to society. As early as 1819, Rebecca Gratz of Philadelphia founded the Female Hebrew Benevolent Society. Believed to be the model for the heroine in Sir Walter Scott's novel *Ivanhoe*, she instituted the Jewish Sunday school system in America. Hannah Solomon established the National Council of Jewish Women in 1893, the first American Jewish women's organization, dedicated to philanthropy, education, slum clearance, and child-labor protections. Hadassah, which was to become the world's largest Jewish women's organization, was founded by Henrietta Szold of Baltimore.

Jewish women have been groundbreakers in politics. They serve their country in the United States House of Representatives and in the Senate. Ruth Bader Ginsberg sits as a justice of the Supreme Court. Madeleine Kunin became the first woman governor of Vermont. U.S.

Trade Representative Charlene Barshevsky reportedly juggled listening to her daughter's bat mitzvah lessons with negotiating a major international business agreement with China.

Congresswoman Bella Abzug and Betty Friedan, author of *The Feminist Mystique*, have been called the "mothers of feminism." Friedan recognized the new realities of women's lives when she declared that "motherhood is a choice." Jewish feminists, many of whom were veterans of the civil rights era, played keys roles in the emerging movement. They helped shift the focus of society, creating a groundswell of support for greater opportunities for women. They fought for equal pay for equal work, reproductive choice, affordable daycare, gender equity, and an end to sexual harassment. They made people realize that enhancing women's opportunities was beneficial to everyone.

The largely Jewish Boston Women's Health Collective revolutionized women's healthcare with the book *Our Bodies Ourselves*. Ann Landers and her sister, "Dear Abby," dispense their opinions as nationally syndicated advice columnists, and Dr. Ruth Westheimer has become the pre-eminent public expert on sexual issues. Estee Lauder, Helena Rubenstein, Abby Joseph Cohen, Linda Wachner, Lilian Vernon, and Ruth Handler (the inventor of Barbie) are business mavens of the highest order.

American entertainment would be unthinkable without stars like Lauren Bacall, Beverly Sills, Fanny Brice, Barbra Streisand, Bette Midler, Joan Rivers, Theda Bara, and Linda Lavin. Playwrights, writers, and filmmakers Cynthia Ozick, Erica Jong, Grace Paley, Wendy Wasserstein, Tillie Olsen, Joan Micklin Silver, Judy Blume, and Marge Piercy have all enriched our lives.

As religious activists, progressive Jewish mothers have been waging a not-so-quiet revolution to change the voice of Jewish worship. Sally Priesand, the first American woman rabbi, opened doors for equality in the synagogue in 1972. Hundreds of female rabbis and cantors now speak from the *bimah*, a place historically reserved for men. In non-Orthodox congregations Jewish mothers conduct egalitarian services using gender-neutral liturgy. They officiate at baby-naming and weaning ceremonies, teach adult bat mitzvah courses, and celebrate the new moon. Jewish healing rituals are being created to mark life-cycle transitions and to help women overcome abuse and rape, and cope with illness or addiction.

America's Orthodox Jewish mothers are deeply connected to their communities. They move within the depths of Jewish traditions, living vital and modern lives. They may run a Chabad House for college

students, teach at the *yeshivah,* manage a wig design service, advise young women on the laws of family purity, and battle against domestic violence and the plight of the abandoned woman, the *agunah.* For several years Rebbetzin Hannah Weinberg of Pikesville, Maryland, the mother of six and grandmother of forty-seven, ran a hotline for abused women in her community. She believes that "children learn from what they see in the family home."

In doing this book, we found that there is no such thing as a typical Jewish mother. The American Jewish community is wonderfully diverse: Orthodox, Chasidic, Conservative, Reform, Reconstructionist, Chavurah, Jewish renewal, humanist, unaffiliated, the intermarried, converts, immigrants, and a galaxy of other groups. We visited women from all over the country and found warmth, wit, and a lot of surprises.

The Jewish mothers in this book include a breast cancer survivor who mediated peace in the Middle East while braving the first three months of life with her newly adopted son. Another is a klezmer violinist, a lesbian mom who has toured with Itzhak Perlman and Led Zeppelin. They come from every avenue of American Jewish life. A teacher. A Holocaust survivor. An African-American convert. The mother of a slain civil rights worker. A Girl Scout troop leader. A children's TV star. A veteran. A marathon runner. A social worker. A professor. A surgeon. A wig stylist. A rebbetzin. A rabbi. A single mom. A choreographer. A midwife. A blind attorney. A Russian immigrant. She is a stay-at-home mom, a Hadassah volunteer, a Hebrew school teacher, and—the backbone of American Jewish communal life—a United Jewish Appeal fund-raiser. Progressive women have created egalitarian services and acknowledge the presence of the *Shechinah.* They read from the Torah, a privilege once reserved only for men. Orthodox women, deeply rooted in tradition, are journalists, homemakers, businesswomen, educators, *mikveh* attendants, and … murder mystery writers.

We have learned that these women have much in common. A strong spirit. A love of children. A passion for learning. A commitment to *tikkun olam,* to healing the world. A deep grounding in their Jewish heritage.

And a sense of humor. There is an old Jewish proverb that goes, "God could not be everywhere so God invented Jewish mothers." These women know a good joke when they hear one.

"Being a mother is like its own religion," asserts comedian Lotus Weinstock. "You must pay full and utter attention. When I caught my three-and-a-half-year-old daughter pretending to give birth, I asked her, 'What are you doing?' She answered 'Enough with the questions, cut the cord!'"

We listened to women describe their labor pains and their euphoria at giving birth. A few painted in cautious words their image of God. Older participants recalled the sadness they felt watching their immigrant mothers singing opera over the stove and slaving in sweatshops. There is great depth in these memories, fertile wellsprings salted sometimes by tears.

We confess to feeling humbled by the achievements of these women. Dr. Rosalyn Sussman Yalow, who is now seventy-six, likes to joke about her Nobel Prize in biomedicine by shrugging her shoulders and saying, "Bronx housewife makes good." Sydell Laskowitz, who became bat mitzvah at 101, contends, "I have overcome everything." Midwife Alice Bailes welcomes newborns into the world singing from Psalms: "From the narrow place I call to God and God answers me in this great expanse of space."

Please read their stories. Look into their eyes. Think of your own story.

Dr. Joyce Antler

Professor Joyce Antler, 56, Samuel Lane Professor of American Jewish History and Culture and Chair of the Department of American Studies at Brandeis University, is the author of The Journey Home: How Jewish Women Shaped Modern America, *and editor of* Talking Back: Images of Jewish Women in American Popular Culture *and of* America and I: Short Stories by American Jewish Women Writers. *She lives in Brookline, Massachusetts, with her husband and two daughters.*

Often the real lessons that our mothers teach us are quite disguised. My mother died last year, and I have been thinking a great deal about the subject of Jewish mothers. It has always been very puzzling, my mother's influences on me.

I think that Jewish motherhood, like any parenting, grows with the job. I also believe that we know very little about Jewish mothers as a "type" either in regard to our own mothers, or about the cultural images that we create of them.

I perceived my mother through the lens of a feminist daughter who found her mother wanting. She seemed too weak, dependent upon and subordinate to my much more assertive, powerful father who was the love of her life. In fact, when Betty Friedan's revolutionary book, *The Feminine Mystique,* came out in 1963, the year of my graduation from college, I immediately bought and inscribed a copy for her, hoping that the book would help her change her life. I am sure that she never opened the pages.

She didn't really need it, though. Much later I came to understand that her devotion to my father and to his work was in fact her own choice. After my father's death, my mother was widowed for over twenty years. Because of her steadiness and other abilities, she was able to make another whole life for herself.

As in my own case, I think that as a society we do not understand the lessons our mothers teach us. They may be quite hidden, both by the intricacies or family relationships and because of the cultural images we project as a society upon mothers. Jewish mothers fare the worst by far of many ethnic groups when it comes to inflicting damage by image. I am exploring these images in a book I'm now working on called *Mama Talks: A Cultural History of Jewish Mothers.* In fact, we can best see these kinds of representations as stereotypes because they are so consistent and patterned, usually in a negative mode. When it comes to Jewish mothers, we know what we don't like and we push away from it. It will be instructive to compare these images to those we hold of other ethnic and nonethnic American mothers.

Why the stereotyping of Jewish women in America? There are many answers to that question. A lot of stereotyping comes from inside the Jewish community, and particularly from Jewish male writers, comics, and the like. Freud said we laugh at what we fear, and certainly Jewish men have projected on to Jewish women qualities that they are ambivalent about—materialism, selfishness, the movement away from faith.

In each epoch of Jewish women's history you can see how the stereotype is presented; you also see how many Jewish women have "talked back" to it. Most people tend to think that the negative stereotyping began in the 1950s as it became clear that Jews were succeeding in America beyond their wildest dreams. Certainly Herman Wouk's *Marjorie Morningstar* and Philip Roth's *Portnoy's Complaint* were formative books for the Jewish mother myth, but they were not the only sources for the stereotype and for the hostility it engendered. In *The Journey Home,* I discuss how media portrayals of such women as Ethel Rosenberg, the executed spy, and actress Gertrude Berg, who played the beloved

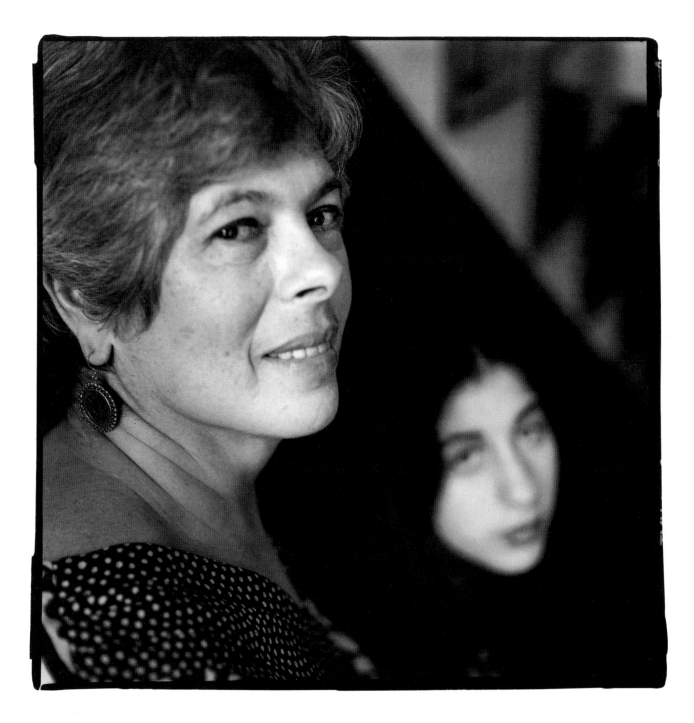

Molly Goldberg, also contributed to Jewish mothers being cast as either "bad" or "good" in basically unreal representations. Jewish female characters on television and in the movies are still one-dimensional. As mothers or daughters they remain largely typecast as negative figures—greedy and demanding. The other trend we find in American popular culture is that the Jewish woman is "missing." There are few, if any, lawyers, doctors, or professionals of any kind, or other kinds of well-developed women's roles. This is in sharp contrast to the portrayals of Jewish men in the media. While Jewish men are also stereotyped, it is usually in more positive ways. Even if they're often shown as neurotics, at least they are well meaning and full of *menschlikheit.*

Writers just don't seem to know what to do with Jewish women. The negative stereotype is constantly remarketed and made into fashion when it should be tossed in the leftover heap. Such persistent stereotyping is unusual even among ethnic minorities.

My daughters used to tell me to lighten up on my worries about the stereotyping of Jewish women. They think some of the stuff about Jewish women is funny. We have had several discussions about this. I think one can laugh at the jokes and ironies, but still be aware of the dangers inherent in the nasty portrayals of Jewish women. Most non-Jews don't understand that these media-constructed images are caricatures and do not reflect Jewish women's successes in either family or professional life. I think outside the Jewish community the population at large does not understand that this is not how it is, that these are caricatures. I don't know why it is still acceptable to stereotype Jewish women and not other ethnic women. My daughters have now become sharp media critics; at the same time they've taught me much

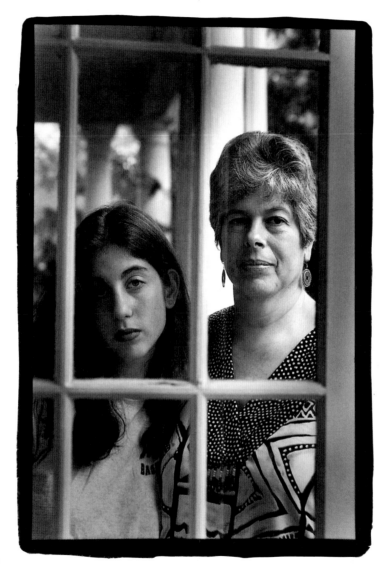

about the culture as seen through the eyes of young people. Very often parents and children do see the world from a different generational perspective; sometimes I wonder how it is that my daughters and I do share so many fundamental attitudes.

Of course I always wonder what kind of mother I am. Can I be a "Jewish mother" when I don't recognize the legitimacy of such a type? I don't think so. Whatever my daughters might think of my mothering, I recognize how much I owe to them. As they have grown older, my daughters have not only been very supportive of my work but an inspiration for it. One day I was driving the car pool home from Hebrew school and the oldest one said, "You know, there are two things in life I am really proud of. They are being a woman and being Jewish." This statement caused me to reflect a great deal about the different kinds of experiences my daughters and I have grown up with, as Jewish women, and how their world points to such a hopeful future, stereotypes notwithstanding.

Two things are true of Jewish women in America. One is that Jewish women have close family bonds and the other is that as a group, they show enormously high achievement. The proportion of Jewish women in professional life has usually been higher than those of any other ethnic group.

Unfortunately, though, we don't know much about their history or their contributions to American life as a whole. That is one reason I wrote *The Journey Home:* to show how Jewish women have shaped all aspects of our nation's life—politics, religion, community life, culture and the arts, law, education, and social welfare.

When you take the stories of Jewish mothers, our own Jewish matriarchs, and move them from the margins to the center of history, from

stereotypes to the real activist figures they were, the record of achievement is astounding. In my classes on Jewish women's history I assign students to do a research paper on a missing Jewish woman, one they might find either in their families or communities or from history. The story and the woman had to have made a difference. The stories they discover have been significant and inspirational.

I have a story about my grandmother that is really a joke on me. When I lecture I usually say that we don't really know our own family histories. One day I was speaking about the garment workers' strike that took place in New York in 1909–1910. Well, a dear aunt was in the audience and afterward she came up to me and said, "You know that during the garment workers' strike your grandmother was arrested and sent to jail for hitting a policeman?" I thought, "My grandmother?" Once I understood that my grandmother had a history of work and protest, my family background and my grandmother's place in it took on a new coloring. Grandmother was the family's main support during the Depression when my grandfather's work as a milliner became very sporadic. During World War II when things were tightly rationed, she insisted on meat for her family and led many consumer protests—if the price of kosher meat was too high, for example. The strong character she showed in molding her family life was part and parcel of her determination and her commitment to her community and to her values.

It is no accident that American Jewish women have been agents of social change in this country. It is the one continuous course of action taken by Jewish women this century. Jewish women were leaders in the union, civil rights and peace movements, and helped give birth to the women's movement. A prime example is Bella Abzug, who was active well before and after the 1960s in many different political settings. She never compromised her values or her efforts to create equal opportunity for women and minorities.

Jewish women's history in America really begins with the arrival of over two million Jews from the Russian empire in the four decades between 1880 and 1920. The experiences of the first generation are fairly well known, and writers like Mary Antin and Anzia Yezierska present voices from that generation. Antin's book *The Promised Land* was published at least thirty times, and it was the classic immigrant success story. It told of Jews leaving the perils of anti-Semitism in the old country and coming to a land where children could attend school, visit libraries, and become educated. Yet, the author had a nervous breakdown and spent much of her life seeking spiritual solace. So, promised land, yes and no.

By the 1920s some Jewish women were attending colleges and the second generation didn't work in the sweatshops anymore—the daughters often went to high school. Like my mother (who was born in 1912), they became bookkeepers and secretaries.

In the 1920s, 1930s, and 1940s a few women started to become professionals—lawyers, doctors, and teachers. By the time of my own generation, college students in the 1960s, Jewish women were in the mainstream, often in the vanguard, of American life. But there is still discrimination, prejudice, and quotas for Jewish women to overcome.

Research about Jewish mothers, and Jewish women in general, is desperately needed. We have much information about Ashkenazi women, for example, but very little on Sephardic women in America. We have very little history about the ways Jewish women have worked with women in other communities. And we know next to nothing about the career paths, the pedagogy, or the impact of Jewish women teachers, to name just a few examples of what is missing. Jewish women's lives in America remain virtually unknown.

I am deeply involved with the Jewish Women's Archive here in Boston, a truly visionary organization that is developing innovative ways to uncover, document, and transmit information about the history of Jewish women and their contributions to society. For three years now, we have developed posters and curriculum materials on extraordinary "Women of Valor," many of them quite unknown, which have been promulgated throughout the country and the world through prize-winning Web sites and posters. We have found documents, done art and museum exhibits, oral histories, and much more. To commemorate the 350th anniversary of the Jewish settlement of the U.S., the JWA is planning a multi-city "dig" in 2004 to uncover the lives and contributions of Jewish women. This time Jewish women won't be left out of any celebratory memorials!

Carol "Bini" Masin

Carol Masin is an exercise physiologist and mother of two children. She resides in Coral Gables, Florida, with her husband, Greg. Having been raised in a secular home she is now studying Talmud and seeking a denominational affiliation for her family.

My parents were not very religious. We never lit *Shabbos* candles. I went to school to learn Hebrew and to be bat mitzvahed and after that, it was over. It wasn't until after I had children that my husband and I started asking ourselves questions about how we would raise them. Actually one of my fitness clients got me interested in studying Judaism. He said to me, "You spend so much time working to take care of your physical well-being, what about taking care of the part that lasts forever?" He started telling me about his lessons with a rabbi and now I also study Talmud with the same rabbi. This makes me feel very blessed.

Learning about Judaism is just endless. This week I learned about the concept of "evil speak" or in Hebrew, *loshan hara*, which tells us how important it is to be careful with words and to think about something before you say anything. This applies to everyone, even children. We are supposed to think about how easy it is to hurt each other's feelings and to remember that we are all part of God's creation.

I am discovering that the more observant my family is, the more *mitzvahs* that we follow, the sweeter life is. We are still searching for a synagogue and have just put up our first *sukkah*. This year will be our first Chanukah celebrating with our entire family. We have yet to become completely kosher and I might consider doing a *mikveh*. The biggest change that I and my husband have made in our home is trying to do *Shabbos* on a regular basis. The kids love taking *challah* and lighting candles. If it wasn't for *Shabbos* there would be no time in the week for us to sit down and have a family meal because our work schedules are so busy.

My biggest struggle right now is living in cosmopolitan Miami and not getting caught up in materialistic things. So I am teaching my daughter Rebecca the importance of *tzedakah,* or charity. We bring *tzedakah* to her school but we just don't give money, we give our time with other people and we donate our things, including toys that she does not use. I think it is important to not spend our whole lives trying to attain things, but to appreciate family, friends, and acts of lovingkindness.

Judaism is very important to me. My husband and I have taken it much further than our parents did and now they are very supportive of us. You know I feel very blessed. The one thing my mother always taught me was unconditional love. She just always made me feel so wonderful, so confident, so loved that I was sure I could handle anything.

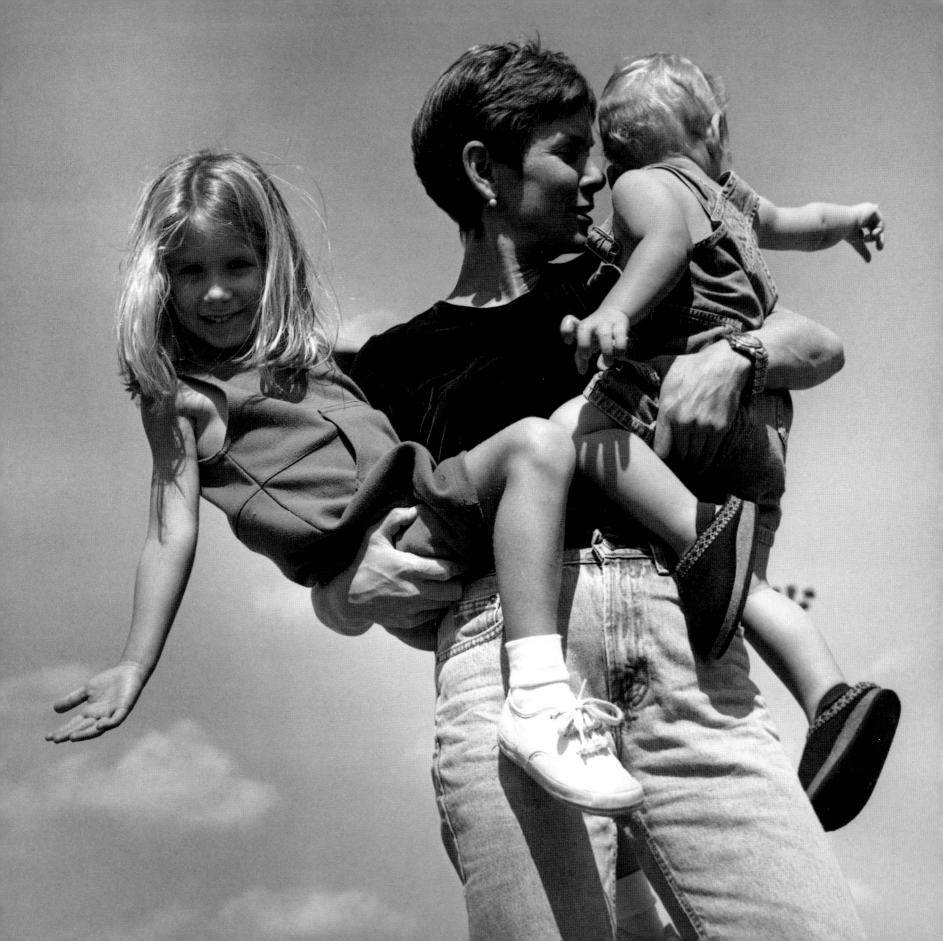

Dr. Carolyn Goodman

Dr. Carolyn Goodman, 82, is a clinical psychologist who designed PACE, a pioneer treatment program for emotionally disturbed women and their children. She was Woman's Division Chair of the Joint Anti-Fascist Refugee Committee and a former president of Pacifica Radio. Dr. Goodman is producing a documentary film entitled Hidden Heroes *on youth activism. The film is dedicated to the legacy of her son Andrew Goodman who was murdered by the KKK in Mississippi during Freedom Summer 1964. Dr. Goodman has two other sons, David and Jonathan.*

My son Andy was in Mississippi for only twenty-one days when he, James Chaney, and Mickey Schwerner were murdered by members of the Ku Klux Klan. Andy and the two other young men had volunteered for the Mississippi Summer Project to investigate a church that was burned because it housed a freedom school. While driving in the area they were stopped by the local police for a speeding violation and taken to the jail. They disappeared, and it took forty-four days to discover their bodies.

I didn't go to Mississippi when Andy disappeared, when he was murdered. I wouldn't have known what to do. It was a horror. Somehow or another I kept thinking if I only knew what happened, maybe I could live with that, but not knowing and having all kinds of fantasies of the possibilities was horrifying. So during the forty-four days he and the others were missing, my husband Robert Goodman and I went frequently to Washington, D.C., to meet with President Johnson and Attorney General Katzenbach.

It was a hard time. I couldn't go to the trial. No one in my family did. I had to think in my own mind how I could somehow or other deal with the people who murdered these three young men. First of all, they were not tried for murder. The state of Mississippi would not try them at all. The federal government tried them on a civil rights issue. There are two of them, Deputy Raney and Assistant Deputy Price, who were the two main people who rounded up the rest of the Klan. And they did make so much light of it, clowning around during the trial on the tapes that I saw. They were found guilty but sent to prison for only a short while. They still live in Mississippi. One runs a pool parlor and the others are still around.

Andrew was my middle child, politically active, wonderfully talented in music and theatre, very athletic. It is incredible that there were so many things that he did and did well in the twenty years of his life. He believed in the Constitution, equality, and justice. These were his guideposts. When the Mississippi Summer Project began recruiting for volunteers to organize civil rights efforts in local communities, my son Andrew came home from college and said, "Mom, I want to go." We all discussed it as a family. Of course, my husband and I said yes, but my heart was in my mouth. We knew it was dangerous. We had already seen on television the violence directed at the Freedom Riders, what happened to people when efforts were made to change the terrible victimization of Black people.

There is no one reason for any change in life. It's many things. Even as a child, there was something that I felt inside—a feeling, a sensitivity to mistreatment, to prejudice. If there was a kid on my block who was not treated right, whether he had a handicap, or was a minority, or a different religion, it just got me angry and I made my feelings known. I made it clear that I didn't think this was the way to treat somebody. While at college I also became involved with issues of social justice, just like Andrew. Although I had certain sensitivities and concerns about mistreatment of people, Robert Goodman

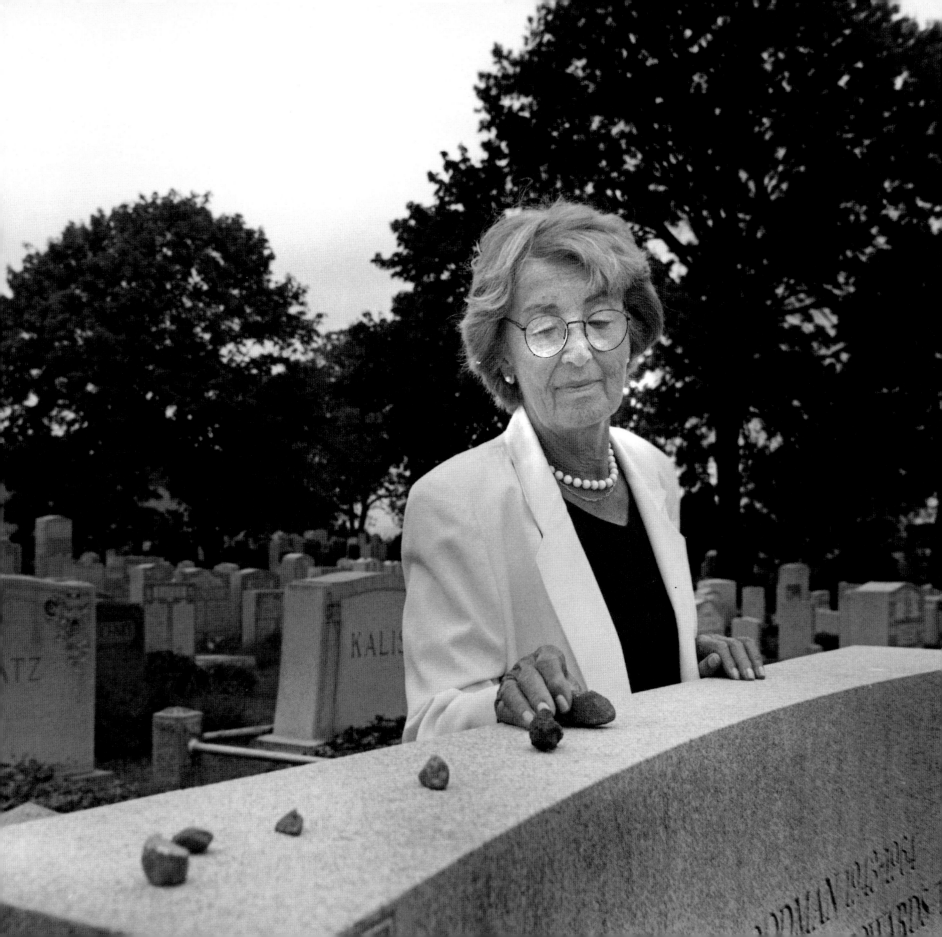

helped focus my ideas. We met in college and fell in love serendipitously. He was a wonderful, incredibly sensitive human being and the father of my three children. His mother was a socialist and a great influence on our lives. We were at Cornell in the mid-1930s, which is dairy country. Already big business was trying to move in on the local farmers. Robert and I helped to organize them into collectives.

As a young mother I clearly had ideas how I would like to raise my children. The thought of motherhood was awesome. At the time of my first pregnancy, my mother was living somewhere else and I didn't have her to call on. Interestingly enough, there was a newspaper that began publication in the early days of my pregnancy, and they had a Sunday feature about a little girl who was born on the same day of the newspaper's first issue. The child's pediatrician was interviewed by a journalist, and he would talk about the girl's development. As the weeks went by I found him fantastic. He had so much intelligence and sensitivity. The newspaper never published his name, and I wanted to know who this unknown doctor was. So, through contacting the journalist, I asked for the doctor's name and address. I proceeded to see him and he became my pediatrician for all three children. His name was Dr. Benjamin Spock.

Ben became a good friend. I learned so much from him that I think that part of the reason I worked as a psychologist with mothers and young children in state hospitals had to do with Ben Spock. He helped me understand that children need limits and boundaries. People at any age need boundaries, and beginning this process in childhood makes their growth so much easier. It helps them deal with feelings and express anger, rather than go out and take a gun and shoot someone, like in today's world.

You know I can talk a lot about Andy, my life, and raising my two other sons, Jonathan and David, I do it frequently in public and in private. In some ways it probably comes up every day. My husband and I raised our sons to think for themselves, but a common thread runs through their personalities in which they are caring, caring people.

My oldest son, Jonathan, is religious and as a child wanted a bar mitzvah. At the age of twelve he was inspired by our neighbor, a cantor, to study. In six months he learned Hebrew and spoke at his bar mitzvah on unity and friendship. It was a beautiful speech. As a young man he became terribly depressed by his father's sudden death, which happened five years after Andrew's murder.

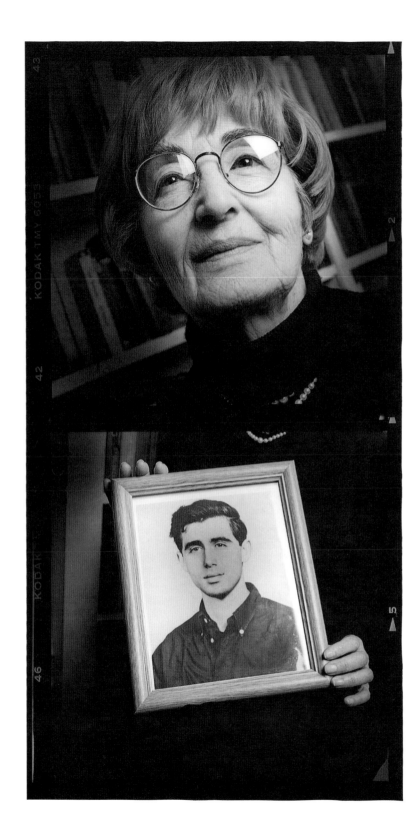

Jonathan was a brilliant musician and was enrolled in Julliard's school of conducting. He realized that bowing in front of an audience and receiving adulation was of no significance for him. He began to meet and study with religious Jews. He found significance in that. He started wearing a Star of David and was told by a friend, "You don't just wear it, you live it." He moved to Israel when he learned what it was to be a Jew. We love each other very much but don't agree on things that have significance for me, which have to do with social issues. His thinking is so far from mine.

My youngest, David, is an engineer and businessman in New Jersey. He develops alternative energy sources for water power and electricity. As a young man David was very sensitive to my being nervous if he came home late. So he always showed up early and surprised me. Once when he went to Israel at the age of fifteen to work on a kibbutz, the doorbell rang. I opened it and said to the long-haired young visitor that David was still away. Then I took another look and said, "Oh, David, it's you!"

As a child I had to always be home on time. My own mother, Ruth, came from a Germanic background and was very strict. In summertime you had to be in at 7:00 P.M. My mother would sit on the porch with a little clock, and at 7:00 P.M. you had to be there. This memory always reminds me of that Robert Louis Stevenson poem, "In winter I get up at night / and dress by yellow candlelight. / In summer, quite the other way, / I have to go to bed by day."

My mother was a very bright woman and a graduate of Barnard College, which was most unusual in those days. You could call her a feminist from the time she was born. I used to love to play football as a kid, with the boys, and my mother saw nothing amiss in this.

After I married Robert Goodman my life became dedicated to fighting social injustice. During the early days of our marriage I became the chair of the Women's Division of the Joint Anti-Fascist Refugee Committee, which took care of families, basically after Franco invaded Spain. We used to hold big fund-raising events three or four times a year, always in honor of the birthday of Edward Barsky, one of the committee's founders and a great physician who took ambulances and medical supplies to help the Spanish Republicans.

Years later, during the McCarthy era, Ed and the committee board were subpoenaed and were not going to give names, so they had to go to jail. We decided to have a farewell party at our home and give them a cake from the Bakers' Union that said "Happy Birthday Eddy Barskey." Andy was about nine at the time and had tears streaming down his face when it was time for Ed and the board to leave directly from the party and go to jail. I inquired, "Andy, what's wrong?" He replied, "It's so mean, it's so mean!" I said, "What's so mean?" He responded, "That a man has to go to jail on his birthday!" Andy was just that kind of a kid, always concerned about unfairness.

For myself, I know now that Andy's commitment, Andy's dedication, and Andy's death in his early adulthood would have no meaning if I retired to some place and was simply stricken, so stricken by it that I couldn't move forward, move with today's young people. And I love them.

The legacy of youth activism is a long legacy. If I live long enough I hope to complete my documentary, *Hidden Heroes,* on twentieth-century youth activism. There are many young people doing great, great work throughout this country, many more than people know. This is what has helped me, does help me, and continues to help me get through the loss of my son. I hope my documentary will inspire others. I suspect that when I am gone my son David will carry on this work. He seems to recognize and accept my complete dedication to Andy's life and work.

I now have nine grandchildren, two in New Jersey and seven in Israel. All but one are girls. My family and many friends have named children after Andrew. There are little Andrews running around and that's great to think about.

Some of these memories and recollections are very hard for me, they touch something, but I was thinking that Jewish mothers and mothers all over the world are the same. I recently had lunch with this young Korean man (whom I adore, who is working with me), and after he was through with his sandwich I asked him if he wanted half of mine. He said no, and I said, "Eli, you know I'm a JM." He said, "What's that?" I said, "Jewish Mother." He said, "Well, Jewish mothers are just like Korean mothers."

Children learn from their parents how to bring continuity to their lives that is significant for family. Because of this I keep thinking of ways to talk to my son Johnny, who is a member of Lubavitch. I keep trying to think of ways to talk to him about how much the fight against social injustice has meant to our family. Even though his thinking is so far from mine I will try again. I am leaving tomorrow for Israel to visit him and my seven grandchildren.

Chanie Baron

Chanie Baron, 28, is a Lubavitch rebbetzin in Columbia, Maryland, and teaches at the Lubavitch Center for Jewish Education. As a shlucha, *an emissary of the Lubavitch Rebbe, she maintains the community center* mikveh, *performs outreach, and teaches bat mitzvah students about the role of Jewish women in history and the home, according to Torah. She is the mother of six children (Mendel, Chaya, Ricki, Yisroel, Mushke, and Yankele). She attended Teacher's Seminary in Brooklyn and received a Judaic teaching degree.*

Torah is actually a very feminist book. Women are the ones that formed our people from the start. They were the catalysts through which everything happened. Some people want to move away from the role that our foremothers had. I want to emulate them.

I teach girls about the role of Jewish women in history by making references to the first book of Genesis that the choices women make are the correct ones. When Abraham didn't want to send away Ishmael, what does God tell him? He tells him, "Everything that your wife Sarah says to you, listen to her voice." Rebecca didn't go up to her husband, Isaac, and say, "You are blessing the wrong child," she couldn't. She respected her husband and masterminded the blessing he gave to Yaacov, the right child. Isaac did not say, "Hey, I was tricked!" Isaac said, "He will remain blessed." Jewish women and Jewish mothers do what they do for the sake of the Jewish people.

When my sister and I were growing up we went to conventions in New York, and the Rebbe would speak only to the women. He would imbue us with a real sense of responsibility for the safety of the Jewish people. The Rebbe believed very strongly about the greatness of Jewish women in shaping the people. Everything we learned was imbued with a strong sense of being completely comfortable with being a Jewish woman. The Lubavitch movement differs from other Chasidic movements in many ways. Our philosophy is different, we are on the forefront of reaching out and do not shut out the rest of the world. The vision that the Rebbe had was one of love and respect for all. His goal was for us to go out there and change the world, to reach out and educate, for us to be a shining light.

I don't keep a calendar, because if I kept track of the things I'm supposed to be doing for the entire day I'd be too overwhelmed. I'm involved in the preschool and the kindergarten, in addition to the Hebrew School that we have twice a week. We also have adult women's classes. Some are private one-on-one studies, some are in groups on Sunday evenings. We also have a bat mitzvah class to prepare girls for their bat mitzvah and a post-bat mitzvah class. We do the bat mitzvah at twelve. The girls get up and have prepared an original speech including some of the verses of the Torah portion and the Thirteen Principles of Faith. Before they do that we spend five months in a group session talking about the role of Jewish women—Jewish women in history, Jewish women in Jewish law, rabbinic statements about women.

I love to give my students a strong sense of the security and comfort I feel being a Jewish woman and mother. I have found many parents have, shall we say, "baggage," and strongly lack comfort with the role of traditional Jewish women. They have a lot of questions, a lot of concerns, a lot of barriers between themselves and the life of an observant Jewish woman. I tell them, "Give me your daughters for a year, allow me to expose them to the view I was raised with, and I guarantee they will grow with strength, that they will not feel they are missing out on anything." The Torah has never had any problem with the

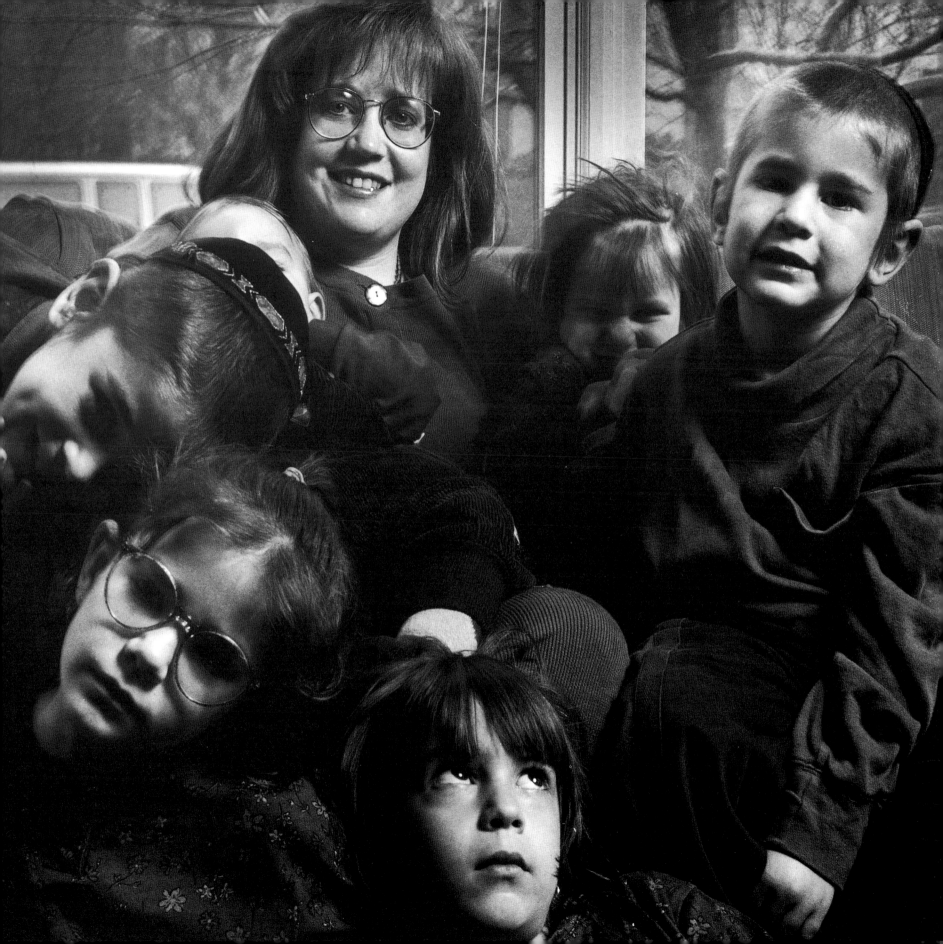

role of the Jewish woman. They do not understand the real traditions of the Torah that place women and mothers on a pedestal.

In the Torah the commandment to marry and have children was not given to woman because she did not require it. Women have a natural tendency within for the creation of a child. Women nurture the seed. Women came to this world already prepared for a spiritual way, the *mitzvahs* that we do not actively do, like wearing the *kippot* or *davening,* is because we're not required to. I believe that a lot of what secular society has expected of women, to be a woman in a man's world, has given many women a sense of trying to be what we're not.

I feel strongly that I'm a feminist and hope every traditional woman feels that way. The rituals are there to maintain the special aspects we have as women. Women came to this world already prepared for a spiritual way. It's harder for men. Rabbi Friedman from Minnesota wrote in *Doesn't Anyone Blush Anymore?* that the more barriers we take down and the more things become comfortable, the less they are special. The *mechitzah,* the divider at the *shul,* is not to put the women away because they are not clean, but to be kind to the men. It was simply put there because it is difficult for a man to concentrate on his prayers, on his time with God, when there's a distraction. I don't want someone to say it doesn't bother me if a woman walks by. I would like for people to be distracted by my presence. The rituals and traditions are there to maintain the special aspects we have as women.

I always wanted to live exactly the way I do and be a rebbetzin, like my mother. I grew up with big *Shabbos* tables, big holiday meals, huge seder tables, I come from a big family, three boys and three girls, very close. My children are being raised the way my parents taught me to see things. My parents were emissaries of the Lubavitch rabbi in Pittsburgh. They were very much involved in Jewish education there, teaching in the day school, and my father is also the rabbi of a small congregation there. I grew up involved in outreach and having all kinds of people coming to our house to study and for help. We were raised to look to the soul of a person, straight to their *neshama.*

My children are taught to tolerate others, not to point a finger, not to be closed-minded. This came directly from my mother, from her inspiration. My children understand some people drive on *Shabbat* and some walk. They have to develop a really strong sense of tolerance and acceptance. They have to develop a sense of balance between what they know we do and what other people don't yet do. They see people at varied levels of observance and they are able to understand that we do it one way. They learn as they grow older not to comment about other people's lack of observance. They learn that it's sort of a road, a path, that everyone is at a different place. The children play-act the kind of roles they watch. My oldest son was like a little rabbi in preschool. He'll ask if he can bring a special Purim present of *shalach manes,* a package of fruit, for a nonobservant child. My daughter invites our neighbor's child to light the *Shabbat* candles. The first sign of success is when children start doing that. They also see that my role is right up there with *Tati.* My husband and I work at the same goal. *Tati* cooks, diapers, and when I'm off to teach classes, he's at home.

As a very young child my mother encouraged me to help others. We believe even children have a mission to do something for someone else and to then learn to let go. My mother strengthened me by telling me it was a gift to befriend someone and teach them, get them to a point where they no longer depended on you. Today my mother single-handedly raises all this money in her community to help families in need. She runs an organization called *Kayrmachim.* She still teaches and runs around. On the holidays we talk on the phone, and my sisters and mother are all doing the same thing, baking kugel, but my mother still bakes it best.

Being a rebbetzin is a big responsibility. With my job as a *shlucha,* an emissary, teacher, and a mother I have to of course organize my family time. My children do enjoy the people coming over to the house and always ask, "Who's coming for the weekend? Can you invite someone?" We try to have a family *Shabbat* one weekend a month, no guests, and the children always say, "Invite someone, we don't want to be by ourselves." They enjoy being a part of everything and have gained a lot from my mother in that she showed us by reaching out to others, in due time you will enjoy that sort of thing yourself.

I certainly hope my children will grow up and want to take an active role in reaching out to the Jewish people. I would like them to be very confident in the way that they live and the choices they make for themselves. God willing by the time my children are grown, the Messiah, the *Moshiach,* will be here and we'll all be in Jerusalem and there won't be any teaching left because everyone will know God!

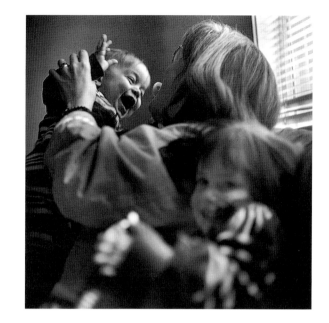

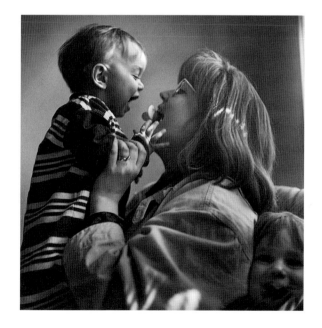

Susan Dmitri Lipczenko

Susan Dmitri Lipczenko, graphic designer, is a single mother by choice.

My baby is due the week of my father's *yahrzeit.* When I was little he told me that I was the best thing that happened to him in America. At the time of his death, I was devastated and knew there wouldn't be room for a man or romance in my life for at least a year. His death also helped me make priorities. I decided that I wanted to have a child, my own family. I'm not a kid anymore, and it had to be now or never. My father used to say that the family was like a crown and each member a precious jewel.

As I mourned his loss I talked to friends and shared my desire to have a child. I spoke only with my closest friends. I began to get offers from men who felt that this might be their only chance for becoming a father.

Father died in March of 1995 and I was pregnant by June. When I called my mother and said, "I hear you're going to be a grandmother again," she was shocked. My mother felt concern for my doing this alone. She knows I wanted a traditional marriage but that it just didn't work out. I have had the opportunity to marry, but it never felt right. My mother has met the father and knows he is a nice guy and plans to help parent our child.

My mother had it rough. She's lived in three different continents and weathered financial losses, war, and political upheavals. Her own marriage in 1938 in Vienna, Austria, was a quick ceremony in response to the *Anschluss,* the Nazi invasion. Mother shared her wedding veil with two other brides. She and my father married along with many young Jewish couples. They had a brief period to take action before the Nazis made Jewish weddings illegal. It was easier to get married men out, then later get the wives.

My mother had lost her own mother to Auschwitz. My maternal grandmother, Ernestina Nacht Ungar, raised her three children on her own without financial support. She became a housekeeper and while cleaning on a ladder, fell and broke her hip. She was classified as an invalid and was unable to get a domestic worker's visa.

My mother was adamant about passing on my grandmother's values. Thoughtfulness. Thoroughness. Eventually, I figured out that I was cleaning my room not for my mother's standards but for her mother's, a woman who died long before I was born. This was a woman who pressed linen, folded it, and tied it with a violet ribbon. My mother was strict, yet she didn't let a day go by without making sure I knew that she loved me.

As a mother I know that whatever path I take it won't be perfect. I have told the father, who is not Jewish, to expect a Jewish presence in my home. When I was growing up Jewishness was all around me. I am now responsible for providing this. I don't believe in God as a superior entity; I believe in Jewish community, ritual, and Jewish education.

I am sad that my child will not know her grandfather. When my Dad was in the nursing home he said to me, "For what this cost, I should have had music and dancing girls." I know that the child is going to be a girl and I will name her with my father in mind.

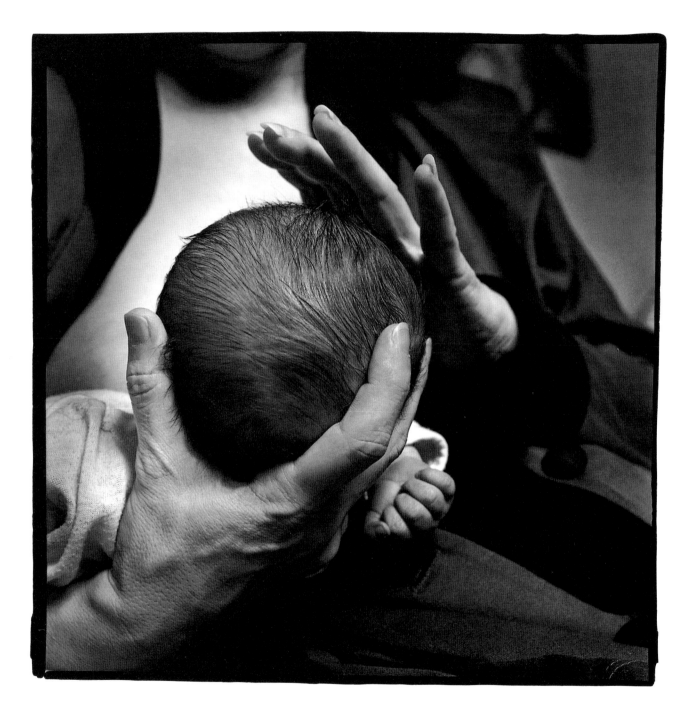

Julia Dubova

*Julia Dubova, 42, along with her husband and daughter,
emigrated from Russia on November 16, 1990. They were
sponsored by Temple Sinai in Los Angeles and now live
in North Hollywood. Julia obtained her citizenship on
February 6, 1998, and is a teacher of math and science.
She has her degree from the University of Russia.*

In Russia I used to think that the expression "Jewish mother" meant the elderly gray-haired grandmother who has lots of children and is always in the kitchen. She is big in the stomach and very religious. Now that I am an American citizen I know that being a Jewish mother is greatly influenced by where you live and if you have freedom.

As Jews in Russia we always felt intimidated. We had to carry our passports, which had "Jewish" stamped on them. It was like having it branded on your forehead. Even at the library they asked to see your passport and stared at you. I didn't want this for my daughter, Natasha, to feel it as I did my whole life. I was always concerned about Natasha and afraid to let her out of my sight.

It wasn't possible to leave Russia until Gorbachev came to power. We applied in 1988. In 1990 we were free to go. We came here with a hundred and fifty dollars in our pockets and nothing else.

Natasha was accepted to a private Jewish day school paid for by our sponsors. The Jewish community helped a lot. My husband took English courses from an ORT [Organization for Rehabilitation through Training] school. We learned about Jewish holidays and Natasha took Hebrew for four years. Yet, it was strange for us because religious expression was forbidden in Russia. I can't say we are religious, because it is hard to expect this feeling from people who were never allowed to worship.

Natasha was eight years old when she came and did not speak a word of English. It was fantastic the way she picked up the language. At times she did not feel accepted. There were some children giving each other bar mitzvah presents that cost two hundred dollars. We could not do this and we probably seemed strange to some people.

My daughter is a straight-A student and I am proud of her. She is a good girl and I trust her. Already we are teaching her to drive. She is in a school of performing artists and the students are mostly girls and gay guys. My only concern is that I think at times they all wear too much makeup.

I think overall the education in Russia is better than here, but here if you have ambition you can do anything. Natasha is highly motivated. She wants to sing professionally. I think theatre is a very tough business and told her she should have it as her second profession. I don't think it is a good idea to work as a waitress somewhere and then wait for a part.

In spite of persecution in Russia, Jews were highly motivated. It was almost impossible to see a Jewish waiter. Here it looks like some young Jews have lost their touch. I meet a lot of young people who sell clothes and serve food. They have no creativity in their work. I imagined that all Jews in the United States were highly educated. When I came here I was surprised. I think if you don't have some sort of struggle you lose your motivation. I think some young people, not just Jewish, have this problem.

I think to give birth to a child is one thing but to make them successful in life, to help them get educated and to help them become a real person, well, that is my goal as a mother. That is the main reason I came to America.

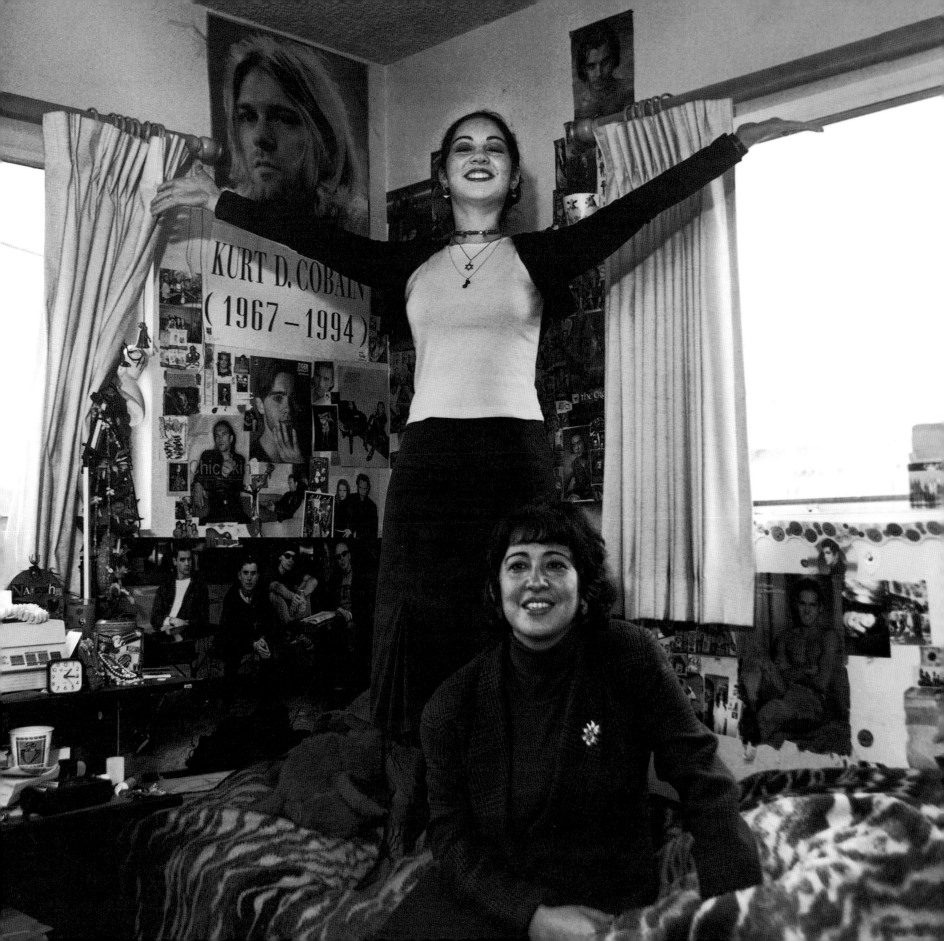

Hannah Weinberg

Rebbetzin Hannah Weinberg has run a telephone hotline out of her home to counsel abused women in the Orthodox community in Baltimore, Maryland. She became involved because there were no services available to help victims. In her pioneering efforts to address the issue of domestic abuse she has lectured nationally and counseled rabbis and lay leaders. She was born in Germany and came to the United States from Europe in 1934. Her father founded the Orthodox community in Baltimore and Ner Israel Yeshiva. Rebbetzin Weinberg is the mother of six children and has forty-one grandchildren and twelve great-grandchildren.

There is a big difference between a marriage and an Orthodox marriage. An Orthodox marriage is not just a partnership of divided chores. A truly Orthodox marriage is a merger. A Jewish marriage is a unit representing God. You are not just in the marriage for yourself or for lust. If you have physical gratification that's great. That isn't what the home is. It is a mutuality of interests. You are the agent for God, for *HaKodesh Baruch hu.* You are responsible to Him.

As a mother I tried to make my children aware of what God gave us, the sunsets, the garden. I would take them outside and show them growing things. I think we had at one time five parakeets. One flew away, one got ill. We even had a funeral for a parakeet.

I have six children, I have bookends, my boys are bookends and four girls in the middle: Aviva, Matis, Miriam, Yehuda, Naomi, and Simcha.

My children learned the 613 commandments from each week's Torah portion. We would play twenty questions and ask what is a *kiddush* cup or a *challah*. As they got older, they prepared themselves and had to be ready with the answer on Friday nights. For example, we would ask, "What land saw the sun once?" This is from the Bible. Then the children would ask us, "Is it in Genesis?" And we could only answer yes or no. (The answer was the Red Sea when it split.) This was how we kept their attention.

My two sons are rabbis and all of my daughters are married to rabbis. My daughter Naomi is an artist and once said she would never marry a rabbi. I said, "Never say never!"

In many places in the Talmud it says to men that you must treat your wife better than yourself. In the Torah, a woman was never chattel, never a possession. You couldn't barter her for cattle. She was always respected and put on a pedestal.

Most marital problems develop because people really don't listen to each other. Once you start the process of listening to each other then you can pretty much override the difficulties. So if you set up a home where the children see mutual respect, care, loving, they will perpetuate them. That's the way it should be.

I have learned there is no such thing as a usual case of domestic violence. My phone rings and it could be a woman of any age, screaming that she has been hurt or was put out of the house without her clothes. I once received a call from a woman who was married twenty-three years. While she was putting things away in a closet her husband asked if she had paid a bill. She said, no she hadn't had time yet and would do it soon. When she came into the room he really gave it to her. She had a broken nose from that one.

It is interesting that her neighbors never questioned her injuries. Looking back they remembered that she "once had a broken leg, or was bruised at times from falling down the steps, walking into a door, or falling out of bed." This was a time when no one asked, "Is someone hurting you?"

Nine years ago the police used to not take reports unless there was evidence of physical damage, but that has now changed. Depending on the case, I will urge some women to make out a police report and document it.

My goal is not to take wives away from their husbands but to stop the violence. I try to get couples to go into therapy, but first we get the woman out of the house. I was fortunate when I began this work because I had two Jewish women helping me. Both had been abused and knew how to comfort victims. When I met with a victim, one of these women came with me and took the woman out of her house. I had two homes where I placed people. It was done very quietly. No one knew.

I once went to see a Baltimore County home; it was so drab, dark brown carpeting. The incoming residents had to be deloused. I told my father about this place, and I said to myself, "Oh, is he going to be shocked. I am really going to shock him." So I told him about what I saw and I asked him in Jewish [Yiddish], "Did you ever see any abuse like this?" and he said, "Of course." Now I was the one who was shocked. My father came from Russia and Lithuania. The windows on the homes, as he described them, faced a courtyard, and so you couldn't help but hear what was going on in the different families. So I said to him, "What did you do when everybody heard the throwing of the dishes, the cursing, what did you do?" He said, "We closed the shutters." And that inspired me to write for an article, "Now the shutters are open."

People have always asked me how could I live with this all the time, with my phones, both phones ringing constantly? Well, each case, each person who calls my house for help is a soul, a *neshama.* Every year I have had more and more cases. One year I had twenty-seven cases, but this is a drop in the bucket compared to 3,500 cases in Baltimore County.

When I first started to do this work I would say to a woman with an abusive husband, "Go to see your rabbi." She would come back and call me crying hysterically. She would say, "The rabbi said, 'What did you do to provoke him?'" So I stopped sending abused women to consult with their rabbis because they got a different response than what I expected. I stopped sending women to their rabbis until I spoke to the rabbis personally. Of course there is denial that this problem exists; however I don't lobby on the political level. I do it quietly and individually. If I happen to be at a community meeting and a judge is there, I speak to them privately. They often give me the names of a few lawyers who will do volunteer or pro bono work for abused women.

I used to meet with the husbands and tell them, "You have two options. Either we go and we have a restriction put on you coming into the house, or else you have to promise me that you will go for therapy."

The first thing the husbands ask me is, "You are not going to tell Rabbi Weinberg about me, are you?" They are embarrassed that I or my husband knows about their behavior. This is my clout, my walk-in, my calling card. So most of them go to therapy. I used to get beautiful letters from the wives and one said, "I was in a tunnel of darkness and now I see the light."

Some of the husbands accept therapy and it does not help. In these types of cases I focus on the couple having a *get,* a Jewish divorce. The problem of *agunah* is still big in our community. In one case the husband demanded money, big money, on the same day of the *get.* It was unreal, like in the movies. We contacted somebody in Potomac and he said, "Meet me before the bank closes." We went with two cars and a suitcase for the money. Then at the house, while we were writing the *get,* the husband turns to the rabbi and asks him to personally count this huge amount of money. Can you believe this? Then when that was all over he says, "Rabbi, I want you to bless me." Can you understand this? Later on the *sofer,* the notary scribe, said that if he had a gun he would have shot the guy. I am so glad I wasn't there.

I can tell from personal observation that men who have seen abuse in their parents' home perpetuate it. These people are not really religious, they are not Orthodox, not really truly Orthodox. These men are mostly controlling, which has nothing to do with the fact that they are Jewish or whether they are Orthodox. They are just rotten people. Truthfully, they are scum.

Once, my husband was home with the flu and he couldn't believe what was going on. We had to get an abused woman out of the country. It was a very unusual case. The husband took her passport and the children's passport. He told her, "When I come back from New York, I am going to kill you." Her neighbor called me. In two days I had her on the plane to Israel. I got her out in forty-eight hours with the help of Senator Barbara Mikulski. I had six different people helping, getting her passport, photos for the passport, clothing. Not one of them knew of the others helping because she felt if the husband found out he would kill all of us.

Primarily what my work has been for the past five years is that I try to get the rabbis to face the problem. That may sound like an easy task but it wasn't. I spoke to one Orthodox organization in California that represents different groups for women in the community, teachers, social workers. One rabbi stood up and he apologized and said, "But

I have to tell you this issue is grossly overdramatized." And I said to him, we have this on tape, "Rabbi, I hope you never wake up in the morning and find that an abused woman has been murdered." A month or two later a Jewish woman was murdered in her garage, in Los Angeles. I had contacted a social worker and she had an *ex parte* with this woman that the husband couldn't come into the house. He found her in the garage.

Up to a few years ago, the rabbis didn't want to recognize it. There was a denial. I am still working at this. In May I spoke to a rabbi who I knew had an abuse situation, and I asked him about it. He said he didn't remember hearing about it. So I took a deep breath and thought, "Here I go …" I said, "Rabbi, maybe you heard and you weren't listening?" I thought he was going to throw me out, but he is a fine gentleman and he let me speak to him for about forty minutes on domestic abuse. At the end of it he said, "Rebbetzin Weinberg, I want you to know I am hearing and I am listening." And ten days later that woman had a *get*. My goal is to get the couple into therapy, or get the woman out and then get a divorce without involving the police.

It is changing now. The picture is changing.

I am working on other projects these days, primarily doing *bichur cholim,* visiting the sick. We are involved with twenty-two hospitals. We do quite a bit of work.

I have a dream. I am envisioning a complex, a block of homes, one for men, one for women, for the developmentally delayed or mentally ill. We are calling the project *Ahava,* which means love. Our motto is "The world is built on kindness." We are hoping to find residential homes for these men whose elderly parents cannot care for them properly. We have just became incorporated. I am also envisioning that we have a home for women after they have had a baby, since they can only stay in the hospital for forty-eight hours. It will help new mothers cope, and then you don't have a dysfunctional family. If you take a woman who has four or five or six children and you send her home before she is ready, what can you expect? Hopefully, some day all of this will happen.

I grew up on *yeshivahs* in Cleveland and in Baltimore, and my parents were always doing for others. My father is from a long line of illustrious rabbis in Europe, and people know the name. Our home was always open and we were always sharing. My mother used to entertain people from all around the world. She named the *yeshivah* where I now live with my

husband. She named it *Ner Israel,* the Light of Israel, because it was like a desert here before there was Torah.

I remember being in Atlantic City with my mother sitting on the porch of this old-fashioned hotel, and the people were telling rebbetzin jokes. Oh, they were having a ball, and they asked me, "Don't you have a joke?" And I said, "Later, later …" I was the last one to speak. They said, "What is your joke?" and I said, "My joke is three words. I'm a rebbetzin."

If you don't have a sense of humor, forget it. You are finished.

Elsie Frank

Elsie Frank, 86, is a well-known community activist to end elder

homelessness. She was a member of the Advisory Committee to

the 1995 White House Conference on Aging, and was awarded

an honorary degree of Doctor of Laws by the University of

Massachusetts Gerontology Institute. She is an active member of

Hadassah and Na'amat U.S.A., and speaks at chapter meetings

across the country.

Elsie Frank is the mother of Congressman Barney Frank;

Ann Lewis, Clinton White House communications director;

David Frank, director of communications at the United States

Department of Education; and Doris Breay, assistant director

of the Sustainable International Development Program at

Brandeis University. She has seven grandchildren and two

great-grandchildren.

My goal in life is to know what is going on in the world and to make it better. My husband and I set high standards for our children. We had a house full of newspapers and lively discussions about current events and social justice. We were involved with labor Zionism, racial integration, and United Jewish Appeal. As my children matured they developed strong feelings about how government should and should not run.

I wanted all of my children to be articulate and able to speak before an audience so when they were young they took elocution lessons. I guess subconsciously I was preparing them for a future in the public eye. My husband and I instilled in them the fact that generations need each other and that they should be concerned about the downtrodden, about the people who have fallen through the cracks.

When my husband died I became a single mother facing enormous college costs. To help pay for college tuitions I became a legal secretary and worked until the age of seventy. I retired to help my son Barney in a tight reelection campaign for a seat in the United States House of Representatives. I made an award-winning TV commercial for him that my son David wrote. I was sitting in a rocking chair and said, "I know that Barney Frank will protect Social Security and Medicare. How do I know? Because I am his mother."

During the campaign I went to senior centers and lunch sites. I was appalled to meet people seventy and eighty years old who did not have enough money to cover their living expenses. Since then I have been advocating on behalf of the elderly as a full-time volunteer. One of my grandchildren recently remarked, "My grandmother doesn't cook anymore, she makes speeches."

At the age of seventy-one I was elected president of the Massachusetts Association of Older Americans. It was quite a challenge for an older Jewish woman to take over the reins from an extremely popular Irish man who had established the organization. I formed an alliance with Edward L. Cooper, a very prestigious man who was president of the Center and Caucus for Black Aged. The word all over the state was that one old Jewish lady and one Black man were working together to make the world a better place for the elderly to spend the rest of their lives.

All of my family events are now fund-raisers. At my eighty-fifth birthday the kids made remarks about me. Ann impressed upon the audience how I used to tell my children to "read, read," and my son David told the story of how he got me involved in Barney's campaign. My daughter Doris had them all rolling in the aisles telling jokes, and I just sat there thinking to myself that their elocution lessons really paid off.

Needless to say I am extremely proud of my children for what they are doing with their lives and their commitment to make this a better world, with social justice for every member of society. I know they are proud of me for my ongoing commitment to preserving the dignity, quality of life, and economic standing of older people, their families, and future generations.

Dr. Rachel
Birtha Eitches

Dr. Rachel Birtha Eitches, 51, an African-American Jewish convert, is the mother of four children, Etan Edward, Eliana Rae, Naomi Shira, and Elyse Jamila. She had twin girls at the age of 48. Dr. Eitches is a research specialist on Near East, North Africa, and South and Central Asia for Voice of America Radio and currently manages the Kurdish language service. She lives with her family in McLean, Virginia.

I tell my kids that they are Afro-Jewish, that they have a double heritage. It is a challenge to maintain a biracial identity. My son, Etan, and my husband toured Orthodox New York with our congregation's religious school. They were shocked to learn that the Orthodox will not accept you as a Jew if your mother is a convert to Conservative Judaism. My son said no matter what they think, he knows he is Jewish. Etan became bar mitzvah in 1998, twinned with a young Jew in Ethiopia. I was proud of my son's confident Hebrew chanting in the service.

As a child I attended Baptist services on Sundays with my family. At the age of twelve, I realized I wasn't committed to Christianity and decided not to be baptized. It wasn't until after graduate school that I began to search seriously for religious affiliation. I was attracted to Judaism because of its ancient commitment to social justice, ethics, and making the world a better place for all. I believe religion should involve one's entire life and not just be a weekend activity.

A trip to Soviet Central Asia in 1981 led to my meeting Eddie Eitches at a lecture on Afghanistan at the Washington, D.C., Chapter of the Asia Society. By the time we were ready to marry I had completed formal conversion classes.

I went before a *bet din* and went to the *mikveh* for a ritual immersion. At the *bet din* three rabbis interviewed me and wanted to know if I would light the candles on Friday night and commit myself to living a Jewish life. At that time Adas Israel had no *mikveh*. The one I found was at the synagogue of a rabbi in Silver Spring, Maryland, who had refused to be involved in my conversion for racial reasons. So I just called up and reserved a time and went quietly by myself. Fortunately the *mikveh* lady who gave me the towel took it in stride.

Probably none of my invited African-American relatives and friends missed my wedding because they had heard a lot about Jewish weddings and had never been to one. Our guest list was truly multicultural, with all kinds of ethnic groups represented. One of my friends surprised us with a gift of a belly dancer in full costume. When our caterer, a Moroccan Jewish woman, heard the familiar rhythms, she ran out of the kitchen to join the performance. Our band was half black, half white, with a repertoire from golden oldies to klezmer. Everyone danced the horas. I wore a white velvet caftan made by my aunt. Eddie's yarmulke was from Central Asia.

My conversion and marriage in the Jewish tradition was something my parents gradually accepted because we always have had a close relationship. Religion is so central to the African-American heritage that my father felt I was giving up a lot. My parents had wanted me to go to a Black college like Hampton, where they had met. Because my sister and I always attended integrated schools, my father was worried about whether we were proud of our African-American heritage. I always told my parents whenever I was taking Afro-American studies courses while I was in college. On the other hand, even without my help, my parents, living in a cosmopolitan city like Philadelphia, were no strangers to

Jews or Judaism. Since the wedding we have shared many life-cycle events and seasonal celebrations. We have even taken the kids to their church on occasion to hear my father sing with the choir. Eddie's parents went from tears over the engagement to a warm supportive relationship with me. We share an enthusiasm for *yiddishkeit* although admittedly our political perspectives are not always the same. I feel blessed that my kids have had the chance to know four loving, active, healthy grandparents.

Over the years I have taken more Jewish studies classes and Hebrew courses than I had time for. Seven years ago I became bat mitzvah with a class at my synagogue. I was one of four who gave birth during the course. Later, when I became pregnant again, our next-door neighbor gave Eliana a white doll with blue eyes and blond hair so that she could have a "baby" of her own. I was concerned that this mainstream image of beauty might undermine Eliana's self-esteem, but I need not have worried. Eliana's acceptance of her naturally curly hair and her African heritage is complete, as is her embrace of her Jewish legacy. With a little help from their Mom and Jewish videos, all of my kids have enjoyed learning to recognize the Hebrew as well as the English alphabets as

toddlers, and are very at home in the synagogue. They also have a warm relationship with African-American family and friends.

My husband is an attorney with the government, has traveled a lot in Africa, and is very involved in promoting human rights worldwide and civil rights for African-Americans. His involvement with the Black community was very important for me and my family. In fact I tend to take more responsibility for getting our kids to Jewish events, while Eddie is the one who tends to make sure that they get to the African-American community events.

I have always identified with Yemenite and Ethiopian Jews. Eddie and I became active in raising consciousness and funds to get Jews out of Ethiopia to Israel. We helped sponsor events at synagogues and got involved in sending Jewish community leaders to Ethiopia for a first-hand look. Eddie visited five Ethiopian villages before their exodus.

One of my most rewarding experiences has been working with the planning and curriculum committee that launched Operation Understanding, D.C. The program brings together Black and Jewish teens for a year of cultural study, a trip through several American Jewish and Black communities, and finally they share their experiences as peer trainers and speakers.

My last pregnancy was not exactly unplanned; we just didn't think we would be successful. A test let us know we were having twins, and the sonogram showed us two little blips.

Lately I find myself focusing on child-oriented gatherings. I go to the toddler enrichment programs at Arlington Fairfax synagogue and Temple Rodef Shalom. I attend functions at the religious school where Eliana goes twice a week and Etan, in the confirmation program, got his first real job as an aide in the synagogue library. I joined Jack and Jill, an African-American mothers' club linking Black families sprinkled through suburban communities. Another group we have been attracted to is the Interracial Family Circle, a social organization of natural and adoptive biracial families.

Now that our children outnumber us, more and more I am aware of the tension between working full time and devoting full attention to raising my family. Four goes into one how many times? You know, life is never as simple as you want it to be. I thank God that so far, twins notwithstanding, my energy level is still amazingly high and I have not lost my sense of humor!

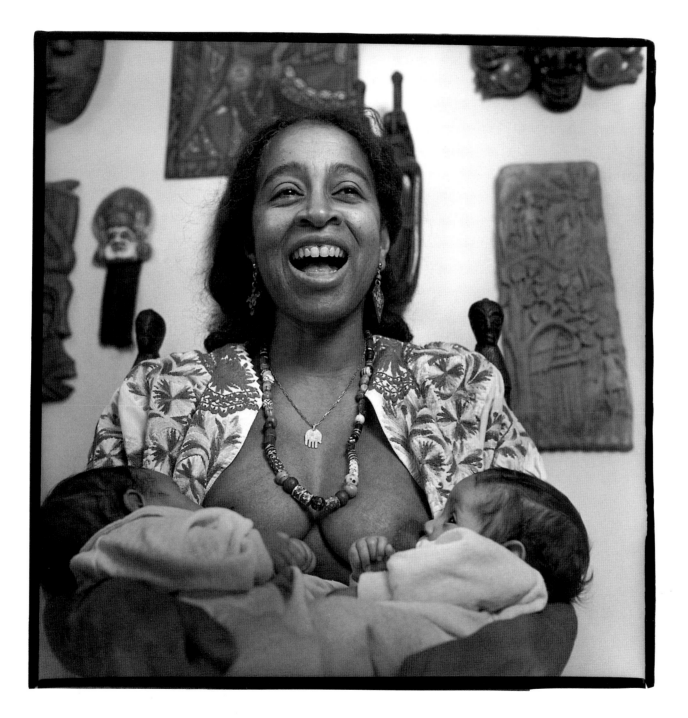

Sue Willis

In 1997, Sue Willis, 36, and her family successfully sued Alabama's Pike County Public School District for religious discrimination against her three children. During the trial they posted a large Star of David on their fence as a mark of pride. After the case was settled out of court, they received several anonymous threats. Sue and her husband, Wayne, have relocated the family to Wisconsin.

When I had my first pregnancy I was in love from the minute I knew I was having Paul. I couldn't wait to meet him because I knew he was going to be wonderful. I was like that with all of my pregnancies, I couldn't wait to meet my children face to face. I was already in love and looking forward to motherhood.

Our lives completely changed when my children entered the public school system in Troy, Alabama. I found myself in a constant battle to help my children cope with religious harassment from students and from teachers. I had very mixed emotions about what to do and how to respond, how to protect my children.

The religious discrimination against my children started in 1992 when my son David came home from elementary school with swastikas drawn on his backpack. He was so young that I hadn't even explained to him anything about the Holocaust. Then it just started to happen to all of my kids. The boys were called "dirty Jews" in school. We even found swastikas on their gym socks. During Chanukah they liked to wear Star of David pins. Well, their teachers told them it was a cult symbol and that these symbols were not allowed in the schools. A few of the teachers actually ripped the Star of David pins off of my kids' shirts.

When David was in the sixth grade he got an award at a school assembly for a 4-H project he'd done. I was in the audience and David was one of the students on stage. They used to start and end the assemblies with prayers. As the prayer began, a teacher sitting next to David reached over and pushed my son's head down. He kept trying to push his head up and she just kept forcing it down. This went on for a while. You can imagine the emotions I felt watching that one. I didn't want to disrupt the assembly for the other kids and their parents, so I waited until afterward to speak with the teacher. I was told it was "tradition" at the assemblies for all the kids to bow and to pray.

The teachers even allowed adults on the school grounds to give out Bibles. The Gideons used to go after my daughter, Sarah.

After Prime Minister Rabin was assassinated, my boys wanted to wear their yarmulkes to school out of respect, and of course the other kids pulled them off their heads and tossed them around. I was told by my children that none of their teachers stopped this.

For at least five years I tried to meet with parents and teachers to educate them about Judaism and Jewish prayer. I was trying to do the right thing, but quickly learned it only made matters worse. It took me quite some time to realize that no one was really going to stop the harassment against my children.

The number one job of a mother is to protect her kids and I felt like I failed at that. There were times I wanted to just grab the cat, the dog, all the kids, throw them in the car, and get the heck out of Alabama. Then part of me questioned if we left, what kind of message would my husband and I be giving our children? I wanted to teach them to stand up for their beliefs and to know that the Constitution is for all of us. I wanted to

43

teach them that the answer to these kinds of problems is not to run away. I wanted them to know that being a Jew is nothing to hide and nothing to be ashamed of.

When Paul was in the seventh grade he was assigned to write an essay titled "Why Jesus Loves Me." That's when I finally went to the superintendent's office. He told me that all of my problems would be over if the family converted. Once I heard that I knew it was time to get help. I was absolutely at my wit's end and really needed somebody to talk to.

At the time of my meeting with the superintendent I was reading this wonderful book *Chutzpah* by Allan Dershowitz. In it he mentioned the Anti-Defamation League. So, I called their office in Atlanta and spoke to this fantastic woman, Betty Cantor. I told her about the religious harassment against my children in the Troy Public School District of Alabama. I said that my husband and I had sent letters to the State Department of Education but got no response. She asked me to send the letters to her. She sent them to the ACLU in Montgomery and then they contacted me.

Our lawsuit was not about money. It was about our children's safety and the safety of the next group of kids or minorities to come along after them. To this day I know that Alabama doesn't believe me, but my lawsuit was not just about my kids but also for their kids. Hate will eat them alive. They will grow up in their small-minded communities and when they go out into the real world, as most of them do, the hate will make them sink.

Once our legal case was resolved, the community made it real clear that we were not welcome. I was isolated, I couldn't go to the WalMart or the grocery store because people spit at me. One woman tried to run me over in her car. We just wanted them to obey the laws separating church and state, but of course we couldn't change individual behavior or beliefs. We began to receive anonymous threats in the mail, so once our legal battle was over we knew it was time to withdraw. You can only live isolated within a community or place for just so long.

You know, I was clueless when we first moved to Alabama. I had just come out of the military and was looking for an affordable place to live. I had grown up on a tobacco farm in Kentucky and in my day everyone respected one another and got along. This was horse country and people from all over the world visited. People were educated, sophisticated, and liberal. We didn't care who was Catholic, Jewish, or Hindu. Heck, what

we were worried about when I was young was buying tickets for a KISS concert. To tell you the truth, when I was in school I don't even know what my friends' religions were.

I had no idea that when I moved my family to Alabama it was still a boiling pot over religion. I had grown up in the South, and my father was the first generation of his family born in this country. They were farmers and I grew up hearing, "This is the greatest country on earth." Of course I believed it. I grew up feeling this tremendous sense of pride and was very patriotic. That's why I served in the military. I learned to repair radar in helicopters and airplanes and was even stationed in Germany.

Hey, I am not the type of person to walk up to you and say, "My name is Sue and I am Jewish," but I did wear my Star of David in Germany. I never experienced anti-Semitism. So, I was astonished by the horrible harassment my children experienced in Alabama.

Today, if Dr. Martin Luther King Jr. came back and took one look at parts of the South he would throw up his hands in disbelief. They didn't take what he tried to teach them and go forth with it. Some of Alabama's public schools are rated the worst in the country. I think they want to keep their children ignorant so that the same fourteen families can run the place as they have since the turn of the century. It baffles me that George Wallace was buried a hero when he spent his whole life keeping minorities discriminated against in Alabama. How do you take a man who blocked a schoolhouse door against children and turn him into a hero?

I hope for my kids that they will take this difficult experience and learn from it to become very tolerant human beings. What is so interesting is that the anti-Semitism we experienced in Alabama has made my children really hungry for information about their Jewish heritage. Last summer they went to a Jewish camp and really loved it.

No matter where they go or what they do, I want my children to be happy. Now, in our new home and community, finally I am just being a mom, thank God.

Actually, after all that we have been through I am thinking about becoming bat mitzvah.

I believe that when you assimilate you lose yourself. No one gains anything from you.

Ida Jervis

Ida Jervis, 78, a puppeteer and freelance photojournalist, was born in Sokhoczin, Poland. At the age of 5, her family immigrated to Tennessee where they lived in back of the family grocery store. At the age of 18, Ida sang ballads with country music stars Roy Acuff and the Smokey Mountain Boys on WNOX radio as "Sylvia—The Colonial Coffee Girl." She lives in Falls Church, Virginia, and has three children.

My kids learned about their Jewish culture and heritage working on my Yiddish puppet shows just as I did as a child helping in my parents' Yiddish theatre in Poland. I gave my puppet shows at the Hebrew schools, Jewish day camps, the Embassy of Israel, and Hadassah fund-raisers. I began by asking the children how many had grandfathers who came from Europe. I would show them my Chasidic puppets and say, "Most of your grandfathers probably looked like this."

It's a family joke that when I was born I got a big birthday present—the Russian Revolution. Everything happening between Germany and Russia spilled across Poland and into my small Jewish *shtetl*. People used to run from their villages, just ahead of the soldiers. Houses were full of starving refugees. Momma and my aunts cooked huge pots of soup to feed people. Soldiers would come into town looking for men to grab, searching for food and for girls.

At times peasants ransacked my Grandma's store. They could be kind, but they had crazy ideas about Jews. I was once kidnapped by some Polish teenagers who carried me into a church. They stood me on a table and took off my clothes to see if I had horns and a tail. I was only two or three years old.

It sounds impossible, but between the misery things were serene. My father had a button factory, a restaurant, and a Yiddish theatre. Momma used to play mandolin and paint the scenery. We were never poor till the war got intense. When my father's older sister sent us ship's tickets to go to Tennessee, Momma didn't want to leave but my *Bubbe* said, "Go. Things are not going to be good for Jews in Europe." The day we left we all got dressed up and took one last picture. My parents, my brother, Sam, and baby Ruth and I escaped from town hiding in a hay wagon. We came over in steerage.

In America my family observed all the national holidays. My sister Miriam was born on the Fourth of July, our first Yankee-Doodle baby. Momma's whole life changed in America. In Poland she was an artist. In America my father developed diabetes and heart trouble. With four children to bring up during the Depression, Momma worked long hours in the store. Momma never again played the mandolin.

People of every kind came into our store. They admired how Momma was bringing up her children, sending them to college, how we stuck together as a family after my father died. Momma even came to help me when I had my children. My daughter helped with the youngest baby. It must've made an impression because Alice became a midwife.

My family didn't have much, so I made some puppets and did shows for money. I wrote in lots of silly Yiddish humor. How else do you keep kids entertained?

Luckily, all three of my children are sweet and understanding. Like most boys, my boy was hard on himself. Little boys constantly push each other. This outlook never appealed to my son, whose motto could be "Make music, not war." Nature put a double whammy on men. I say there's Mother Nature and Father Nature and Mother Nature is easier to get along with.

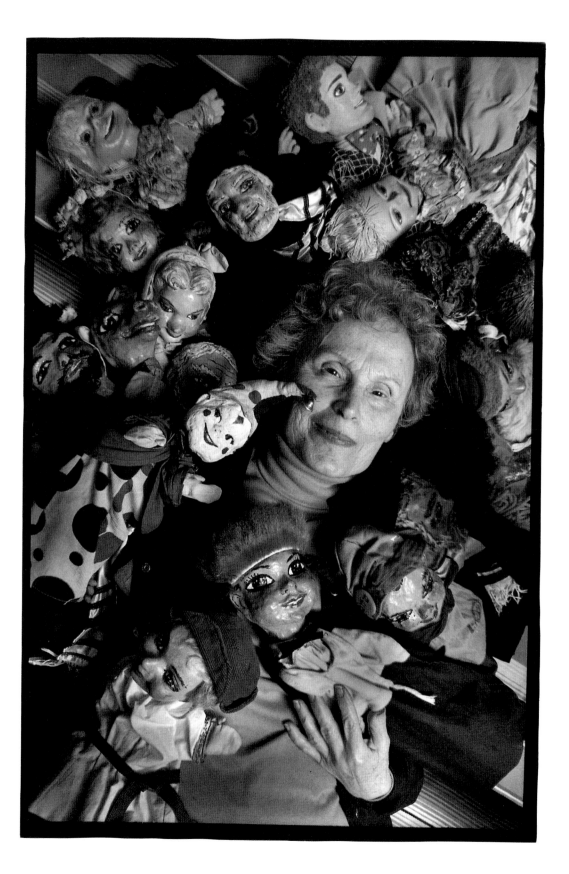

Alice Bailes

Alice Bailes, 51, is a certified nurse-midwife and codirector of BirthCare & Women's Health Ltd., in Alexandria, Virginia. She is coeditor of the Handbook on Home Birth, *published by the American College of Nurse-Midwives. Alice has two children, Jennifir and Benjamin Bailes.*

Babies are so wonderful, so soft. There is nothing that smells better than a brand-new baby. My work is so much fun. I love it. I help women turn themselves into mothers.

There are psalms that I sing to myself in Hebrew when I am attending a birth. If the baby's head is a little big for the mother's bones and it has to mold to fit through I sing "*Min Ha Metzar,* from the narrow place I call to God and God answers me in this great expanse of space." I think that my singing these prayers helps the baby come.

Jewish midwives go a long ways back. My office has posters of Shifra and Puah, the midwives in the Book of Exodus. All of us midwives are kind of attached to them.

It was an amazing coincidence that my first *aliyah,* the first time I chanted from the Torah, contained the Hebrew words for birth, for nursing, and for weaning. It was on Rosh Hashana, the portion that describes Sarah's response when she learns that she is pregnant.

I always knew that I wanted to have children and I was delighted when my first pregnancy was confirmed. At the age of ten I had read my first childbirth book, and I just always assumed that I would have natural childbirth. I found myself somewhat of a novelty to the hospital nurses. They had never seen anyone give birth without medication.

Giving birth was incredible. I liked how it felt to greet the contractions. An amazing amount of energy came into me from somewhere else. I really felt like I was a vessel and there was this life force that was running through me to get this new life into the world. It was fabulous to feel all of that strength.

My first birthing experience made me want to become a midwife. I had studied dance and was at one time in a premed program. The birth experience linked together for me the creative mind-body interaction I learned studying dance with the scientific approach of the premed program. The intense spiritual part of giving birth and having the baby nurse from my breasts brought together all of my beliefs. I was also concerned with social justice issues, feminism, and taking back control of one's life from the so-called experts. As a midwife I empower women and their families to welcome their babies into the world in a way that gives them control of the experience.

Just as I have loved pregnancy I loved mothering. My mother helped me after my first child was born. She taught me with so much skill and perception that it was like receiving a gift. My children have thrived, and their steps toward independence were consonant with mine. They walk carefully on this earth and try to help others. I believe each of them has that *tikkun olam* kernel inside of them.

My children kept me grounded in a very positive way. They kept me anchored. Now that they are out of the house, that force of gravity is gone, and I sometimes feel like I could fly off the earth's surface. I keep myself busy with my work.

After I've been awake for days while attending to a birth I go to the ocean. The ocean renews me. What a wonderful metaphor it is for birth. The ocean rocks you and is full of salt, just like amniotic fluid. Just the smell of the ocean does it for me. I feel reborn there.

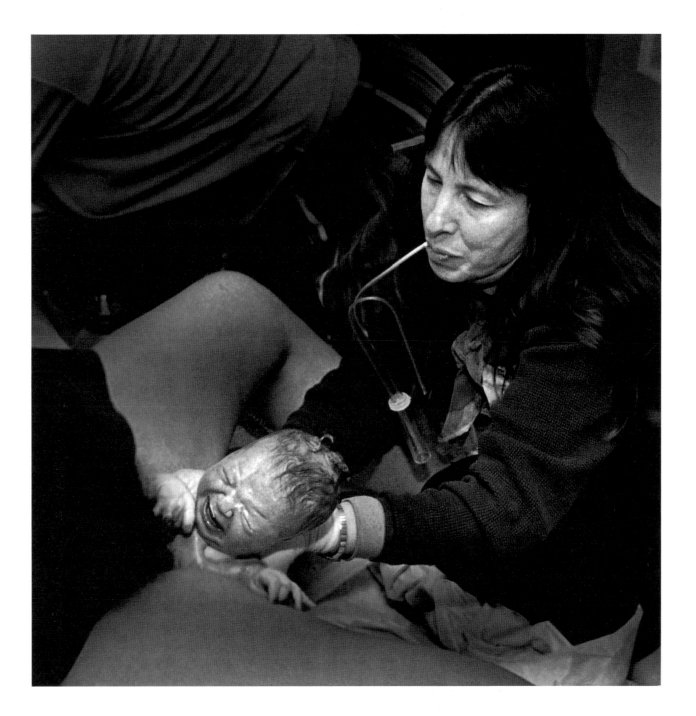

Alice Conant

Alice Conant, 48, is a medical social worker, mother of Isadora and Abram (Avi). Her husband, Michael, is Creole and Catholic. They are raising their children Jewish and live in Albuquerque, New Mexico.

Y ou know it's funny when you have kids and you and your husband don't look anything alike. You don't know what the kids will look like. Sometimes when I think my marriage was not meant to be, I look at the kids and say, "Yes it was, because my kids are so wonderful, so precious, healthy, and beautiful. This was obviously meant to be."

My husband and I met at a time when we were not religiously affiliated. I knew I always wanted children, and there was no question in my mind that they were going to be raised Jewish. At first my husband, Michael, discussed their being baptized, but I said no. He acquiesced pretty quickly, but I don't think he really knew it involved dealing with Hebrew schools, bar and bat mitzvahs, and car pools.

I met my husband at a dream workshop in Sacramento. My parents were so relieved that I was marrying someone who made a living that he could have been from Mars.

The problems we have are more marital than from having racially or ethnically different backgrounds. My husband was raised on television and baseball. I hate television, and my husband just likes to have it on all the time. On Friday night I want to be spiritual, so we have started lighting the *Shabbos* candles and sometimes I go to synagogue.

I don't think racism has been a major problem for my children. My daughter gets very dark in the summer and has a sense of being different from the blonde cheerleader type. She sometimes wants to "fit in" but is mostly proud of her differences and is open and comfortable about her Judaism.

I am teaching my children to be true to their beliefs by giving them the Jewish values of *tikkun olam.* I want them to be kind and aware of the importance of trying to help heal and repair the world. My daughter has worked during the summer for a student wilderness conservation project, and my son sings in a community choir. I have allowed him to have a soft side.

There are a lot of ambivalent feelings people have about their mothers, just as I have a lot of ambivalence about my own mother. I think she has an incredible amount of energy and is sort of an individualist, but she wouldn't consider herself a feminist. She managed the family finances, but her life was the house, gardening, and cooking. She is always parenting, and at times you do have to interrupt her.

My mother stressed the importance of food. I would like to say that I am different, but my daughter says I drive her crazy. She thinks I feel that we will all starve unless we are constantly eating.

My mother placed a high value on education and she was always reading to us every night. Now I do that with my kids. I make sure that each of my kids gets individualized quality time with me.

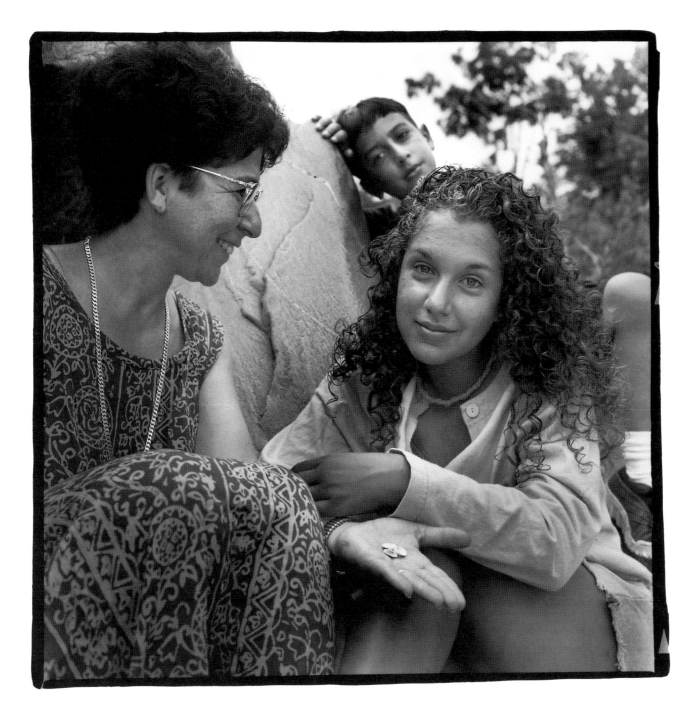

Rhonda Weiss

Rhonda Weiss, 45, is a lawyer and policy analyst for the Department of Education in Washington, D.C. She was born with premature retinopathy and is legally blind. Rhonda is a member of Fabrangen, an egalitarian chavurah. She sings and helps conduct services in Hebrew. She is the mother of Jordan and Elana.

I find myself extremely blessed having healthy children when so many women cannot find partners or have fertility problems. Because I have been visually impaired since birth and got so many messages growing up that my life was going to be hard, I wasn't sure if I was going to be able to have children and family life.

A lot of people find it hard to imagine somebody almost blind could have two children, but my home is like any American home with small children—full of clutter. That's the way life is with parents trying to juggle work schedules and family responsibilities. I am a lawyer, but I am also a mom concerned with the day-to-day details that moms think about: who needs shoes and haircuts. My children and husband are very affectionate and we do things together as a family.

I am self-conscious in situations where people can see me but I can't see them. When my children were very young, people told me what to do all the time, like, "You're not holding him right." If I changed my baby's diaper in any public place, people wanted to help. I get comments from people who express incredulity by exclaiming, "I don't know how you do this!" Some of the comments are kindly and some are not. I do feel pressure from external sources and from within myself to show that I can take care of my children.

There's a lot that is very formidable for me because so much of communicating with prelingual children is through visual cues. When I first became a mother, I worried about having somebody help feed the children once they started on solid foods. That's a difficult time because they move in all directions. We started my daughter, Elana, on finger foods quite early. My four-year-old son, Jordan, plays with many toys that are visual. If we are outside, I ask him not to run away but to hold my hand. It's hard for him because he's at the age of wanting to declare his independence. If I drop something my son is sweet and says, "Mommy, I'll help you."

I believe it is important to teach my children to respect other people's boundaries, to be kind, and to play respectfully. I feel that passing on values about the importance of Jewish ethics and rituals is an important part of family life. During Jordan's *bris* I was nervous, but this tradition defines who we are as a people and it is very important to me. For my daughter, Elana, we had a special naming ceremony at the time of *havdalah*, which marks the separation between *Shabbat* and the rest of the week. I selected to do the ceremony during *havdalah* to signify for me the end of the act of creation and the beginning of the act of life because I knew that I wasn't going to have any more children.

I think there is something unique about being a Jewish mother. I believe that a lot of the decisions I make and the values I have are because of the human-God relationship and the commitment to Jewish tradition. I would like to think of it as a way to reach and relate to each other. I think that one of the struggles modern Jews have is how to feel closer to God in the kind of society that doesn't really value the human-God relationship. I feel God's presence in time of sorrow, need, tragedy and at times of blessing and thanking God for bounties.

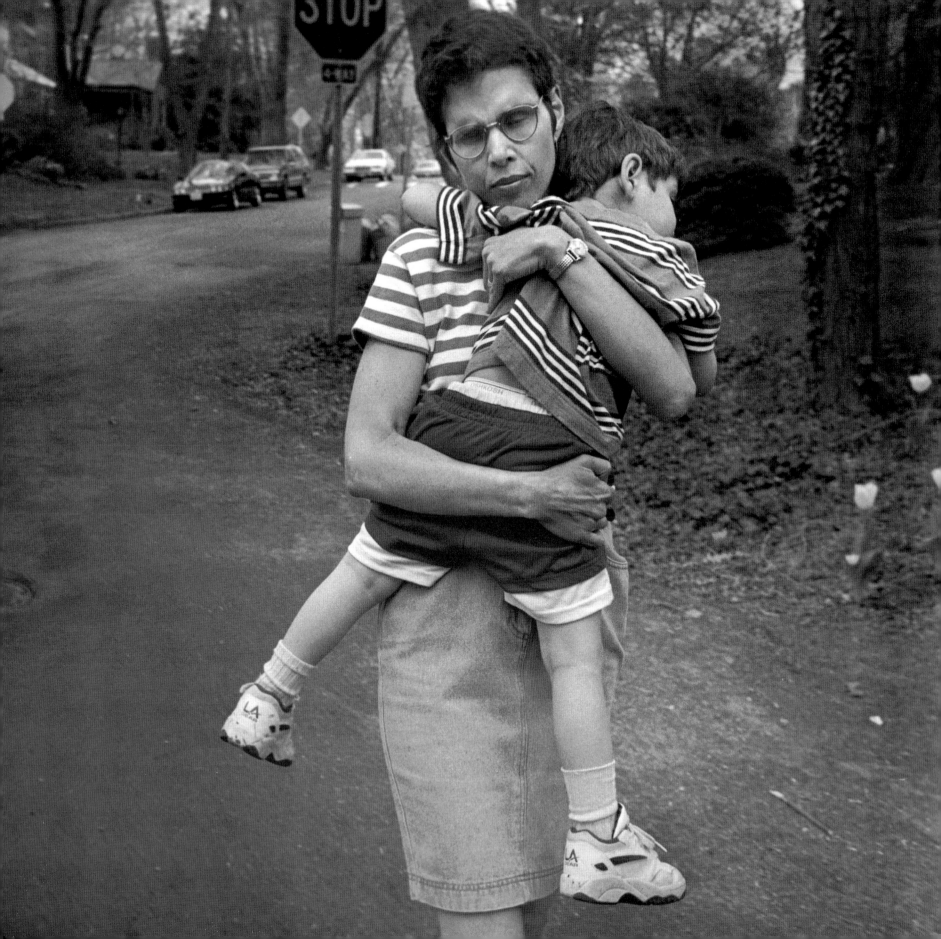

Drs. Lila and Margaret Nachtigall

Dr. Lila Nachtigall, 64, is a renowned reproductive endocrinologist and director of the NYU Medical Center's Women's Wellness Center. In 1994 she was named one of New York's 100 Best Doctors by New York magazine. Her book Estrogen *is considered the authoritative guide to hormone replacement therapy and menopause. In 1995 she coauthored* What Every Woman Should Know—Staying Healthy After 40 *with Dr. Robert D. Nachtigall and Joan Rattner Heilman. She is the mother of two physicians, Drs. Margaret and Lisa. Her youngest daughter, Ellen, is an assistant district attorney in New York.*

Dr. Margaret Nachtigall, 36, obstetrician-gynecologist and noted infertility expert, is an assistant professor at NYU and Bellevue Hospital, New York. She is the mother of Julia and Gregory.

Dr. Lila Nachtigall: Sharing a medical practice with my daughter Margaret is a life's dream. Working together is terrific. I was surprised and thrilled that Margaret chose the same field.

Honestly if I didn't work a ten-hour day I would probably be a smothering mother. I want my children to have everything and I want to protect them from any pain. My youngest daughter, Ellen, once asked, "Mom, you are not always happy, are you?" I said, "No, of course not." She said, "Nobody is always happy. You want us to be happy every minute. It is hard to do. I can't be happy for you." I thought, "Wow!" I got more insight from that than from four years of medical school.

I have been present for the birth of all of my four grandchildren and it was nerve-wracking. Margaret had to have a C-section for her first so I was in the waiting room and there was an Orthodox Jewish man praying, standing by the window. I was so overcome that I went over and asked him to say a prayer for me, which he did. Two minutes later the nurse comes out and says, "You have a beautiful granddaughter with eyelashes up to her forehead."

As a physician I face an ethical issue every minute and consider myself a very moral person. I think physicians have to be careful not to play God and to put the patient first.

For the past twenty years I have directed a clinic at Bellevue for women with infertility problems. The clinic is really to help people have babies. At least 50 percent of our patients are on Medicaid, which means the taxpayers are paying for the medical care. I have asked myself, "Is this fair when the mother cannot afford to take care of her own baby?" If I am going to give total care to women as approved by the government, then I have to be thorough. If desiring a baby is what a patient wants at least I can work them up to find out if there is a medical problem.

I have always said that I would march in the streets with my family and my daughters to support the pro-choice movement. For one of the marches in Washington, D.C., we chartered an airplane and brought 300 people to the march. I hope we never have to march again, but if we do, the next time I will get three planes.

Dr. Margaret Nachtigall: I idolized my Mom. While we were on family vacations my parents would spread out this big sheet at the beach and instead of reading us junk, they would read us the case review in the *New England Journal of Medicine.* Honestly, we were ten, nine, and eight years old and would try to help our parents figure out these cases. I learned very early the intricacies of medicine, the fun and the puzzles.

When I completed college I decided to go into medicine. I loved every rotation but found that gynecology provided the opportunity to do surgery and work in women's health care. After graduation I had plenty of job offers but none as great as working with my Mom. She covers me at home and in the office.

Rabbi
Avis Miller

Rabbi Avis Dimond Miller is the first female rabbi hired by

a major American Conservative congregation, Adas Israel

in Washington, D.C. She is also the first woman to chair a

national committee of the Rabbinical Assembly, the organiza-

tion of Conservative rabbis. She raised five sons while attending

rabbinical college in Philadelphia and was ordained in 1986.

Rabbi Miller was active in the movement to free Ethiopian Jews.

wouldn't give back my early days of motherhood for anything. I think some of the professional young mothers at my synagogue assume that I think it is great to work an eight-hour day. It might be for them, but it wasn't for me. Even while I was in rabbinical school I made time for my sons, playing with them, giving them haircuts. When the guys are home for Passover I still cut all of their hair.

I was raised by a mother with a clear sense of propriety. "Be a teacher. You can always use a teaching degree," she used to say. She would also advise, "If you are playing shuffleboard with a boy—lose! Boys don't like girls smarter than they are." For my parents, my becoming a rabbi was not a Jewish concern but one of propriety, on the order of enrolling a hippopotamus in a ballet school.

The idea to become a rabbi must have been growing when the children were small, but I did not acknowledge it. The first woman applicant for the rabbinate entered school in 1968. It must have planted a seed in my head, but I wasn't always listening. I did not enter until 1981. By then I had been married for sixteen years and had five sons. I had already passed through my earth-mother phase, baking bread and gardening.

What if I said God told me to become a rabbi? I didn't exactly hear a voice, but something like a hand was pushing me. Looking back I can see that my fascination with all things Jewish was like peeling an onion, layer by layer, grabbing me spiritually and intellectually. As a child I was quiet, prayerful, and the wheel was turning.

My rabbinical class was the first one that was more female than male. I was told I was their first "mature" student, and if I didn't work out, I might well be the last. If you are told you are going to fail there is nothing left to be scared of.

When I told my children I was going to school for five years and asked them what I would be afterward, one of them piped up, "Over forty!" They learned to read in self-defense because Mommy was always studying her own books.

By the time I was hired by Adas Israel the feminist issue was no longer a big question. I see myself as someone doing what they were meant to do. I am not out to prove anything and I'm not interested in reestablishing the matriarchy. Yet, I have heard stories from my congregants of little girls "playing rabbi" with a rolled towel for a Torah.

Prior to women becoming rabbis most female Jewish professionals were limited to being Hebrew school teachers. If we look at ancient Jewish history we see that sometimes women were out in front, women like Deborah, Ruth, and Judith. I think there were always religious women who functioned as mentors. My grandmother was called *vorsagerin*. It's a Yiddish expression for the woman leading the prayer in the women's gallery.

Preaching at Adas is intimidating. During my very first time on the pulpit chanting the *Haftorah* on Rosh Hashanah, I almost blacked out. I knew the material so well that I was able to get through it. There is never a time that I don't feel nervous or just outright fear when I am up there. You just never get up on the *bimah* and speak off the cuff.

Nita Lowey

Since 1988, Nita Lowey has been the Democratic member of the U.S. House of Representatives from Westchester County, New York, currently serving on the key House Appropriations Subcommittee on Foreign Relations. She is a lifelong civic activist, concerned with issues such as women's health care, labor unions, and human rights, and is a staunch and outspoken supporter of Israel. She has three children and two grandchildren.

There is a direct path from my role as a mother and president of my kid's PTA to my work in Congress. My life as a Jewish woman helps promote the agenda that I support. There is really a deep connection, it is not coincidental. Jews have always spoken out on issues within the public square. We grow up with the values of *tikkun olam, tzedakah,* and *l'dor v'dor* that involve us with community life. We pass them on from generation to generation. I want my children to be loving and committed to making this world a better place.

I've been called the *baleboosta* and the "Jewish mother" my whole life. I think when people use the term "Jewish mother" they are referring to women who are totally committed to the care and nurturing of their children. For instance, my commitment to my own children is directly related to my stance on many issues. If I fight as a Representative in Congress for food safety, it is because I want the fruits and vegetables safe for all children, including my own grandchildren. If I fight to prevent tobacco use among young people, I do this first as a mother.

My mother, Beatrice, nurtured the core part of my values and was my role model. She was not working for money as I was growing up, but she was active in the temple Sisterhood, in Hadassah, in almost every community volunteer group. We grew up in the Bronx in the shadow of Yankee Stadium. When we moved to Manhattan she became one of the original founders of the Asphalt Green, which was an institution on the east side of Manhattan that focused on a whole range of activities in the neighborhoods.

I grew up in a home where my parents gave me unconditional love. It was, you could do no wrong, you were the best. This kind of warmth and security given by both parents creates a solid sense of self in children.

I consider it a real privilege as an American Jewish woman to be sitting on the Appropriations Committee that funds aid to Israel. It has been more and more difficult to get aid to Israel. I feel very firmly that the Israel–United States alliance is critical to finding peace in the Middle East. Israel is the only democracy in that region, and it is in our interest to support aid to Israel because they are defending our interests and values. Military aid to Israel is absolutely justified, and in fact I think additional military aid to Israel is appropriate.

I work very closely with Representative John Lewis (the great African-American civil rights hero) who is a wonderful member of Congress and a dear friend of mine. We work against any kind of hatred and bigotry that occurs—not just to our peoples but to all people. Jews have always spoken out against wrongs done to all peoples.

I don't think it is accidental that there are so many Jews in public life. This is a golden age for Jews. There are so many Jews in this administration. And it is our tradition that brings us to the public square. It is our tradition that moves us to participate in community life, whether it is the PTA or other forms of public service, or running for office or school board, this desire to make the world a better place for our families, for other families. I think it is a core of Judaism.

Ethel Kleinman

Ethel Kleinman, 74, was deported to Auschwitz from Hungary with her family in April of 1944. In the work camp, at the age of 20, she was assigned to make bombs. She and three other siblings out of a family of fourteen survived. She met her husband in a displaced persons camp and arrived in America on July 4, 1949. Mrs. Kleinman lives in Borough Park, Brooklyn, New York. She is the mother of one daughter and two sons, grandmother of thirteen, and great-grandmother of eight.

My family arrived on *Shavuos* day, 1944, in the middle of the night to Auschwitz. During the last night in the cattle car father said *kiddush* and made each of us wash our hands and have a small piece of *challah*. As we got off the train we were dazed and couldn't walk. It was dark, they kept moving us very quickly, they knew how to do it. No one talked except the Nazis kept telling us to move fast, quick, "Schnell, schnell, gehen." I picked up my sister's two-year-old daughter, who could not walk on the big hard cobblestones. As we got out they right away starting separating the men on this side, the women on that side. My mother and sister to the left and my other sister to the right. I was holding the baby and a man came over and grabbed the child from me. The child was crying, "Don't let me go," and the man pointed to the smokestack flames and said to me, "That's it for you, now do what I say, if not you go on that side." He pointed to where most of my family was already standing.

You think back and remember how it was in the family house and nobody did anything in my family without first saying please. My parents married when they were just eighteen and seventeen years old. It was an arranged marriage, my father's *rebbe* met my mother's family and said he knew of this woman to be my father's bride. My mother was a tiny little woman and my father a tall guy. I used to wake up and find my mother with the light on reading Hungarian, German, and Rumanian books. She suffered from ulcers and there was not much medication. She was in bed a lot.

In a big family the older children take care of the younger ones. I had an older sister with long gorgeous hair. When she got married, next day they cut it off to put on the *shaitl*. I was a little girl, crying, pulling on the women cutting her hair to leave my sister alone. This sister was killed in Auschwitz. When my family arrived in Auschwitz and they made the women undress, they shaved everything. My other sister Toby was next to me in line, but I didn't even recognize her. After the war and I had been through so much, I didn't know anymore how I feel or what to believe. For several years after the war many Orthodox women wore hats. I kept my hair.

The Nazis killed my mother, father, two sisters, two brothers, and five of my nieces and nephews. My mother was sixty-one and my father sixty-two years old when they were taken for destruction. I was left with my sister Toby. That first night the Nazis took away everything except our shoes. We were each given a dress and undershirt. Then it just started. From May until the end of October we were in Auschwitz and then we were taken to a work camp to make bombs. While in Auschwitz they kept making selections by Dr. Mengele twice a day. I was very, very skinny and always chosen for destruction, but I always ran away. One time I was sent to the shower and by that time didn't know if water or gas will come. It was water. When you are destined to live, you live. One time a gun was pointed at me and I just walked away.

My sister and I sometimes thought we had to end it ourselves. Sometimes we just didn't care. We were surrounded with electric wire and saw a mother and daughter reach

out to one another through the wire and then they just dropped. Once I witnessed across from me in the barrack a woman giving birth. They didn't detect her pregnancy. After the baby was born they took it away. I didn't hear it cry so I don't know if it was born alive. A few minutes later this woman who just gave birth had to stand in roll call.

When Passover came the men from the other side used to throw over the fence little pieces of paper with the *Haggadah* on it. The men knew it by heart, we didn't. My sister was very *frum* and did not eat her little rations of bread during Passover. She exchanged her bread for potato. I couldn't do it. I had to eat my bread. Sometimes my sister and I talked about food, we became foolish, we pretend what we cook. We were always so tired. My sister gave her bread away to get a canteen. We

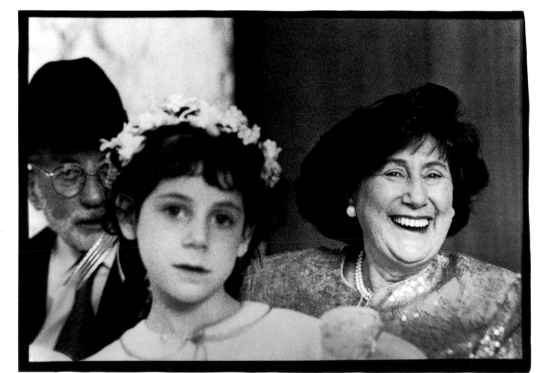

would stand for roll call for hours in the morning and afternoon and the older women were fainting. My sister kept the canteen between her legs because you were not allowed to have anything. And when someone fainted she was there right away. Water was precious.

Many of the women started itching but it was not lice and very contagious. They gave us a big bucket of salve and I used to smear it on all the girls from top to bottom. They ask me, "Aren't you worried about getting this?" And I always say, "It's OK. Nothing happens to me." Once,

I cut my finger to the bone on the timing mechanism while making bombs but didn't even notice it. There was blood all over. A nail went through my platform cork heel into my foot and I had a red infectious streak up my leg. A girl found a rusty scissor and cut the skin to squeeze out the pus. They had to carry me to roll call. The kapo told me to get out of bed or else and she pointed to the flames.

Can you imagine what it was like for the people who were in camps for years? About three days before Liberation Day one SS guy told us to go to sleep in the fields because the camp was going to be bombed. Somehow or another my sister and I stayed in an empty garage and then got two horses and a carriage. We started to go home. My sister was sick with typhus, and Jewish Czech soldiers from the Palestinian army got us a hotel room to stay in. By then we were traveling with many girls from our country and so we stayed together. It was a hard trip because the railroads were bombed.

We found one brother at our home. It was a big, empty house, with only a few objects left, but the *mezuzah* was on the door. Can you believe they left that? We could not stay in the family home, we did not have anything. One of the neighbors gave us back some clothing. My father had written a *sefer* and we found a whole crate of them, so we each took a few. My grandson Dov, who is a rabbi, is now translating it to English.

I met and married my husband in a displaced persons camp in Germany. My first child, Leah, was born there. I was in labor yelling, "Nazis, you killing me …" and fell asleep with being tortured in my mind. I woke up and had this little baby. She was very tiny and I couldn't nurse, so somebody sent me Karo syrup from America. She became a beautiful baby. My husband and I named her after each of our mothers.

Leah likes to tell about my wedding day because I told her stories of how I made my veil from curtains. I even donated photographs of my wedding to the Holocaust Museum in Washington, D.C. We had nothing to get married in and had to borrow everything, dress, suit, shoes. There were no smiles during wedding because we did not have our families. My husband was really in love with my sister, but she was in

love with someone else. I knew him twenty-four hours before we got engaged. We were not normal people then, but everyone needed somebody to take care of them. These marriages had many problems but lasted because you learn to work together. Today the weddings are so lavish, truly enjoyable—but not what marriage is really about.

 I followed my husband to America because he was a *yeshiva bucher* and thought he had no skills to live in Israel. My family arrived in America on the Fourth of July; Leah was just two years old. We saw all these lights. We had no lights in Europe so this was very beautiful. I remember one thing before we left Germany, we had an orientation class. This lady, American people, came to lecture us. I never forget, she held up a fork and said, "Do you know what this is?" I said, "Lady, fork was before America was!" The attitude I felt from lots of Americans was that they were superior. They didn't know what happened to us; some even asked, "How many times was your bedding changed in Auschwitz?"

 I never wanted to come to America. I wanted to go to Israel. I didn't believe in any other place because I felt they threw me out from one country, they're gonna do it again. I believe it can happen again and it still does. All around the world there is fighting. It is crazy. I am concerned with the news from Germany and from here. If they didn't need us here, they wouldn't be so nice to us. After Auschwitz I thought I would never be afraid of anything in my life, but one time my husband and I were mugged. Two men came up and asked for the time. They held up a gun and took our money and pulled my necklace off. We couldn't sleep for days afterward.

 I really don't know what my dreams were in life. Maybe to teach. If I would have had the chance I wanted to go to school. After I had my two children I remember my boy asking his big sister for help with the homework. I said to him, "Why don't you ask me?" He said, "You? You don't know nothing." That is when my husband and I began to take English classes, study, read. I used to take out of the library children's books to study with Leah. I read a book, *Mrs. Harris Goes to Paris,* about a charwoman who went to Paris and bought a hat. I named one of my hats Mrs. Harris and I used to vacuum in it.

 I feel that Hitler didn't triumph because we started over again and have all these grandchildren. And it's an incredible feeling. My granddaughters come to visit, they like to come here, maybe it's because I have a dirty mouth sometimes. You know I am a feminist. I read a portion of the Torah every week and some of the things demean women.

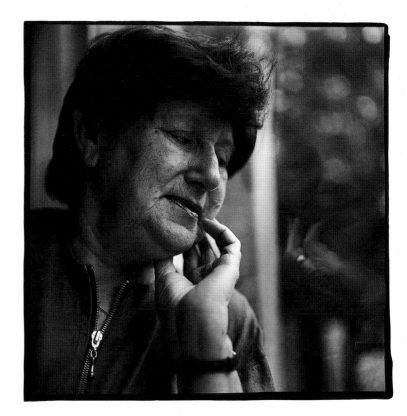

I always fight with my husband and say, "Look it says that because men wrote it."

 I try to go swimming every day and sometimes go to a pool where I swim with the men. They don't know me and I don't know them. So, what's the difference. You know I did start wearing the wig because my hair was no good. It is a good innovation. Movie stars and all kinds of people use them. When I came home from working in the garment industry the first thing I used to pull off was the girdle. Now when I walk into my house the first thing I take off is my wig.

 I have lived life as an Orthodox woman, wife, mother and you know the *shaitl* doesn't make a difference. It is what you feel on the inside.

Leah Lipman

Leah Lipman, 51, styles wigs for Orthodox women and for clients suffering hair loss from illness. Ms. Lipman is the daughter of Ethel Kleinman, 74, an Auschwitz survivor. She has four children and five grandchildren.

Once an Orthodox woman is married her hair is considered an area of the body that is reserved for her husband and immediate family. Wearing a wig is a reminder for married women of laws of modesty and sets into motion a whole method of behavior. Knowing that I have this responsibility to appear to the world as a married woman, I wear skirts below my knee, I always wear sleeves, and I won't go mixed-sex swimming. I feel that my wig service is doing a *mitzvah* because I am helping Jewish women observe the commandments, plus I help them look really nice.

I remember that when my mother got her first wig I styled it for her. I was a kid, probably twelve years old. My mother came from a Chasidic family in Europe, but as a Holocaust survivor did not cover her hair for her first years in America. It just wasn't generally done. These young women lost their mothers and didn't have anybody to emulate or to teach them the laws of modesty.

My parents met and married in a displaced persons camp in Germany. I was born there. My mother made her wedding dress out of curtains and cooked her own wedding dinner. We came to America when I was two and my mother sewed in a sweatshop. My father was a *shammes;* he worked as a ritual director for the rabbi at the synagogue.

My parents' marriage truly amazes me. You hear of troubles with some of these deportation camp marriages, but most of them are incredible relationships, incredible marriages out of the ashes.

My mother is now seventy-four. Until she was knocked down and badly injured by a bus in February 1998, she went swimming every day and knew all the latest dances. The same strength that got her through the camps has helped her get through this ordeal. She has lots of friends and is soulmates with my children.

Becoming a mom was fantastic. I had my four kids in seven years and had energy to do so many things—teach, run a household, finish a degree. I've raised my children equally. My son is now a rabbi, but he was also raised to do his own laundry. All my kids can do the same things.

Passover is a time when my children feel very comfortable asking my parents about their war experiences. My mother says, "Well, I had my own personal exodus," and tells the story of how her brothers wrote a *Haggadah* on potato peels and threw it over the fence into the women's camp at Auschwitz. One thing that really sticks in my mind is that my mother has *yahrzeit* for her entire family on *Shavuot.* It is a difficult holiday for her because it marks the anniversary of her arrival at Auschwitz. She saw most of her family being taken away to the crematorium, including her parents. She and three other siblings survived out of a family of twelve children.

A few years ago she was at my house for *Shavuot.* After I lit the candles I saw that she went off alone into another room and cried. She never cries for sad things. She cries for happy things. It was shocking to see her do that. I went in and we talked. She grabbed me and said, "Thank God that we lived to see this." She meant my family and children.

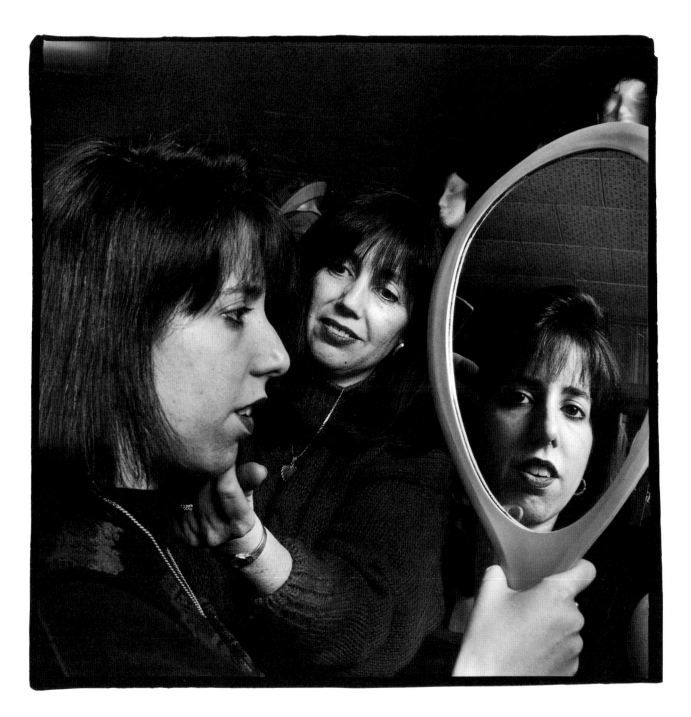

Fraydele Oysher

Fraydele Oysher, 82, performed cantorials and Jewish folk music with her renowned brother, Moishe Oysher, on the Yiddish stage. Her daughter, Marilyn Michaels, was a professional impersonator featured regularly on Ed Sullivan, and her son, Michael, is a teacher and musician.

brought the synagogue into the theatre. My brother, Moishe Oysher, and I come from a family of seven cantors. Our heritage. We loved the theatre, but our soul was in the synagogue. I wanted to make a break for women to sing wherever they want. I am the stone-age Yentl.

When I was about thirteen I opened my mouth and sang. I earned a buck seventy-five and Papa said, "It's a gold mine!" My first performances were in Philadelphia in 1931. I sang Jewish folk songs, did recitals, and performed in Yiddish theatre. Shows were written especially for me: *Fraydele's Wedding, The Cantor of Chelm.* Every show was made so I'd come up a little boy, a young *chusidl.* I played the part in order to be boy of thirteen and to have the bar mitzvah on stage. I would sing all my stuff and suddenly became a young woman. Y'know, comedy, it was comedy but my life was not so funny.

I was born in Lipkin, Besserabia. Russia. (My God, I'll be Russian right out of here!) My father left and went to America when I was ten weeks old. We went to live with my grandfather. I remember it was, "Dear God, keep us alive." We had fifteen at the table and food for five. I was eight years old when I came to America.

My mother had to worry about the two of us, our voices. Moishe and me. My mother did not enjoy so much. Her heart was always fluttering, "Is this right? Are you hoarse?" My mother never relaxed and said, "Oh, look at my children!" There was no Shirley Temple bit here. You know, it was hard. I was busy working, but I knew I wanted to be a mother. When I was pregnant, about in the eighth month, I had a concert at the Stone Avenue Talmud Torah, the most Orthodox synagogue in Brooklyn. I walked up those tiny little steps, very gingerly, to the *bimah.* The rabbi comes over and says, "I'm very sorry, Mrs. Oysher, you can't stay here." And I said, "Why can't I stay here?" He said, "'Cause you see the ark, you can't stay here, women can't stay here." I said, "Well, the mike is here and I wanna do the concert." He said, "No, you gotta leave." And I said, "Rabbi, I can show you a miracle! I can do the concert and have the baby right here!" He sat down and I sang.

My mother said to me about my daughter, Marilyn, "Don't you dare make Marilyn a singer, it's the worst thing in the world." I said, "Momma, what do you want her to be?" She said, "Let her be a typewriter!" When Marilyn was three she crawled up on stage. We were standing in a whole group at the National Theatre, and couldn't imagine why is everybody laughing. My little kid is standing there, conducting the orchestra! She carved a career as an impressionist and had gigs. Nightclubs. Television. Ed Sullivan.

I knew the male Jewish comedians. Buddy Hackett. I know Henny Youngman very well. "Hey, take my wife, please!" How did the Jewish mother jokes begin? Somebody tried one, somebody laughed, and they said, "Hey, let's go with it!" Hey, they made a living. That's it.

After retirement I focused on lectures. Women were terrific. They would come up to me and say, "Mrs. Oysher, you were a trailblazer." I got phone calls from women training to be cantors and they would say, "I'm having trouble." I tell them, "Stick it out."

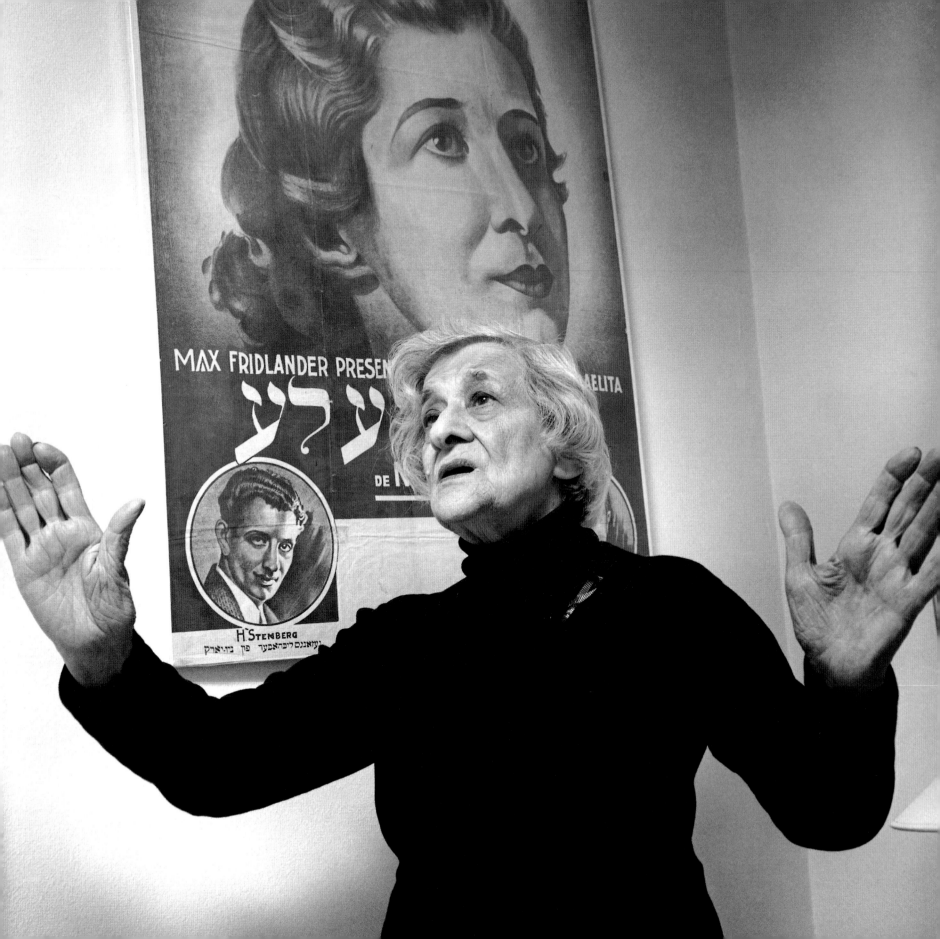

Alicia Svigals

Alicia Svigals, 34, violinist and composer, is a founding member of The Klezmatics and has recorded a solo album, Fidl. *She has toured internationally, performed on both radio and television, and has collaborated with Tony Kushner, Itzhak Perlman, Led Zeppelin, and Allen Ginsburg. Alicia is an advocate for gay and lesbian rights. Her partner, Ellen, became pregnant through the process of artificial insemination and gave birth to their son, Benjamin.*

Now that I am a mom it is difficult being on the road. I've been touring with The Klezmatics for ten years and at first it was really fun. Recently I went away for ten days and it was horrible when I came back: my two-month-old son, Ben, had gone ahead and developed without me. He had changed and there was something really heartbreaking about not seeing it happen. I have really been so in love with watching every little moment of his development, every time he learns a new skill it feels like a national holiday to me. I've decided that from now on, I won't tour for more than a few days at at time.

My partner, Ellen, is a few years older than I and was ready to have a child before I was. We really had to work on our relationship and decide if it was a lifelong partnership or not. Once we resolved this we decided to have a family. We chose an anonymous donor and Ellen started insemination; she became pregnant on the third try.

We had a lesbian ob-gyn who was great in the delivery room. The nurses wanted to know what I was doing there and she said, "That's Alicia, the other mother." She legitimized our family and it was like being a first-class citizen for a change.

As a Jewish mother I am faced with the task of raising a good man, you know, a *mensch.* I'm fairly agnostic, but I'm into having a culture and having a tribe. We didn't have a *bris* and couldn't believe how much flak we got from our progressive lefty Jewish friends. I am Jewish, but I think that the *bris* is a tradition that should change and feel that it is my right to be pro-active.

Benjamin will be exposed to lots of Jewish culture because as a klezmer fiddler I'm a professional Jew and very immersed in *yiddishkeit.* I was brought up kind of a Yiddishist. My parents sent me to the Workman's Circle School. I had a Yiddish bat mitzvah and did the *Haftorah* in Yiddish. I had no idea that I would go on to do this professionally.

My mother is vivacious and has an incredible spark. When the women's movement came along she really soaked it up. In a way I was raised with a very natural feminism.

At the time I came out to my mother I was out of college and went to visit her at a beach house in Connecticut. I practically told her within the first few minutes of my arrival that I am gay. It was like this intense coming-out beach party. At first her whole world crumbled, and she said, "You'll never have children." She went through the Kubler-Ross stages of denial, anger, and grief in twelve hours.

She now gives me advice about being a mother and has said, "You know, Alicia, having kids is the best thing you can do; everything else pales in comparison. One day, after the first six months, your child will reach up, put his arms around you for the first time, and you will just melt." That has been a good thing to meditate on in the middle of the night.

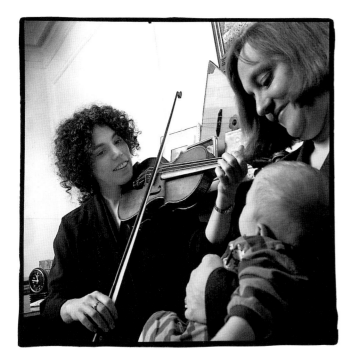

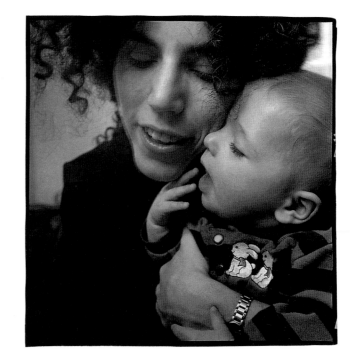

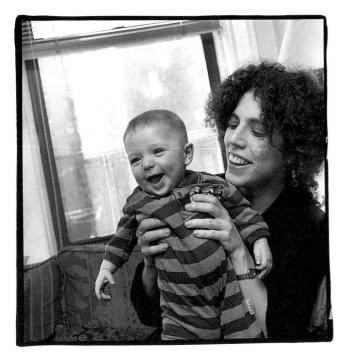

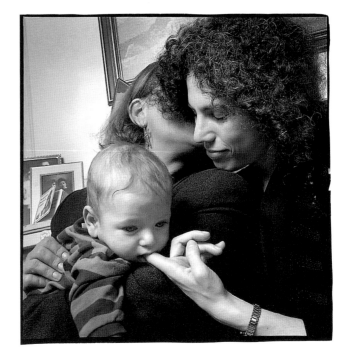

Judy Adler

Judy Adler is a Jewish philanthropist and fund-raiser for United Jewish Appeal and cancer research. She resides in Miami Beach and is the mother of three children. Judy is a marathon runner and uses sports as a way to raise funds.

My kids know that they are in a family that believes in sharing what we have and in caring for others. This is a Jewish value that my husband and I have taught our kids. My son has worked without getting paid for Jewish political action committees and has gone on the March of the Living in Poland and Israel. It is a program that brings Jewish youth together from all over the world to learn about the Holocaust. One of the things on my list to do as a family is to take all of my children to the camps in Poland and Germany. We have already been to Israel many times.

My Jewish and American identity is very much influenced by my mother, who was from Munich, Germany. She was a very elegant woman and taught me to appreciate Jewish culture. We went to the opera, theater, and museums. One of the things that I remember about my childhood though is that we never did any sports as a family. We didn't really do American things, like go to football and baseball games. I think there needs to be a balance.

My kids are exposed to Jewish culture, but we are also big Miami Dolphin fans and, like many American families, spend a lot of time watching baseball and football. You know, we mix it all up. For one of my son's bar mitzvah we had Velcro olympics, sumo wrestling and virtual reality games. No adults were allowed. For another bar mitzvah we used *Fiddler on the Roof* as our theme and turned the party room into the village of Anatevka, complete with baskets of food, fiddlers, and jugglers.

Although the bar and bat mitzvah scene in Miami tends to get really lavish, my children are very aware of the importance of their Jewish heritage and family history. My husband's family is very involved with United Jewish Appeal and I have an incredibly busy social calendar to help raise money for charities. I like to use exercise and sports as a way of getting financial sponsors and have probably raised over $30,000 bike riding for cancer research.

I started exercising after my last pregnancy to lose baby fat. I was in my mid-thirties and remember not being able to complete a hike and a bike ride. Now I get up at 3:30 in the morning to train for marathons and run a twenty-two miler before sunrise. I get back home while my kids are still sleeping. I try not to let my fitness program get in the way of my responsibilities as a mother.

Last Sunday I ran the New York Marathon in four hours and twenty-eight minutes, and have already run three times this week. For marathons I always run with a slogan on my T-shirt. The one I wore in New York said, "Pain is temporary. Glory is forever." I could hear runners in back of me saying, "Hey, thanks," or "Right on. Just a few more miles." That made me feel really good.

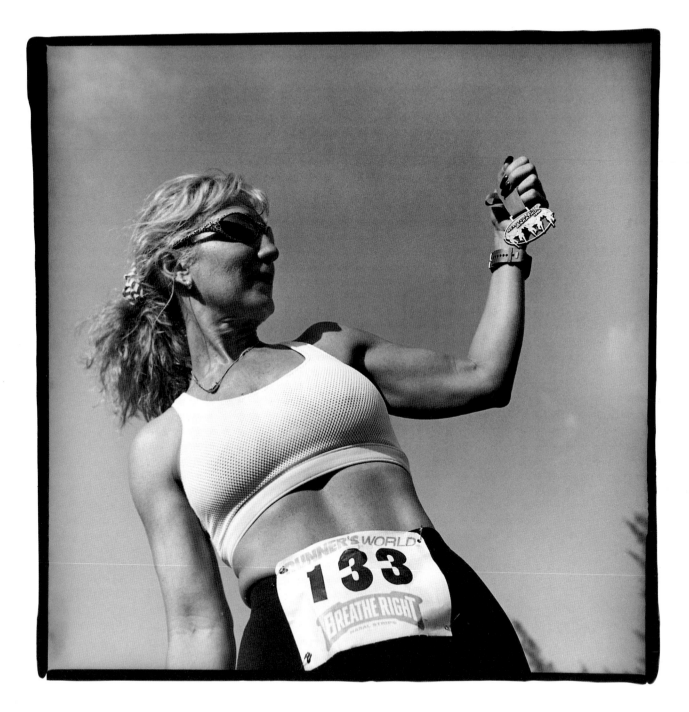

Rochelle Majer Krich

Rochelle Majer Krich, 51, is a mystery writer. Her novel Where's Mommy Now? *won the Anthony Award for best new mystery and was made into a TV movie called* Perfect Alibi. *Her other books include* Till Death Do Us Part, Fair Game, Nowhere to Run, Angel of Death, Fertile Ground, *and* Blood Money. *She is Orthodox and the mother of six children, and taught at Yeshiva High School for eighteen years in Los Angeles.*

loved being pregnant, all six times. I loved feeling my body change to accommodate the life that was growing inside me. Watching our first child being delivered, I felt I was witnessing a miracle. If I hadn't believed in God before, I would believe in Him now.

I have funny memories from my pregnancies. During my last pregnancy my husband and I were listening to our kids debating what the sex of the baby would be. One child said, "I hope it's a girl." Another said, "No, I just want a boy." Our daughter Chani sighed and said, "I just hope it's Jewish."

Daniel, our youngest, always referred to God as "she." I took it as a compliment to our relationship that he saw God as nurturing and maternal. I didn't start writing until Daniel was two and a half, and when I did, it seemed natural that I would write a mystery. As a kid I read all the Nancy Drew books. I can remember my Mom saying, "Put down that book!" Now, my kids say the same thing to me, only in a different sense.

Sometimes my career calls for hard choices. One year I had to miss my ten-year-old son's open house at school because of a book signing. He said, "Mom, if your work makes you happy, that makes me happy." I felt enormously grateful for his understanding, but still a little guilty. The truth is, all my kids have always been very independent.

Some of my writing is very much autobiographical. My mother died twenty-seven years ago of lung cancer. In my novel *Speak No Evil* my heroine has difficulty coming to terms with her mother's death. In *Blood Money* I narrate some of my father's war experiences. Both of my parents, Polish Jews, were in a number of concentration camps. My mother was single before the war and my father was married; his first wife and two daughters were killed. I didn't know about my father's first family until I was a teenager. I remember feeling a tremendous loss, thinking, if not for the Holocaust, I wouldn't have existed. I found this very disturbing.

I suppose I write mysteries to purge myself of fears of physical danger, of the unexpected. I also write to explore the inner workings of the mind. I like to become my characters, to enter into their psyches, even the evil ones. In real life we don't get to be nasty without consequences, such as going to jail.

Writing a "Jewish" mystery has its tensions. I feel a tremendous responsibility in terms of how I portray the Orthodox Jewish community. There's a stereotype out there already that we're weird and out of touch with the modern world. I don't want to perpetuate stereotypes or increase anti-Semitism—among non-Jews or nonobservant Jews.

I write with Jewish texts and commentaries on hand, and I consult with rabbis about the *halachic* views on the ethical issues I present in my novels. I'm very aware of mortality—I think that is one of the effects of my mother's death. She died a few months after I was married and before I became a writer. My mother shared my passion for reading. Every Sunday morning I would join her in her bedroom and we'd lie next to each other, engrossed in our novels, until my father and brother returned from *shul.* I think my mother would have enjoyed my mysteries.

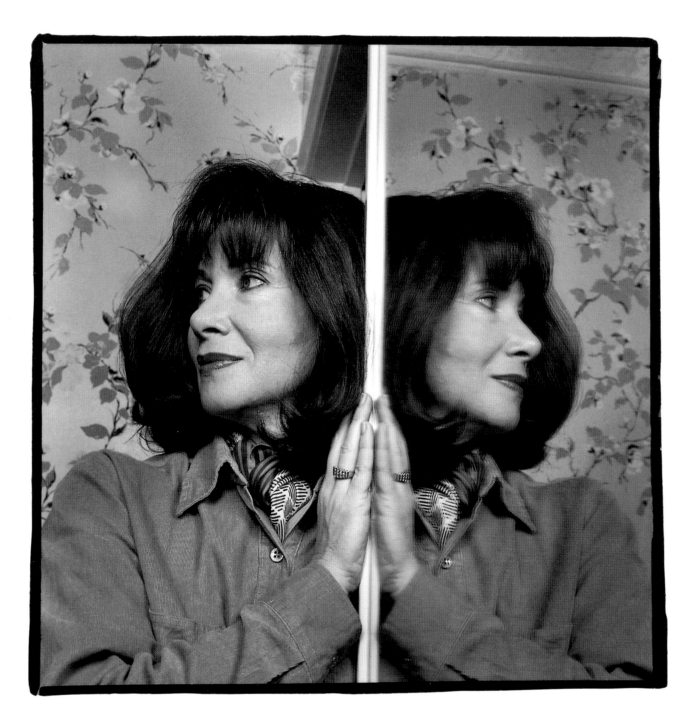

Marcia Jarmel

Marcia Jarmel, 39, is a documentary film producer. Her work includes The F Word: A Short Video about Feminism *and* The Return of Sarah's Daughters, *which examines two women's experiences with Orthodox Judaism. She is currently at work on a film about midwives. Marcia has her M.A. in journalism and mass communication and a B.A. in philosophy, both from the University of Colorado. Her son, Mica, spent his first year nursing in the editing room.*

A few years ago if you had asked me to describe ten things about myself, being Jewish would not have been one of them. I would have told you that my parents were Jewish. My feelings about Judaism changed as I completed my film *The Return of Sarah's Daughters.* I was exposed to a spectrum of Jewish wisdom and tradition that I never knew about. I really began to appreciate the attempt within Orthodox practice to bring forth the sacred in every moment.

I was inspired to make my film after attending the wedding of an Orthodox friend. I was amazed to see so many young, modern, American women who had chosen to lead an Orthodox life. I even spent three weeks at a Chabad school, sitting in hallways listening to teens and young women examine what it means to lead a spiritually satisfying life.

Kids are so vital and a big part of life in the Orthodox world. There are always people around to watch the kids—it feels very holistic. As I began to spend time in the community and learn more about it, I began to change.

While making the film I became pregnant, so the work became a very personal journey for me. I interviewed one woman who had returned to Judaism when she had children. She questioned if parents raised their kids without a Jewish identity would that mean Hitler succeeded? When she said that a lightbulb went off in my head. What does it mean when all these indigenous cultures that have been around for a millennium disappear? What about my own?

Then the thought occurred to me that I was about to become a Jewish mother. I said to myself, "Oh, no, not that." I grew up hearing that Jewish mothers are overly protective, possessive, strangling women.

As a child I got all the trappings of Judaism but none of the substance. My family went to synagogue, but it was not a big part of our lives. In my house the rule was that everyone had to be home for Friday night dinner. We always lit the candles, had wine and *challah,* but we could go out afterward. We were not very Jewish.

I grew up in a suburban community in New Jersey and spent a lot of time in New York City. During those years I experienced Jews as predominantly very status-conscious. I felt pretty estranged from the Jewish community and wanted to distance myself from it. Jewish people seemed judgmental, pushy, and loud. I remember hearing people quibble about small amounts of money and make racist remarks. I told myself I don't know what I am, but I am not *that.* I didn't want to be part of that. "Part of that" was the stereotype of Jewish women, what Jewish mothers were, and what they did to their children.

My relationship with my mother was very complicated. My mother is no longer alive, and I want to be respectful of how I talk about her because now I am able to understand what happened in her life. She was open-minded, adventuresome, and I think unconventional for her time. She was pretty much of a suburban housewife until we were all big kids, but she ran a creative arts and a theater program and was kind of flamboyant, which was challenging for me as a kid. She was very identified with me, and it was

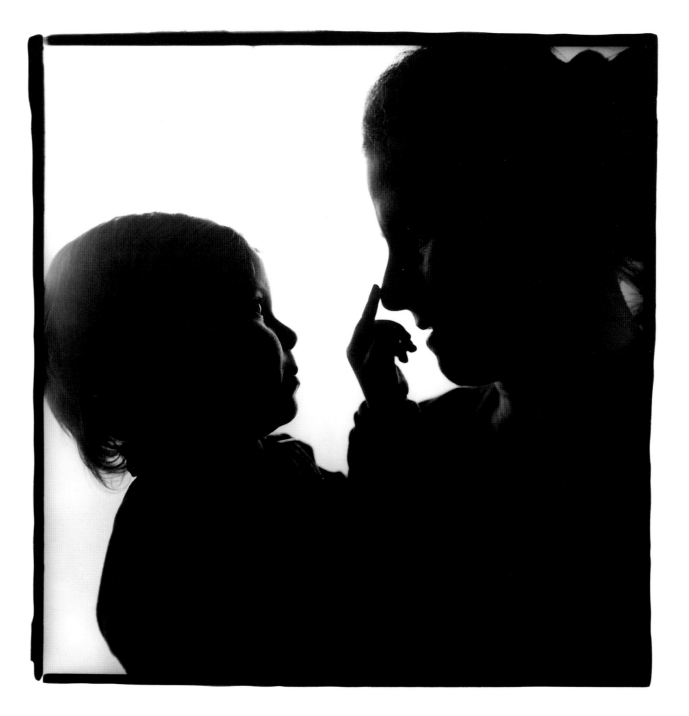

very hard for her to see me being anything she wouldn't want her daughter to be.

My mom was forty-six when my father died of cancer. She was single for fifteen years and we went through a terrible, terrible time. She was in a tremendous amount of pain and became overly involved in my life. I felt she was clingy and overbearing, and used guilt to get what she wanted. I really needed to be out of the house and be on my own, but my father had just died and she needed me. I did not know then how my mother felt and I didn't understand how young she was. I didn't really understand what it was really like to be her.

My mother had never lived on her own, ever. The family story was that she didn't even know how to boil an egg when she married. She moved right from her parents' house into an apartment with my father. Some twenty-three years later she'd never balanced a checkbook. Then when I was seventeen she was widowed and home alone with a teenage son and two college-age daughters coming into their own.

In her early sixties she married a man who was a pilot and traveled. She became more independent and even learned how to scuba dive. Her husband had work in Ecuador, so my mother went on a trip by herself to the Galápagos Islands. It was a big deal for her to do it, like a coming of age for her to be able to have this adventure on her own. One night there was a fire on the boat and she was killed. She went to Ecuador and she just never came back. It was like she was swallowed by the sea.

There was a memorial service at her synagogue in Boulder, Colorado. Our whole extended family was there for about a week. We sat *shiva*, which I had never understood before. Strangely, it was also a fun time. People were telling stories about her, lots of laughing and crying. It was very healing.

Before her trip to the islands we had had a talk, and it was the first time she treated me like an adult. The six months after her death were the hardest of my life. I think her death was the start of my own spiritual journey. Life becomes very profound when someone you love just disappears. It is exactly like when someone is born.

When I gave birth to Mica it was the most amazing moment of my life. I wished my mother could have been there to see the continuity of our family.

I had married the first Jewish man I ever dated and was excited about becoming a mother. I had wanted to be a mom for a long time.

Now I see myself as a Jewish mother with big decisions to make about how to raise my son. I want him to be more connected with his Jewishness than I was as a child.

My first decision was about circumcision. When my son was born he was perfect. Newborns are in this sort of blissful, otherworldly state, and I knew that circumcision within eight days was going to change that and ground him here like nothing else. So I decided to consult with a friend, Miriam, who is a Reconstructionist rabbi. She is featured in my film because of her love of Orthodox Judaism and her search for belonging as a gay woman in a Jewish community. Today she is probably the closest thing I have to a spiritual advisor. When I asked her about circumcision, she said, "This is the one thing everyone still does." So I decided not to break the link in the chain in my family.

Mica is going to grow up in a world where people are very identified with where they come from, wherever it is. Well, Mica is not just another white boy. He comes from a unique history and the circumcision will make his future easier if as a man he feels strongly Jewishly identified.

My husband said at the moment of circumcision he felt a line of connection through the generations because he was initiating his son into the tribe the same way his father had brought him. I hope to guide my son to become the kind of man his father is. I see Ken as someone who is gentle, warm, compassionate, and thoughtful. I want my son to become a man who is concerned about how his actions affect others. Hopefully he will do good work in the world.

I really am in transition regarding my own Jewish identity and I can feel my son, Mica, pulling me along. It becomes a much different issue when you have a child and are trying to figure it out. I want him to have a meaningful connection and relationship with his Jewishness, but I don't even know fully what that means. I don't yet know how to do it in a way that feels like it has integrity to me. Whatever he comes to understand about who he is and where he comes from, I want it to be something that matters in a way different from my upbringing—more centered, more spiritual.

My husband and I like saying the *Shehechianu*, which is a prayer that says how grateful we are to be with these people in this place and time. My family and friends recite it often at events and gatherings.

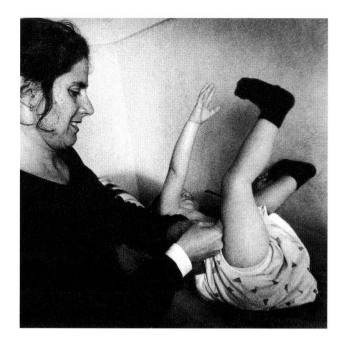

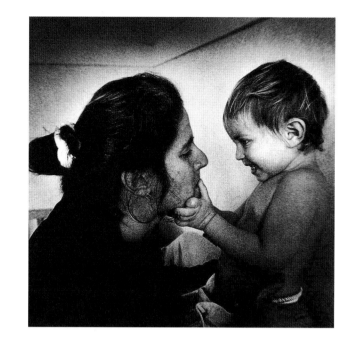

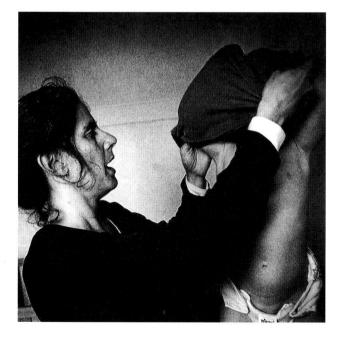

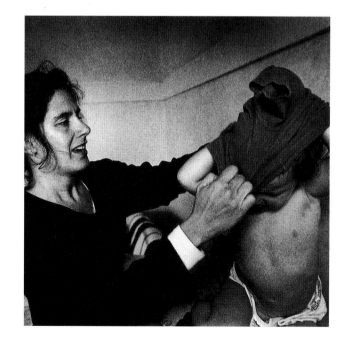

Dr. Marjorie Cramer

Dr. Marjorie Cramer, 56, is a plastic surgeon who graduated

from the first New York City class for Reform Judaism's mohalim

and mohalot *at Hebrew Union College, and was the first regu-*

larly elected president of the National Organization of American

Mohalim and Mohalot. Dr. Cramer speaks extensively on Brit

Milah, *ecofeminism, and animal rights. She has written two*

editions of the Heights Haggadah, *a Passover* Haggadah *used*

by the Brooklyn Heights Synagogue. She is the mother of two

daughters, Jennifer and Heather. Dr. Cramer was born in

England to Irish Catholic parents and is a convert to Judaism.

never met a Jew until I went to college in the United States. When I was in medical school in New York I met my husband. After we married I thought very carefully about the fact that our kids were going to grow up with a Jewish name and with some sort of identification as Jews. I wanted them to feel strong about who they were and to have a sense of real pride in their background. So, I began to study Judaism and became very attracted to it. I read everything I could get my hands on and finally took a course by a rabbi. After a year or so I converted and did a *mikveh* at one of those synagogues on the Lower East Side. It was a very important moment and a beautiful experience. It was a clear day and I felt reborn.

Conversion is joyful and fulfilling, but I was also rejecting my parents' Irish Catholic identity. Somehow my mother managed to deal with it. My parents know that they have the love of their grandchildren, they know that their grandchildren think that they walk on water.

I think the secret of being a parent and a grandparent is that you have to grow with your children.

I have two very strong-willed daughters. I encourage that. Both of my kids became vegetarian when they were eight years old. They went to religious school in Brooklyn Heights where they could just walk to the synagogue. They both became bat mitzvah, which was an important moment in their lives. I tried to make it not just a party. My daughters are now twenty-seven and twenty-three years old. They are toying with the idea of veterinary school, having grown up with millions of pets.

Our congregation in Brooklyn is a vital part of our family life. I was encouraged to become a *mohel* by my rabbi at the Brooklyn Heights Synagogue, Rick Jacobs. He was sort of a mentor to me, just a wonderful person. One day while we were standing on the synagogue steps, he said to me, "Marge, the Reform Movement is doing this wonderful thing and I think you might be interested. They are going to certify physicians to be *mohels.*" I said, "That sounds really sexist. Why would I ever want to do that?" A year or two later the *Brit Milah* Board in Reform Judaism had been set up and there had been a course already in California, and five or six people had been certified. They gave a course in New York and I got a call from a friend of mine who is an internist who was in the course. She said, "I just think this is the perfect thing for you. You should do it." And it sort of rang a bell at that point.

The semester course is taught by rabbis at Hebrew Union College. It lasts for about three or four hours, once a week, in the evening. I went down somewhat skeptically to the first class. Until the end of the first class I was almost ready to leave. I stayed because of the other people in the course, physicians like me with busy lives. They really wanted to make this sort of manifestation of their religious and professional lives to come together. And I really began to love the course. I got very excited about it and felt it was a privilege that I have a gift, surgery, that I can use for religious expression. This was very exciting.

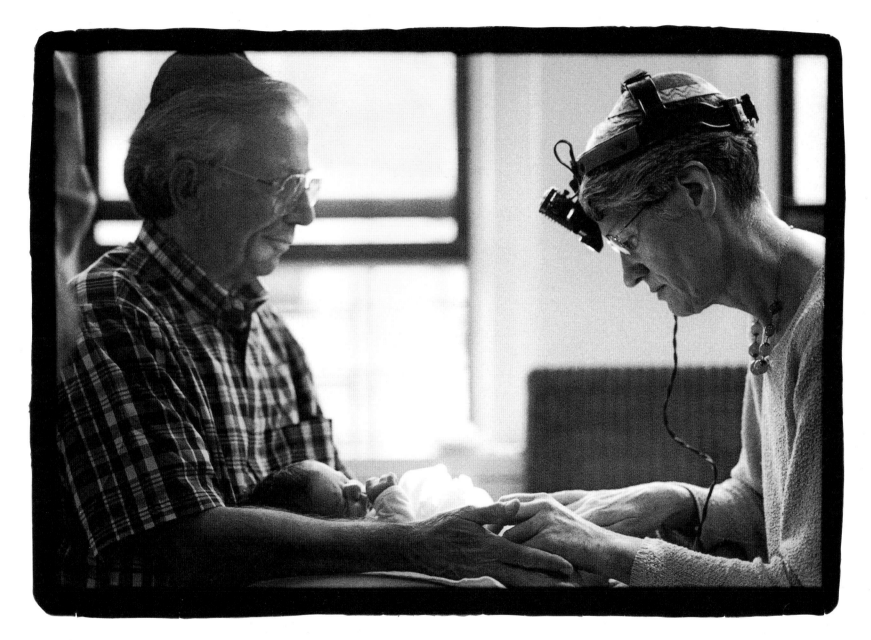

My very first *bris* came right after the High Holy days about ten years ago. The rabbi in our congregation had introduced the fact that I was certified as a *mohel*. He had said, "Well you know how it is. You know you have a *mohel* who comes to your house, and he is an old guy and he's got herring in his beard. Well, you know Marge Cramer won't have herring in her beard."

So I went nervously and did my first circumcision for an intermarried couple and they were really nice. When it was over I went home and called up this rabbi and said, "You know you're right. I didn't have herring in my beard."

I have mostly Reform clients and some Conservative Jews. Couples come to me to be the *mohel* because they are gay and have adopted, or the couple has an interfaith marriage. They feel that an Orthodox *mohel* will not perform the ritual for them or he will give them a hassle.

There are many people who call me because they want a *mohel* who is sensitive to their modern views. They don't want the mother to be hustled out of the room. Some people just actually like the idea of a woman *mohel*. They think I will bring more of a nurturing, maternal presence to this ritual.

Many people say to me, "I thought women were not allowed to do circumcisions." In the Talmud there are some conflicting texts, but there is one that very clearly says women can do circumcisions. In Shulchan Aruch Yore Deah 264:1 it says, "All are eligible to perform circumcisions, even a minor, even a slave, even a woman, even an uncircumcised Jew provided there was a reason for the circumcisor not being circumcised." Not very welcoming, but it says very clearly that women can perform this ritual.

I like to tell people that the precedent for women doing circumcision is in the Bible. Tzipporah, who was Moses' wife, circumcised their sons. In fact when I went down to the Lower East Side to Levine's Bookstore, owned by an Orthodox rabbi, I asked for a Reform rabbi's manual on the service. I was really afraid that the Orthodox rabbi would be very skeptical. He asked why did I need a copy of the service and I said, "Well, actually I am a *mohel*." He said, "Oh, I think that is wonderful. You know Tzipporah in the Bible circumcised Moses' sons."

Of course there are always jokes about my being a *mohel*. The only cute one is that somebody once said, "So, you are a *femohel*?" Sometimes a grandmother will come up to me and say, "When you have done the *bris*, let's go into the other room and you can do my eyelids."

Many people are in conflict about whether they should circumcise their sons or not. Well, it isn't medically necessary, you can get through life without it. The American Academy of Pediatrics' most recent pronouncement is that it is not medically necessary, although they change every few years.

I tell people really that we are performing a surgical operation, but we are not doing it for medical reasons. We are doing it for completely irrational reasons. We are doing it because it is a covenant ceremony and this is what we have done since the time of Abraham; you have to make a decision based on religious grounds. The important thing to point out here is that it is not harmful to do it, that the disadvantages of doing it or not doing it balance out.

If you do not do it, kids can get into problems with recurrent urinary tract infections and need to be circumcised at age ten. I think this is the most significant medical issue, because if the foreskin is very tight and cannot retract and the boy retains urine he will get infections that might lead to kidney infections, which are potentially very dangerous. I think that circumcising a ten-year-old boy, which I have done in my residency in general surgery, is pretty traumatic. That is really scary.

I think the important thing is that it is a religious ritual and that is what the decision is.

You know traditionally you bury foreskins in the backyard and plant a tree, which I think is a lovely ritual. A friend of mine did that and had three sons, and now she has three trees. So I always ask people, "What do you want to do with the foreskin?" Most people go, "Oh yuck! Throw it away!" But some people plant it and so I give it to them, discreetly wrapped up.

The other thing that I think is really, really, really important is to educate people about having a covenant ceremony for girls. If I had my way I would have every Jewish person who had a newborn girl have a covenant ceremony in the home on the eighth day.

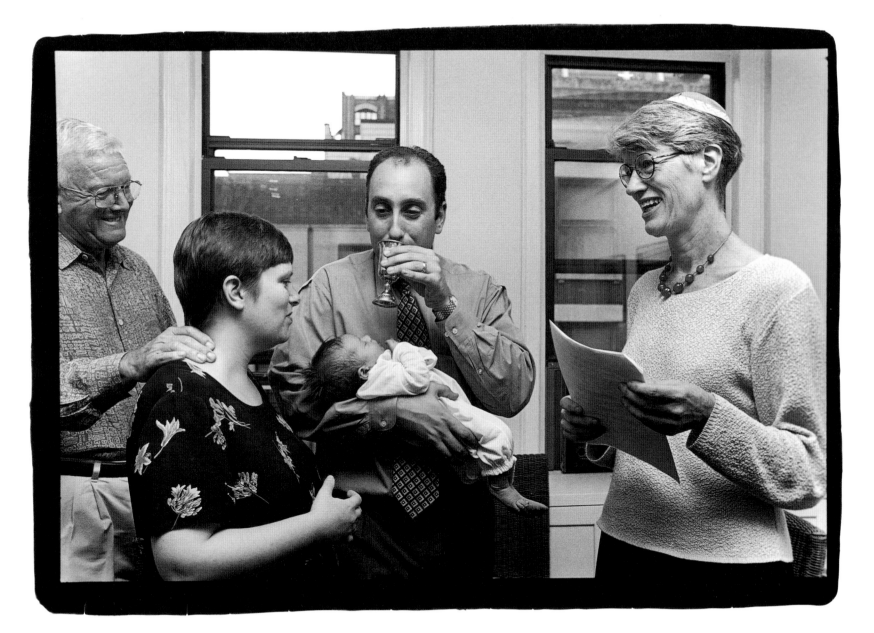

Ava Brand

Ava Brand, 49, is president of the San Francisco Mikveh Society

and director of the Bay Area Council of AMIT Women, which

provides funding to social service programs in Israel. She has

a B.S. in Psychology from University of Pittsburgh. She is the

mother of three children; two have made aliyah.

The mikveh *photograph on page 84 is not of Mrs. Brand.*

It was taken at Adas Israel in Washington, D.C.

Judaism centers me. It is my anchor. It gives me direction and focus. It gives me depth of character. It has made my children deeper people. I have told them that I believe in *tikkun olam* and hope they do work that will leave the world better than they found it. I think what is important in Judaism is how you act and what kind of a person you are.

I was thinking what makes us different as Jews or as Jewish mothers. How do we transmit Jewish values? By osmosis? It begins by having a Jewish home. There have to be concrete things in your house. When you walk in you know it is a Jewish home because there is a *mezuzah* on the door, there are Jewish books on the shelves, the kitchen is kosher. *Shabbos* is *Shabbos.*

Now, eating Eastern European foods does not make you Jewish. I have never made chopped liver in my life. I don't make blintzes or gefilte fish from scratch. Sephardic Jews never knew what latkes were.

Clothes don't make you Jewish, either. There really isn't a Jewish dress. Your outside appearance doesn't make you anything. I am an Orthodox woman, but I don't wear long dresses. I do wear pants, and I don't cover my hair. Some people look more alluring in their wigs than they do in their own hair. It is human hair that is considered by the laws of modesty to be taboo.

My parents were never hypocritical in their religious practice. They decided if you are going to raise children you have to be a cohesive unit and that our home would be observant. We did *Shabbos* at the correct time on Friday night and we went to *shul* on Saturday. I grew up a certain way and don't feel that I am missing anything in my life. Judaism is a beautiful way of life.

On Saturday when I go to *shul* I see guys washing their cars. Compare that to going to services and thinking about God.

My children know who they are and being Jewish is a very integral part of our lives. I feel very blessed. I have three good kids. I think a lot of discipline problems with young children can be avoided by trying to be more understanding of kids' limits. I never took them to *shul* for the entire service because I did not want them disturbing people in prayer. My kids sat next to us and were behaved. As they got older we stayed longer at synagogue. I feel that we gave them the roots and the foundation and a lot of what happens next is up to them.

I did push them to consider doing a one-year program in Israel after high school, which is what I did through Bnei Akiva in Pittsburgh. I think it is really good for a young person to take a year off after high school to get their head together. I felt I benefited and grew up a lot from that experience. So I wanted them to have it also. And where would I want them to go? Why would I want them to go anyplace other than Israel? Israel is very much a part of our lives. I don't think my children have much of a future in San Francisco.

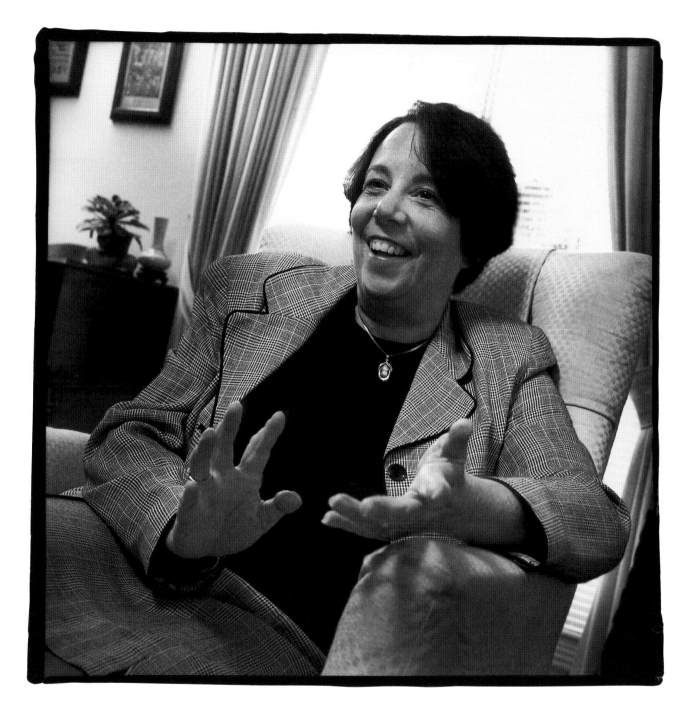

I want them each to marry and live the kind of life we have managed to have in our household, which is an Orthodox Jewish life that is Zionist oriented. My husband just saw my mother at a bar mitzvah and told her that I transmitted this to them. I have a very strong love for Israel. My father's brother was selling Israel Bonds during the Depression. Nobody had money to buy Israel Bonds during the Depression!

My son Eric is sleeping downstairs. He just returned to San Francisco after spending the last fifteen months on the front lines, with the *kiravi*, in the Israeli Army. He is in a special program for new *olim*, which after military service allows study and community service back in the United States.

Eric was stationed everywhere including Lebanon. I did visit him while he was on duty in Hebron. I took a bus there. It was scary. Someone we knew had just been pelted with rocks while driving back to Jerusalem. When I got there I was really upset because his ears had frostbite from guard duty during freezing weather. On guard duty a soldier has to be able to hear everything and cannot cover his ears.

It was a rough fifteen months, but I am proud of him. I could go about two weeks without hearing from him and then I would start getting crazy. I would call his kibbutz family. Everyone is assigned a family on kibbutz and they would hear from him. I won't lie. I am glad it is over. I know he will have reserve duty, *mi-lum*, for the next twenty years. I think it is to age forty-five if you are in a combat unit.

My daughter wants to live in Israel as well. She took Mandarin as her language in high school for four years and she knows that Israel is doing lots of business with China. I have told my daughter that I do not want her to be dependent on someone taking care of her as an adult. She needs to be able to support herself, and not get in the position that a lot of women get into where they stayed in marriages because they couldn't afford to do otherwise.

With two children making *aliyah* I did some research to find out what the long-term ramifications are. I called an organization called Americans and Canadians in Israel. I learned that if my kids come back and live in the United States and have children, that my grandchildren are considered Israelis. If they go back to Israel at age 18 they will be drafted. Well, you can't worry about children who don't exist, but I want all of us to be aware of our family's future. I want my children to know that their decision to become citizens of Israel has long-term consequences and that it is a very serious decision.

As my parents have aged and now my father is ill, I can't imagine making *aliyah* myself at this time, but I visit Israel frequently and it is a possibility in the future. For now my life is in San Francisco.

When I first moved here with my husband it really wasn't my plan to help rebuild the *mikveh*. I was available to do volunteer work because I was taking care of my young kids. The original *mikveh* was built in 1906 in the Jewish neighborhood, which later became unsafe for women to travel to alone at night.

The new *mikveh* was placed in a senior housing project with the help of the local Federation. I do tours and educate young women about *niddah* or family purity. What I tell women is that there is not a good English translation of the word *niddah*. We are not "unclean." I use the word taboo. A physical relationship during the time of menstruation is taboo, and before resuming sexual relations with their husbands, women go to the *mikveh*.

The *mikveh* is not a bathhouse. We have to shampoo and bathe and be perfectly clean before getting into the *mikveh*. The *mikveh* is done not for hygienic reasons but for spiritual ones. There is a huge misconception about what happens in the *mikveh*.

For me it was never a question of whether or not to practice *mikveh*. My husband said definitely that not doing it was not an option.

You know there is an egalitarian *minyan* that formed here many years ago, and an older Orthodox woman went to it and kept nudging me to go. She is very feminist oriented. I said to her the last thing I want to do Friday night is open up the Torah and practice how to *leyn* for the next day. When I grew up girls didn't have bat mitzvahs. At our school they gave the girls silver candlesticks and it was the first time girls wore nylons and heels. That was our big coming-out party. We didn't know differently. This was a nonissue. I don't feel I miss anything because I don't pull the cord to open the ark or get an *aliyah*. I like where I sit in *shul* with the women.

I think it is very sad that some women feel like they are missing out because they can't do something a man does. Men can't do everything that women do either. Men can't really know what it is to give birth. Men can't really know certain feelings that women have. So what? We are just different.

Miriam Jacobs

Miriam Jacobs is a recovering alcoholic and member of JACS, a support group for Jewish alcoholics, people chemically dependent, and their significant others. She is a Chabad House administrator, mother of two adult children, has five grandchildren, and "expects more." Mrs. Jacobs' name has been changed to protect her privacy at her request.

I love working at the Chabad House with college kids. It is an outreach program of the Lubavitch to bring Jews back to *Yiddishkeit*. I started out as a secretary and became the chief cook, confidante, wedding consultant, *Bubbe*, and more. On Friday night I have a regular group over for *Shabbos* dinner. It is the nicest thing to watch people without a lot of Jewish knowledge learn to say the blessings. We believe when a girl is three she starts lighting the *Shabbos* candles. When you light those candles you turn the world off. Everything is peaceful.

One of the other activities that I do is answer the JACS recovery hotline to give people referrals for help. A lot of us do not like going to AA meetings because most of them meet in churches. I have been sober four years and feel great. In the Jewish recovery program we ask for God to help restore us. The twelve steps of Jewish recovery are like a spiritual awakening, so I try to carry the message to others.

I had been drinking for ten years when my daughter threatened that I could not see my grandchildren if I did not get help. She and her husband gave me a brochure on a Jewish recovery program, and the brochure contained a hot-line number. The rabbi told me, "You will be surprised to discover how much you can do when you are not pickled."

I started drinking to hide family problems, but of course they did not go away. My parents could never accept the fact that I became *frum*. A lot of people knock Orthodox lifestyle. In my mother's case it was ironic because I was raised in an Orthodox *shul*. Sometime after my marriage my parents became Reform and my husband and I became Orthodox. My mother said I was "moving backwards." Well, Judaism reinforces who I am. When I told my mother I was sending my children to a Jewish day school she replied, "They will grow up to be bigots." I think that people outside the Orthodox community feel that our kids will not be normal.

My children grew up to respect people different from us; they do not make fun of anyone. My grandchildren are growing up without watching television. They don't need it. We go to museums, the zoo, and their greatest treat is to go with *Bubbe* to the kosher market and buy candy.

I adopted my first child because I was told I would never be able to have children. I remember thinking that to really feel like a mother a woman had to become pregnant. Well, I soon learned that was a ridiculous notion, a mother is the person who takes care of the child. A few years later I became pregnant, what a happy surprise!

My husband and I became *frum* when our daughter was three and my son was six. We belonged to a Conservative temple and went with the congregation on a trip to Israel. On the tour we spoke with rabbis about our Judaism. When we got back we enrolled our son in a Conservative day school. We learned we could not send the kids to school with non-kosher food. So, my husband asked, "How about keeping a kosher home?"

Orthodox women have a very important place in life—rearing the children with good Jewish values. So, call me a throwback to the Dark Ages, but this is how I feel.

Sarah Portnoy

Sarah Portnoy, 80, is a switchboard operator for Jewish Social Services in Rockville, Maryland. She has also worked as an accountant and bookkeeper. She is a lifelong member of Hadassah and Na'amat USA and is the mother of three sons, Larry, Martin, and Kenneth.

My mother was a very strong character. There wasn't much money, but we had a household that functioned. We knew what day it was by what we were being served to eat and by our chores. On Sunday you had to take your clothes to soak because Monday was laundry day. On Tuesday we ironed. My mother scrubbed the floor on her hands and knees. I remember on Thursday we began to get ready for *Shabbos*. Friday was when you finished with the cooking.

It was a hard life, but everybody lived a hard life. Of course there were Passover dishes in the attic and in the basement. My mother began to collect *schmaltz* a long time ahead. We had the fish in the bathtub because you bought the fish live. The carp was not in the bathtub for a long time, just until you got around to it.

My mother had very rigid ideas about behavior. She didn't want us calling attention to ourselves for bad behavior because we were Jewish. My school dress was starched and stiff. My mother used to say, "You better not get a bad mark or else."

The worst thing that my mother could say was, "She is so ignorant. She doesn't even know how to set the table." My mother wanted to be Americanized. She read, but never learned to write. She was very strong about not being considered a greenhorn. Many of her contemporaries didn't care about the way they dressed or how they lived. I think the Jewish American mother stereotype came from them. I don't think it exists any longer.

As a young girl I wanted my name to be like other people's because we lived in a mixed neighborhood. I wanted to be Jane or Carol or Barbara. Sarah was so Jewish. My name is really Sarah Rebecca.

I was nineteen when I married and twenty-three when I started having children. My mother never said one word about sexuality. Not a word. I had no idea what was going to happen. By the time my second son was born I was already a little wiser. My oldest son was born in 1940, before the war. When I became pregnant with my second child people were appalled that I would consider having a child in "times like this!"

I have strong feelings about being Jewish and was a member of the labor Zionist movement. I actually did see Golda Meir. She was a member of Pioneer Women and at a UJA fund-raiser gave us a pep talk. It is very difficult to bring younger people into Jewish organizations because they have different lives. My membership in my Pioneer Women's group was part of my social life, too.

Young women today have jobs and children—they don't have quite the same needs. I don't care for making phone calls on Super Sunday because you encounter people who are antagonistic to the whole idea of money going anyplace other than their favorite group. People do not have the same feeling about Israel or community that we did.

I always tell everybody I didn't need a women's movement. I was liberated long before the women's movement. This came from probably my own personality. To this day I have a very strong sense of myself. And I don't let anybody step on me.

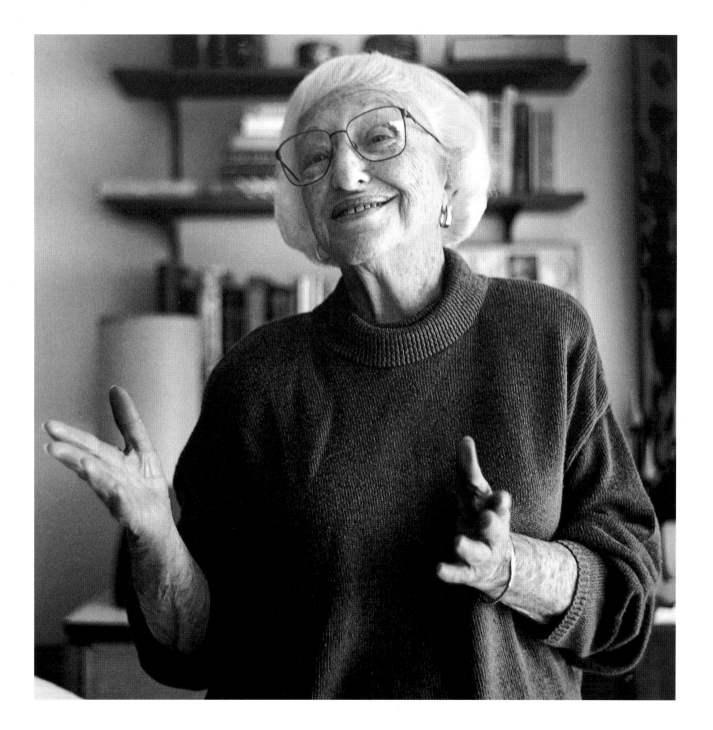

Lotus Weinstock

Lotus Weinstock was a comedian, actress, and writer, and the
mother of Lili Hayden, a classical violinist and recording artist.
Lotus performed on the Johnny Carson and Merv Griffin shows
and at the Comedy Club in Los Angeles. In her comedy she had
much to say about motherhood, Judaism, humor, and the
influence of Lenny Bruce in her life. She was engaged to Bruce
the year that he died.

In December of 1996 Lotus was diagnosed with cancer.
This interview took place the night before she was hospitalized
for a brain biopsy. She died in 1997.

Raising a child in Los Angeles is very difficult ever since they lowered the official age of puberty to six. When my daughter was three and a half, I caught her giving birth to her doll. I said, "What are you doing?" She said, "Enough with the questions—cut the cord!"

Kids are such divine creatures when they arrive. Lili was a fabulous child. I named her Lillith after the first feminist and tried to be an enlightened mother. Motherhood is the ultimate responsibility. Being a mother is like its own religion. You must pay full and utter attention.

My own mother was a piece of work, she was just one of a kind, very Jewish and knew every prayer. She would sneak into the Talmud studies. She loved being Jewish and was incredibly active. She was very Jewish spiritually and emotionally, very old world and elegant. Mother conveyed Jewish values by teaching me to question, to do constant battle, to challenge, to get at the marrow of the issue. I went to Hebrew school at Temple Emmanuel in Philadelphia, as long as you could go.

I have always been attracted to the more kabbalistic and metaphysical side of Judaism. I was in a study group with Rabbi Laura Geller. We would read a Torah portion and examine it. The mysticism grounded in pragmatism made sense to me, full of insight.

At first my mother felt very sordid about my work. In order to be in comedy I had to live in an aesthetic, which was very difficult for her. My mother didn't understand the nightclub scene but loved me on television (because she could turn me off). The night I was on Carson he got sick, so Ed McMahon was the host. After the show I called my mother and asked how she liked my performance. She said, "Well dear, you know I love Johnny, but if he isn't on I just don't watch." I did get a call from her after I was on Merv Griffin. She found me "feminine, funny, and profound." The most important thing for my mother was for me not to degrade the human spirit but to uplift it.

I learned comedy by osmosis. As a kid at camp I used to perform and impersonate my friends, movie stars. After studying dance and music in Emerson College I worked in New York. I was a hostess at the Bitter End, which was a very hip coffeehouse. Everyone was there. We all hung together—folkies, artists, thinkers. Bob Dylan was there. People who had taken a deeper look. I went out with Woody Allen a few times, but I never met his mother. I think Woody was putting himself down, not just Jewish mothers. It was a self-loathing that went across the board, but his self-loathing was a tickle, it was brilliant. I used to sing people to their seats. I was spotted by Bill Cosby's manager who made me part of a comedy duo called The Turtles. I created my own act and opened for folksingers Tim Harden, Phil Ochs, and Richie Havens.

I moved to Los Angeles for work and met Lenny Bruce. I was taken to see him by a mutual friend who thought Lenny would love my work. I walked in his office, wearing this yellow Swiss-dotted dress, yellow shoes, and it was just one of those days when my pores were hanging together. The light was shining just right and it was a done thing.

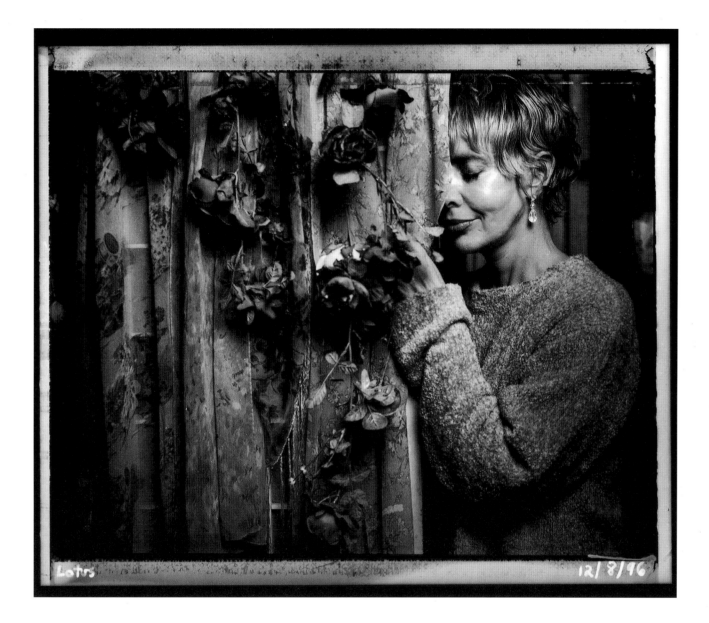

Lotus 12/8/96

I just plain loved him. Every day that he could he gave me a rose he plucked from a bush. I would giggle with terror as he crawled to the steepest point of an overhang to pick the most beautiful bloom for me. I loved the way he made me feel about myself. Lenny helped me become more honest in my work; he introduced me to the "Hounds of Heaven" and the "Truth Bug" and they never let you go. Lenny Bruce helped me realize that the truth is funny enough. Truth burns through you, the searing truth.

What my mother said about our engagement is not one for the family scrapbook, but in time she got to know him and thought he was adorable. When he died it was horrible. Can you imagine every newspaper in the country displaying your daughter's fiancé dead, naked on the bathroom floor? I could cry right now just thinking about him, but I am grateful for knowing him. He influenced my work tremendously.

It was excruciating for me to go back and do comedy that was frou-frou. Nothing will get you to be honest faster than a roomful of people who can't stand you while you are up on stage.

After Lenny died Mama Cass and Richie Havens helped me get myself together. I moved to a commune for a few years where I had my daughter. I was given the name Lotus and my daughter was called Cherub until she was thirteen. It is very Talmudic to change your name to get new vibes.

I believe that humor should not be at the expense of someone, but there is no joke that doesn't have a tear in it. You can't possibly be a surviving Jew and not have a sense of humor. The demarcation line is the difference between humor and ridicule. I never did a variation on the Jewish mother jokes. Personally I always felt that reducing an entire group of women to a one-liner is loathsome and profanes the entire Jewish tradition. I think it is an attempt to make women less powerful. It offended me on that level.

On stage I used to wear big overalls and say that women in the future will be more concerned with developing their sense of humor than their breasts. It makes more sense. Your humor doesn't sag after childbirth. Humor must be the sixth sense. It must be, because without it we would just become disillusioned flower children, stranded in the '60s with stretch marks on our brains.

I started to perform with my daughter when she was young as a matter of pragmatism. They didn't let her in the club unless she was on stage. Our act just evolved and soon she had a little violin in her hand.

You know I can go into eternal *kvellsville* whenever I hear my daughter play her violin.

In our relationship we guard nothing. We go head on and embrace life, and not always to everyone's comfort. I wrote a play about the first time we lived apart entitled *Molly and Maze.* The story takes place on the eve of *Shabbat* the night before the daughter departs for college. The mother is teaching the daughter about lighting the *Shabbat* candles (which is something we seldom did in real life) because the mother wants to give the daughter a sense of Jewish heritage, in case, God forbid, anything should happen to her.

In the dialogue of the play the daughter asks the questions that all mothers dread. The daughter asks the mother if she was a virgin before her marriage. I say, "Sort of." The daughter responds, "Sort of? What does that mean?" And I say, "Well you know how Madonna was 'like' a virgin? Well I was 'like' a virgin. Nobody ever penetrated my soul." Then she says, "So Momma, if you can't tell me how you lost your virginity, how can I tell you if I ever lose mine?" And I say, "Well you won't have to, honey, I will be there."

If you are not honest with your child, they may find out the truth from someone that doesn't love them as much as you do. I have been very protective of Lili. I told her that if she wants to try any kind of drug or experiment with sex, that she should try it at home. That way when the commercial comes on the TV that says, "Do you know where your kids are?" I can say, "Yes. They are in the bedroom smoking and screwing their brains out." Though honestly, Lili has told me she has no interest in drugs and I have taught her to be thoughtful, that there are appropriate ways to deal with things.

I know that my approach to discipline was quite different from my mother's. It had to be with the children of the Woodstock generation. How can you hit a kid who says, "Hey Mom, it's your karma that you will come back as my daughter."

You know that would be great karma, anyway you cut it.

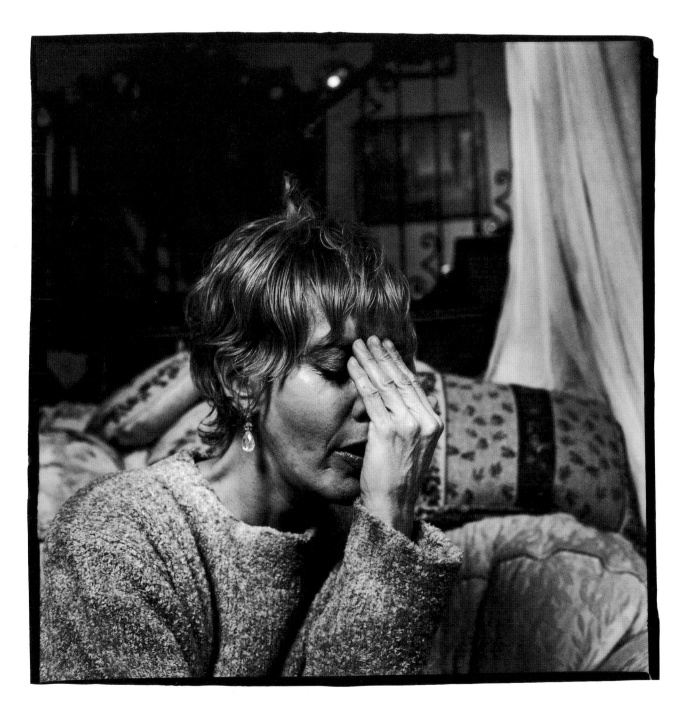

Liz Lerman

Liz Lerman, 49, is the founder and choreographer of the Liz Lerman Dance Exchange, an intergenerational dance company that conducts residencies and workshops in the United States and abroad. Her work has been commissioned by the Lincoln and Kennedy Centers and her credentials include an American Choreographer Award. The author of Teaching Dance to Senior Adults, *Liz brings together community groups in nursing homes, schools, prisons, military bases, and synagogues to explore issues and to find common ground through dance movement and story.*

My mother was so deep that I always think of her as the deepest river. She was a great woman and encouraged me to fight for my values. She was an ecologist before the word was fashionable. I remember that when she returned from her first trip to Israel she said to me, "The thing is, they made it green."

My mother died of cancer just as I was becoming a choreographer. Her death got me started dancing with old people and bringing dance to community groups. As she was dying she talked about people in her life. I imagined them floating about, as if we were living in a house with spirits. After she died I starting visiting senior centers and looking for old people to be in a piece about my mother called "Woman of the Clear Vision."

I think of my twenties as my roughest period. My mother had died and I was struggling with how I was going to make my version of dance, and not just accept what was handed to me. This is a process that I liken to my relationship to Judaism. To have a vibrant religious identity I want to maintain traditions but also push its boundaries.

I have done several Jewish pieces, including *Shehechianu* and *The Good Jew?*, which is a dance that came out of an image I had of a group of Chasidic men pointing their finger at me in anger. In the piece I am on trial for not being a good enough Jew. The Sabbath Bride, the matriarch Sarah, and the *Baal Shem Tov* all came to my trial. In the end the prosecutor asks, "Where are you going?" I tell him that I am returning to the woods, and then the piece conveys the famous story about pious Jews praying in the woods who are unable to remember how they got there. They are eventually saved, but later cannot remember the prayers. They know only the route to the forest and all they have left is the story.

In this piece I move from a marginal character to one that says, "Let's go back to the woods," and find our natural place in the Jewish constellation. By the end of the dance I am able to see myself as central to the Jewish world, that women like me belong.

I felt at one time that services were the most difficult place to bring movement. At Temple Micah in Washington, D.C., we have danced together studying Torah. The movement helps people make a connection between mind, spirit, and body. I might have people trace the letters of a Hebrew prayer close to their face, and then over their heart, and then farther away from their bodies. People are incredibly moved by how beautiful the movement is.

I love to see my daughter, Anna, among the dancing congregants. When Anna was a baby I could take her on the road. Somebody once complained that if you booked my dance company you got the whole village, the kid, the sitter, the old people!

Anna and I have a unique relationship because we don't get enough of each other. This fall I will bring a Hebrew tutor to the house so we can study together. I struggle with Judaism because I don't have a primary contact with the language. If I can show Anna how strongly my values are based in this extraordinary experience of being Jewish, then my hope is that she will find her own way with great pleasure.

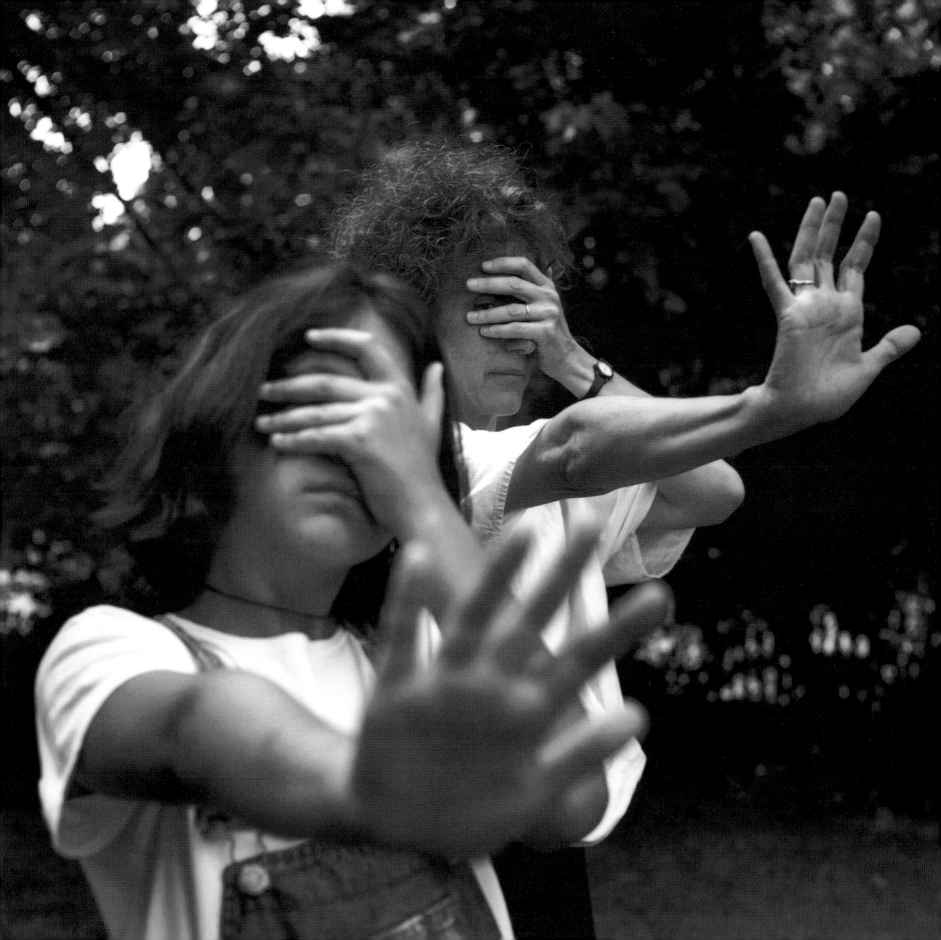

Sydell Laskowitz

Mrs. Sydell Laskowitz, a resident of the Hebrew Home of Greater Washington, became bat mitzvah at the age of 101. In 1920 she was among the first women to vote. A retired hospital administrator, Mrs. Laskowitz was a volunteer for the Jewish Council on Aging and the Prevention of Blindness Society. She is the mother of two daughters, grandmother of three, and great-grandmother of seven. In 1996 she helped carry the Olympic Torch as it passed through Annapolis, Maryland.

The week before my bat mitzvah I was in the hospital. They didn't think I would be here, but I made it. I need to have oxygen from a tank because part of my lungs are filled with fluid. For my age I have minor ailments and believe God has been good to me. I am aware of all my blessings.

My family are my pride and joy, and I have lots of *naches* from them. A good mother gives her all to her children; you raise them to be honorable. I made up my mind that my children were going to be good Jews. As a young mother I spoke to Rabbi Forster at the synagogue on High Street in Newark, New Jersey, and said, "I would like my children to have an education in your temple, but I don't think I can afford to pay the fee." He said, "I will make it affordable for you." They went to temple and made money on Sundays teaching other Jewish children. I was very proud of that.

I wanted them to have have religious values even though I was not raised that way. My parents were free-thinkers. I was born in Odessa, Russia, and my family came over here when I was two. We lived in low-income poverty, but we didn't know the difference; we were happy children. In good times my mother could afford to spend seven cents for a towel and a little piece of soap.

My mother was very educated. She graduated from what they call in Russia *gymnasia* and she could speak five languages, but she worked to death as a janitor. I will never forget that. And that it was what took her life away. Her name was Fanny.

I went to grammar school and to high school for a week or two but got a job for six dollars a week. My father encouraged me to take the job because it was close to home.

It seems that I was never really interested in money because all I could ever think about was volunteer, volunteer! I never said no in my life to anything. I was a volunteer for the suffragists and passed out pins to men that said Votes for Women. Sometime later, I remember helping at the polls the year everybody voted for Franklin Roosevelt. Even the sick people in our neighborhood, everybody in our territory voted for him, especially the Jews. They thought he was heaven on earth.

This is very, very embarrassing, but I don't want to do anything now. I feel as though I have completed everything. I have little books of my poetry and have composed my own eulogy. I asked my daughters to please read it when they get together after I die. I said it is nothing to be afraid of because it is very cheerful.

"Mourn me not when I am gone but rather carry a memory of one who has had a full life. Of giving and receiving love. Of knowing adversity and hardships. And of having overcome many heartaches with infinite happiness and contentment. . . ."

I feel I did my motherly duties with love. After my death I want all of my family to go on living and just have good memories of me.

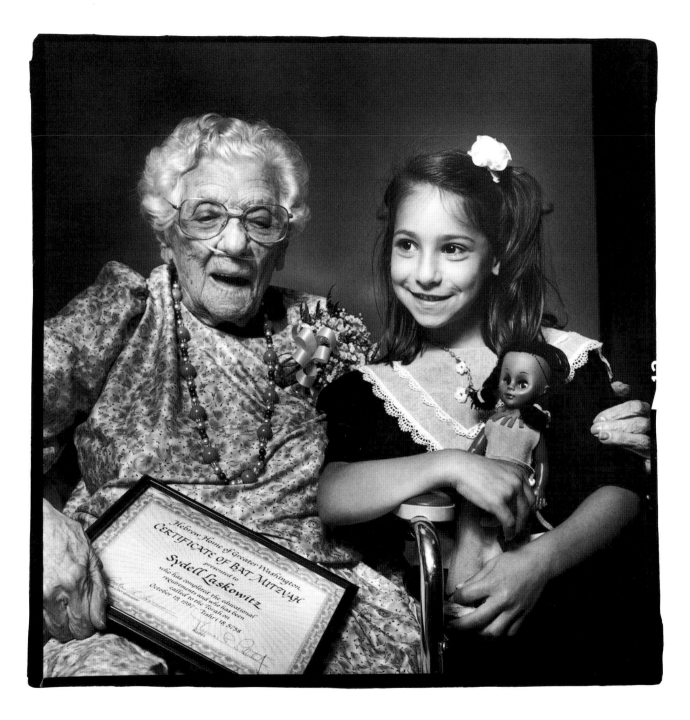

Patricia Lunior

Patricia Lunior, 50, is the mother of Joshua Nathan Lunior, 16,

who is hemophiliac and HIV-positive. Mother and son speak

together at schools and community events to promote AIDS

prevention and education about hemophilia.

Patricia lives in Accord, New York, with her companion,

Bob Lesnow, and cares for foster children in her home. She is

a former Waldorf teacher.

Having a baby was the biggest dream of my whole life. I waited until I was thirty-four to have my first child and I just loved being pregnant. It was a beautiful experience and then so very painful to have a child born with so many problems. I wanted to have a home birth but was rushed to the hospital because I had a horrible infection in my uterus from meconium aspiration. Joshua was born with fluid in his lungs and immediately taken away to a hospital with a specialized neonatal unit.

It was the most difficult thing being apart from my new baby. He was suffering and I wasn't there. I would meditate on a symbol of eternity to bond with him because the physicians didn't know if he would live. And I would pray, I just prayed all the time. I tried to visualize him perfect and healing.

A few weeks later Josh was able to come home. I was going to be one of those New Age mothers who did not circumcise my son but changed my mind because this was so important to my father. When I was young our family belonged to a Conservative synagogue and my mother belonged to the sisterhood. The ritual of circumcision was very important for my parents. So, I found a *mohel* and we had a lovely ceremony. Josh hardly cried. However, Josh did not stop bleeding. Each morning his diaper was full of blood and I started praying again. No one had told me what to expect so I called my mother and she freaked out. I didn't have time to consult our local pediatrician. So, having just gotten him home from the hospital, I had to take him right back.

That day I was totally transformed. It was the beginning of my being involved with all of his medical procedures. I decided if my son was going to be in pain that his mother was always going to be right at his side. I used to be a very squeamish person and could not stand needles, but the physicians let me stay with Josh while they did all these procedures. I saw them cut his skin, stitch his penis, and was told that he was a hemophiliac. This started my process of learning about the disease. My only image of this disease was that a scratch would result in bleeding. Actually little scratches on the surface are not the real problem. It is any impact or fall that can create a muscle bleed. I was trained to infuse my child with blood factors that clot internal bleeds in case he fell or was injured.

I was in such inner pain for the first six months of my child's life that I told no one except my family about his illness. I did not want him rejected or hurt. I could not even speak the word hemophilia. While he was a tiny infant I could shield him in my arms, but then when he started learning to walk it was harder to protect him from falling. I remember being at the beach and two mothers were very upset at the bruises all over my child's behind. They thought I was abusing him.

By the time Josh was three he had three intercranial brain bleeds and needed brain surgery. He went into a coma and it was at that point I felt like my life fell apart. I stopped teaching at the local Waldorf school because my child needed me at his side. I had no income, but I got Josh on supplemental security, disability, and Medicaid. Since I was paying all of my attention to my baby my marriage then dissolved.

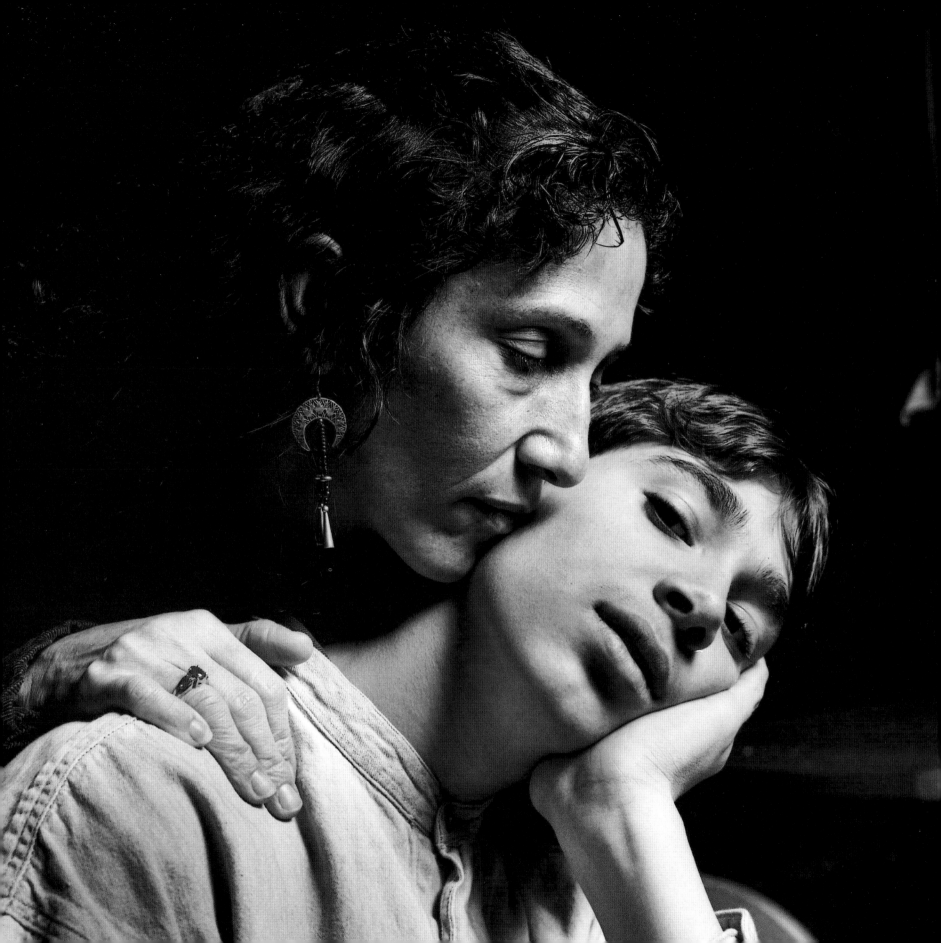

After the surgery Josh was brain damaged and had to learn to sit up, walk, and talk all over again. He has learning disabilities and visual impairment but made incredible progress in school with specialized help.

What kept me going during this first period was my inner connection to God and knowing that this is the path that God gave me. There was no doubt in my mind that I needed to love this child, and it is the strongest love that I have ever felt. I was going to do anything to keep him alive and as normal as possible.

After my husband left I decided to try to meet new people. I took Josh with me to a dance camp. By then I was well trained in how to infuse him if he had problems. He was still learning to walk and at the camp he hit his head. I had to find other adults who would help hold his arms and legs while I injected him. He kept getting away and I had to stick him three times. When the transfusion was over I looked up and one of the men was crying. This astounded me. I finally felt like someone understood my pain. It was an odd way how Bob came into our lives, but he consciously made a choice to be with us and has been there for Josh ever since.

In 1984, when Josh was four years old, I was asked by a team of physicians if he could be part of a transfusion study. I asked if this would help others and then I was told there was concern that hemophiliacs might have been infected with HIV from tainted blood transfusions. They tested him and found him positive for the virus. That moment I felt like I was being shoved in the face with just one more thing, like someone or something was saying, "Here, let's see if you can take this one, on top of everything else."

It was so hard. I was crying all the time and afraid for my son and for other children. I was afraid that he would be completely rejected and also afraid that he might lick another kid's ice-cream cone. We didn't know much back then about the virus, and infected kids were being treated like lepers. We had heard HIV was in tear ducts. I made a conscious decision to not tell anyone. I was aware of what had happened to Ryan White and the Ray family, whose home was burned down.

We took Joshua to the National Institute of Health, and it was then that I met other mothers in the same situation who were coping much better than I was. I decided to get help and became involved in my local AIDS community and joined the Women's Outreach Network of the National Hemophiliac Foundation. Josh was the one who actually wanted to go public. He was only eight or nine when he spoke at a con-

ference about his life. He got up on the stage and was completely calm. I was amazed. Someone heard him and asked him to speak at a local elementary school. I said yes, if we could change our names. Well Josh got mad at me and said, "Don't you change my name. This is who I am."

As a mother I would not want another woman and child to go through what Josh and I have had to endure. So we began telling our story. We put together slides of Josh growing up and some of the medical interventions he experienced. We have stacks of letters in the house from high school students, and one kid wrote, "I was going to party this spring and not worry about it, but after hearing your story I decided to be careful and not risk my life."

We live in a very special Jewish community in Woodstock, New York. Our rabbi is an incredible person, Jonathan Klinger. When we shared with him our medical history there was no rejection of our family at all.

When Josh was ten I thought, "Yes, he is going to make it to his bar mitzvah!" My mother even found my father's *tallis* and *yarmulke*. It was a peak moment for me to celebrate my son's life. Of course, each year that has passed is a miracle for us.

For his bar mitzvah, Bob trained Josh not to read but to memorize Hebrew. He spoke about the concept of *Pikuach Nefesh*, the saving of lives. This means that you may disobey *halachah*, or Jewish law, in order to save a life. We decorated his cake with AIDS ribbons and on it we wrote in the frosting "To Life."

In 1996 a nurse at our local hemophiliac center was so inspired by Josh that she nominated him for the Ryan White Award. She asked me not to tell him until the week before the conference when she called to say he had got it. She raised money and sent us to New Orleans for the conference. That was the first time I ever saw Josh nervous before speaking. He told me that since he was older that adults expected more from him. He wanted to give a prepared speech.

Joshua is now sixteen and treated at NIH for his HIV infection. They run lots of tests and he is on a research protocol. Josh still has the virus in his body, but the thing is he is growing more than he used to. He isn't as tired as he was last year so we are encouraged that the virus isn't taking over.

Josh is now in the tenth grade and finally having a social life. There are not many services for HIV-infected teens, but we participate in programs, camps, and attend a retreat called *AIDS, Medicine, and Miracles*. It is a gift in my life because we go every year and have people there

who just love and accept us. I have met people with HIV and AIDS of every race and nationality. All of us feel connected with one another in a very deep way.

All of this, of course, has been extremely difficult for my mother. She had a minor bleeding problem but was never diagnosed with hemophilia. We have had genetic testing done because of Josh and learned that my sister and I are carriers of hemophilia. We believe it came from my mother's side of the family, but of course hemophilia existed long ago. Hemophilia is even mentioned in the Bible. Someone told me that it says if a child bleeds after circumcision the parents do not have to circumcise the other sons.

When Josh was little I became pregnant but was advised because of my emotional state not to carry the pregnancy to term. Last year at Yom Kippur I told Josh about this and asked him to forgive me for making him an only child.

Most people don't really want to know my pain. Unfortunately I think suffering helps one come to a place in life to acknowledge what is most important. The average person may hear about what I and my son have been through, but it kind of scares them. Most people want to avoid what it is like to really suffer. I guess I can't really blame them.

I believe you take what life gives you and you make it work. I just love children and my heart is open to any kid. I have taken in a foster son for the past two years from our synagogue. I love him dearly, but he will be going back to his parents soon.

We embrace in our lives positive thinking, the power of prayer, and some forms of holistic medicines. At home we light a candle every night and pray. I have had my son's blood on my hands and I have been stuck by his needle. I don't even worry about it. I no longer have fear.

I am not angry at God, but at times I do feel sorry for myself and the pain that my son endures. The way I survive is that I put God's light all around Joshua and place him in the hands of angels. I cannot protect him or keep him away from every sick person. I encourage him to wash his hands a lot.

Dr. Rosalyn Sussman Yalow

Dr. Rosalyn Sussman Yalow, 76, is the first American woman

trained in physics to receive the Nobel Prize for Science (1977)

and the Albert Lasker Prize for Basic Medical Research (1976).

Her discovery of radioimmunoassay (RIA), a method of mea-

suring chemical and biological substances such as hormones

and viruses with radioactive tracers, revolutionized medical

research and diagnostics. Dr. Yalow is an author, lecturer, and

staff member at the Bronx Veterans Administration Hospital.

She has two grown children.

Being happy in life is based on doing what you want. I was lucky that there were opportunities for women to go into science during and after World War II. Physics is an exciting quantitative science and during the '30s it was an intriguing time for nuclear physics. We were just learning about the atom bomb. Back then physicists had great jobs. What is fulfilling is discovering new things.

I ran what became the Nuclear Medicine Department at the Bronx Veterans Administration Hospital. Although it was a male hospital they didn't limit me. I had complete freedom. I began experimenting with the safe use of radioisotopes. It was an inexpensive substitute for radium and used to treat cancer patients. Eventually we learned to use radioimmunoassay (RIA) to measure very small trace materials to study hormones, viruses, and other substances in the body.

Scientific discovery is for the good of society and not to make your own profit. I did not want to patent RIA. In fact, I gave courses to train physicians on the use of isotopes and soon it was used in every lab all over the country. This was the day when Geiger counters first became available. We used them to measure trace materials. The same basic principles are used today, but we have different devices to measure substances in the body.

Religion and science were never a conflict for me. The rational mind and the religious mind—maybe they are the same? They have to think hard. My home is still kosher in honor of my deceased husband, who was also a physicist. We met in graduate school at Urbana, Illinois. There were four Jews in the physics program; I was one of them and the only woman among the four hundred faculty and graduate teaching assistants.

My parents had very limited expectations for me because they both left school by the eighth grade and went to work. And that was it. My parents figured if I got a bachelor's from Hunter I would end up teaching like all Jewish women in those days.

I had wonderful teachers at Hunter who really encouraged my studies. I was a good math student and then I started to take science. In those days Hunter was a girls school so they really didn't have a physics department. However, while I was there for about a two-year period they had a few really excellent physics teachers who inspired me.

As a parent I was an ordinary mother and wanted to give my children the values common to my generation. I wanted them to meet the right kind of man or woman, get married, and have children. Sometimes I fool around and say about my Nobel Prize, "Bronx housewife makes good."

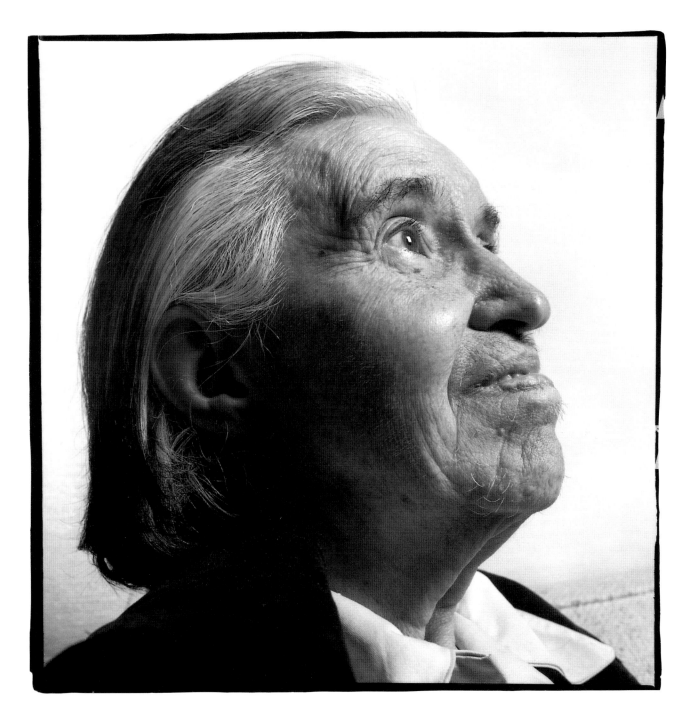

Blu Greenberg

Blu Greenberg writes and lectures on issues of contemporary Jewish interest from the perspective of a modern Orthodox feminist. She is the author of How to Run a Traditional Jewish Household, On Woman and Judaism: A View from Tradition, *and* Black Bread: Poems After the Holocaust. *She lives with her husband, Rabbi Irving Greenberg, in Riverdale, New York, and is the mother of five children.*

Being a mother is truly wonderful and amazing. It put me on a different plane in terms of self-understanding and achievement. I visit my daughter and grandchildren in Israel, and I see her exhilaration. My other daughter lives next door and is pregnant with twins! People say that if you love having children, at some point you will experience a special euphoria, not necessarily with the first child but later. When my second son was born I had an overwhelming feeling of connectedness through the generations. It was visceral. I could see myself and my son as another link in the chain.

I love Jewish ritual and while growing up felt that it was a great gift given to me. Every minute I'm both a feminist and an Orthodox Jew. At a wedding recently, I listened as the rabbi read from the *ketubah* the names of the bride, the groom, and the fathers, but the mothers' names were not included. I no longer simply hear these things without them setting off questions and dilemmas in my mind. Is feminism good for the Jews?

My experience bridging feminism to Judaism began in 1963, though I wasn't quite aware of it. I read Betty Friedan and it jolted me! The idea of feminism was wonderful, but I distanced myself because of the put-down of men (and somewhat of family); it went against the grain of everything I had been raised on. On the other hand, I encountered this idea that you don't have to be just an enabler or second in the hierarchy; you could be your own person. I started thinking about these issues.

Though I am a feminist, actual changes in my daily ritual practice have been gradual. About five years ago I began reciting the *HaMotzi* at my *Shabbat* table. I would say the one area of my daily life that should have changed for me but hasn't (I have struggled with this a lot) is daily prayer. To quote a five-year-old, the reality is that "mommies don't daven" in the modern Orthodox community. I could take this on, but I know I'm not under the same kind of obligation as are men to pray daily. It is not me to get up and *daven* or participate in a morning *minyan*. I remember while growing up in Seattle I used to *daven* alone. The women in my family *davened* by ourselves, which is the essence of women's prayer—it is individual. This also makes it harder to sustain.

I did this study of women in the modern Orthodox community and learned that ten percent of them engage in daily prayer. And that ten percent is mostly elderly women and girls just back from study in Israel. Once the younger women start having children there is a good deal of lapse. But the situation is changing as women become more learned. And I hope I'll change, too.

In my book *On Women and Judaism* I question how we as a culture went from the image of the self-sacrificing Jewish parent to the totally self-interested one. I think the entire American culture swung during the twentieth century from the notion that you do first for family to "do first for yourself." Jewish women were not immune to this value change, despite the persistence of self-sacrificing Jewish mother images in the popular culture. In some ways feminism catalyzed this for Jewish women. Feminism is about putting oneself forward, which is fine, except in excess. There needs to be a balance.

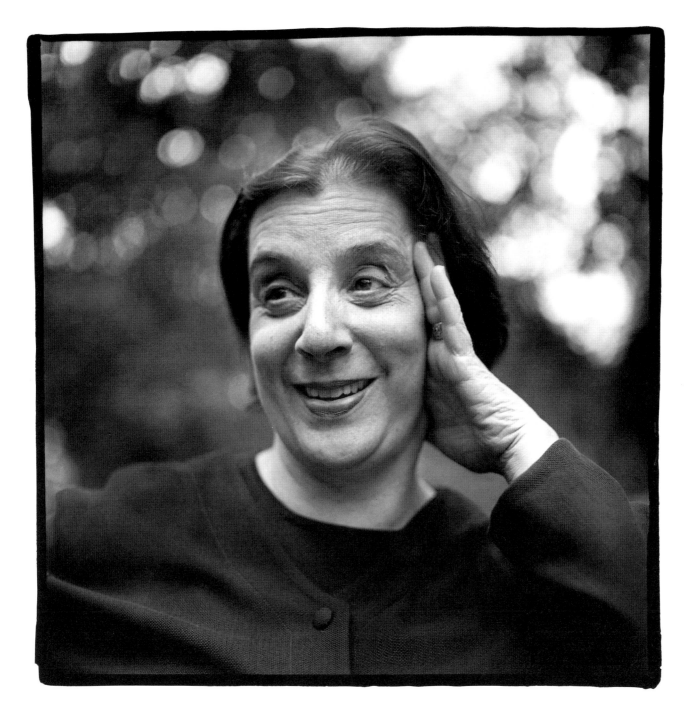

Phyllis Ocean Berman

Phyllis Ocean Berman, Jewish Renewal leader, is the program director of Elat Chayyim Center for Healing and Renewal in Accord, New York. She composes liturgy and life-cycle rituals, conducts chanting and Torah services focused on blessing aliyot, *and has written articles on Jewish women's rituals for* Good Housekeeping, Moment, *and* New Menorah. *She is the co-author of* Tales of Tikkun: New Jewish Stories to Heal the Wounded World. *Phyllis is the founding director of Riverside Language Program for newly arrived legal adult refugees and immigrants in New York City. She is married to Rabbi Arthur Ocean Waskow, and they have a blended family of four children—two each from their first marriages—and two children-in-law.*

Judaism is about bringing ourselves to a state of consciousness or awareness to appreciate the holiness of life. All of the *mitzvot* and blessings, such as eating *kosher*, keeping the Sabbath, honoring our parents, are acts and words to help wake us up and recognize the sacredness of life.

I was raised as a Conservative Jew, but my religious practice changed once I was in college at the University of Wisconsin. I began to feel that denominational Judaism, especially because of the barrier of Hebrew, creates a very excluding community and circle of practice. This discomfort, coupled with my own growing feminism, catapulted me into a process of transition. I realized I could not stand the sense of God as a "he" within the liturgy. I think the language of liturgy has a profound effect on the way we think about ourselves in the world.

I was an active member of the University of Wisconsin's Hillel and participated in a life-changing *Shabbat* my junior year led by Rabbi Zalman Schachter-Shalomi. I credit Rabbis Max Ticktin, director of UW Hillel at that time, and Reb Zalman as my spiritual guides to another kind of Judaism.

Jewish Renewal has no single denominational address; it is a grassroots movement of people from every aspect of Jewish life, trying to create a vibrant Judaism that reflects the totality of our lives. Most of us in the renewal movement believe that politics and spirituality are part of the same continuum. We believe that seeking only an inner peace is a selfish way of being within the world. We are concerned with ecology, peace, and helping to heal the world. During services some of us use meditation and chants to focus on touching the emotions, so we use fewer words in our prayers. We want to bring the body back into the prayer experience. We find that Hebrew is a lock-out for many Jews, so we use more English. Our liturgy is gender free.

One of the areas that I work on in Jewish spiritual life is talking about rituals and ways for people to create their own ceremonies. I think we get stuck in traditional Jewish practice by turning over important transitions in our lives to the so-called experts who do the same bar mitzvah, *bris*, baby-naming week after week. Then we ask ourselves, after such experiences, why we are left feeling so unsatisfied, so unmoved.

At the start of the twentieth century most Jewish rituals focused only on males: circumcision, bar mitzvah, participation in the *minyan*, reading Torah, saying *kaddish*. What we now see taking place is Jewish women reclaiming ancient rituals and traditions for themselves. I have heard women talk about ceremonies for the onset of menstruation, childbirth, weaning, menopause, or for recovery from miscarriage, abortion, rape, and abuse. Women no longer want to give up ownership of their bodies or spirituality to the so-called experts. For too long Jewish women have felt unfulfilled or left out of traditional practices. This is one reason why I became one of many people interested in the renewal of Judaism.

I have actually created two life-affirming unconventional Jewish ceremonies for myself. At the age of 40, during Chanukah, I held an "unmasking ceremony." Chanukah is the

holiday we celebrate by lighting an increasing number of candles each night to ward off the darkness, so I drew on this holiday as a time in which we celebrate the journey in our lives from darkness to light. In my ceremony, parallel to my fortieth birthday, I finally took off my wig after twenty years of keeping my baldness a secret.

I was in college—at the age of twenty—when all my hair fell out from a condition called alopecia. I had the most extreme form and lost all of my body hair, eyelashes, eyebrows. It was so devastating that I believed I would never marry or have children. I went from being an extraordinarily gregarious person to feeling ashamed of my own body. So, I spent most of my young adulthood in wigs, in some form of hiding.

For each of us, too much energy is wasted on hiding our secrets. These secrets hold too much power over us. We become emotionally locked up. I used to live in fear of something as simple and loving as holding a baby in my arms. Babies like to tug at whatever is in reach, like hair. I was always on guard that somehow my wig would get pulled off. I no longer danced up a storm at parties—I completely lost my sense of freedom, my sense of self.

I did marry in my early twenties, but I chose a partner who matched my flawed sense of who I was. After our separation, my ex-husband attended a two-weekend training known as EST, which he recommended to me so that our children might attend as well. Those two weekends

unexpectedly changed my life. People have said a lot of things about EST (Erhard Seminar Training), but it helped me to do personal work I had avoided for twenty years. In front of three hundred people I told the story of my hair loss, and when I sat down I felt free. This began the process of my Chanukah "unmasking."

In truth my baldness has become a gift in my life. What I get in return for my baldness is other people's "baldness," their intimacy. People assume all kinds of things when they look at me—that I have cancer, or that I am a Buddhist nun, or that I am making a political statement about beauty. Even when their assumptions are wrong, they sense that I am speaking to them and reach out and talk to me with an intimacy that otherwise I would not receive. What else do we want in life but to feel connected to others?

I find creating rituals for oneself is important spiritual work. When I reached menopause I held a women's seder to talk about transitions in our lives. I invited thirty-six women on the day of my fiftieth birthday. Since the traditional seder is built around four cups of wine and the telling of the story of liberation, I served four cups of liquids that for me symbolized four stages in my life. My guests ranged in ages from twenty to sixty, so I felt like we were having an ancient women's circle. This is the gift of women's communities, passing our stories down.

For the first cup we drank sangria to commemorate our first menstruation. Many of the stories I heard from the other women present were both bitter and sweet. I vividly recalled being slapped by my mother at the time I told her I got my period. She slapped me across the face, not hard, and told me it was "traditional." Then she went across the hall in our apartment building and whispered to the neighbors. More than the slap, it was the whispering that had a deeply negative effect upon me. What was happening to my body that was so shameful it needed to be whispered? That experience has made me think about the ways we introduce young girls to womanhood. Of course, I wanted to do something different for my daughter. And I did, for her first menstruation. But that's a ritual for another day.

The second cup contained champagne, which I felt symbolized that stage of life that coupled beginning sexuality with love. Yet, as women shared their stories about first sexual experiences, there was as much as bitterness as sweetness in the stories.

For our third seder cup we drank milk to honor motherhood. The bottom line in parenting is that you simply love your child. I know that

my mother loved me very much. When my hair fell out, she got me a wig within twenty-four hours and was there for me during the worst moments of the trauma. She wanted me to come home from college and was very protective.

My mother died a number of years ago, and I certainly understand that she came from a very traditional background and did not cope well with teaching me about sex, love, and the aspects of life that are now talked about openly. She did manage to tell me that I was an accident of too much *Pesach* wine. No wonder I love seders!

One of the gifts that I received from my mother was a retelling of a Bible story that she says was passed down from her mother, who got it from her mother and so on. The story is about the relationship between Sarai, the wife of Avra(ha)m, and her handmaiden, Hagar. Sarai and Hagar each have a son from Avraham. The traditional Torah story has Sarai forcing the expulsion of Hagar from their land so that her own son Isaac will rule next. My mother says that this was a cover story. In my mother's version Sarai had dreams that Avraham heard voices telling him to sacrifice his firstborn son, Ishmael, whom he fathered with Hagar. To save Ishmael the two mothers pretended to not get along so Hagar left. Actually they were heartbroken over the separation of their family but felt it was necessary to protect Ishmael. What my mother gave me in this story was a sense of the deep bond and attachment women, mothers, have for one another. It was certainly evident during our talk at my women's seder.

During the discussion over the motherhood cup, my friends spoke about passion and attachment to their children in ways that I had not heard spoken aloud before. Friends said that they felt capable of killing to protect their children if their children's lives were threatened. As I heard my friends talk, I realized that I certainly feel the same way.

Mothering is the most profound experience of all, and it provides you with the essential lessons of life. It is a fountain to draw from for all other relations, at home, at work, with friends. If you are lucky enough to become pregnant and then spend time nursing, there is an absolute bond that takes place with your child like none other. You begin to speak a language of understanding with the child; it is the practice of loving. It is as though you tap into the road of understanding that you can re-create in a million other loving contexts.

Motherhood is also very difficult. I don't think people should only talk about it in a glamorous way. I caution women who are single and

thinking of adopting or having a child. Even when you are successfully partnered, being a mother is still very hard. I have sweet kids, a son and a daughter, and our relationships are not perfect; they change as our lives change.

The fourth cup we shared at the seder was water and stood for menopause—the unknown stage that I was entering. The women who had experienced menopause said that they did not feel any bitterness. They described their lives as being at the point of infinite possibility, a time to think of one's own desires, since children were grown and no longer needed hands-on mothering.

I believe that Jewish storytelling and rituals encourage people to talk about the truth within own own lives. This is at the heart of the renewal of Judaism—to connect with one another around that which is full of meaning, not around empty words or around our silence. Rituals become opportunities to tell our truths, to come out of the isolation of hiding. We must take responsibility to make conventional ritual moments meaningful and to take unconventional ritual moments out of the closet where too many of us have felt ourselves locked in. All of us have different truths. There is no one truth.

Shari Lewis

Shari Lewis was an actress, producer, orchestra conductor, ventriloquist, puppeteer, and author. She won twelve Emmys and for five seasons in a row was awarded the Emmy for Outstanding Performer in a Children's Series for her PBS television show Lamb Chop's Play-Along. *At time of this interview her daughter Mallory Tarcher was senior producer of the show. Shari Lewis died of uterine cancer in August of 1998, two years after this interview took place at her home in Los Angeles.*

I think as a parent you get what you give. Children should push the envelope as far as they can and the job of a parent is to hold the line. Between the pushing of the envelope and the holding of the line comes the happy medium.

I have traveled with my daughter all over the world. The most fun we had was on airplanes, just the two of us, no phone calls. I do origami and I would work with her. We would cover the dining trays with people, boats, and villages. Now, she is my senior writer and producer. If she gave up the sky-diving, I wouldn't mind.

My first memory of my Momma is of her never putting me down. I really had a sense of being cherished and that is the greatest gift she gave me. Mother was one of six music coordinators for the New York Board of Education. She worked hard and took her responsibilities very seriously. My mother taught me discipline by example, the only way you can teach anybody anything. I got into New York's Music and Art High School because of Momma and it was the making of my entire professional life.

I started in television very young, after winning the Arthur Godfrey Talent Scout program. I sang with a big wooden dummy and was invited on the *Captain Kangaroo Show.* The Captain said to me, "Don't you have anything that is little and delicate?" And I had this lamb. My father said, "If Mary had a little lamb, why shouldn't Shari have a little lamb?" So I took out the lamb and she was a big hit from the first moment. *TV Guide* has described my relationship to Lamb Chop, Charley Horse, and Hush Puppy as "tough love."

I often perform in Branson, Missouri, which has become a little Las Vegas. It is a Christian community. At the end of most shows there is a big cross and people sing "Jesus Loves the Little Children." I have autographed for fifteen hundred people and someone usually says, "I want to thank you for the good Christian values you bring to our children." And I say, "Thank you, but those are Jewish values too. I am Jewish."

I love being Jewish. It is more heartwarming than almost anything else. When I did my first Chanukah special with Lamb Chop, I felt I was really putting my menorah in the window for the first time. I have never been a closet Jew, but I don't think the American public had absorbed the fact that I am Jewish the way they do now. It has become acceptable to share your culture, but I really have no idea how my being Jewish is genuinely accepted by the public.

I think when people thank me for the values in my work they are relating to my respect for children. There is a Hebrew proverb that says, "Do not limit your children to your own learning for they are born into another time." I learned this proverb from my father. Poppa used to say children are messages that we send to a future that we will never see. We have to think about what kind of messages we are sending to the future.

Children's animation shows are the most violent shows on the air and the early evening slot is all sex material. You don't let your children eat anything they want to eat. You give them nourishment. I have lobbied Congress to put rules and regulations in television.

Sherry Rosen

Sherry Rosen is the troop leader of a predominantly Jewish Girl Scout group in Rockville, Maryland. She is a part-time religious schoolteacher, and besides raising her two children, Stacy and Andrew, also cares for three dogs, four parrots, six guinea pigs, one rabbit, and goldfish. Mrs. Rosen is a graduate of the University of Maryland with a B.S. in education and a teaching certificate.

think I dispel the Jewish American Princess image because in my Girl Scout group you all pick up trash. You all work together and if somebody is having trouble, you help. It is as simple as that. I don't accept the children being pompous. I think children adopt their parents' hates or dislikes, but they don't get to use them in my group. If there is a dislike they can go sit somewhere and think about it. I've been very fortunate, no yelling. I just give them the "mother's evil eye."

My biggest thing is trying to work on self-image, feeling good about yourself, with the girls and with my religious school students. We do a lot of soul searching. What do they feel is important about being Jewish? What does a Jew look like? They usually give me some idea and then I hold up a mirror and say, "Do you look like you are Jewish?" And we talk about what that means. I tell them that their great-grandparents and grandparents had a long hard battle to overcome discrimination and become Americans. That this is something to be proud of, to be both American and Jewish. I tell my students that they are going to struggle all of life to attain who you are, and that if there is no struggle you are probably dead.

My daughter, Stacy, is in Cadet Girl Scouts. She got the *Lahavah* Award, which is a Jewish Girl Scout award. The Council in New York sends a booklet for Jewish Girl Scouts to complete and to discuss how they view Judaism. The girls work on it with their parents and discuss family history. They also draw how they view themselves, and I have been very lucky because most of them draw smiles. For doing this they get a gold pin engraved with the image of a flame. The term *Lahavah* means "light of my life." It's the only pin that stays with them through all the different levels of scouting and can stay on their vest or sash.

My husband and I went through so much that was not good when we were each growing up that we are bending the other way for our two children. He is a Boy Scout leader. We also have several pets and now do animal projects with the 4-H Club. Both my son and daughter have been very responsible taking care of our animals, and because of this I think they have developed a mature compassion for life. They work well together and have many Jewish and non-Jewish friends. My daughter is very independent and is not afraid to state what she wants. My son is very gentle.

My children have had their bar and bat mitzvah, are on honor roll, and are great people. I am very proud of who they are.

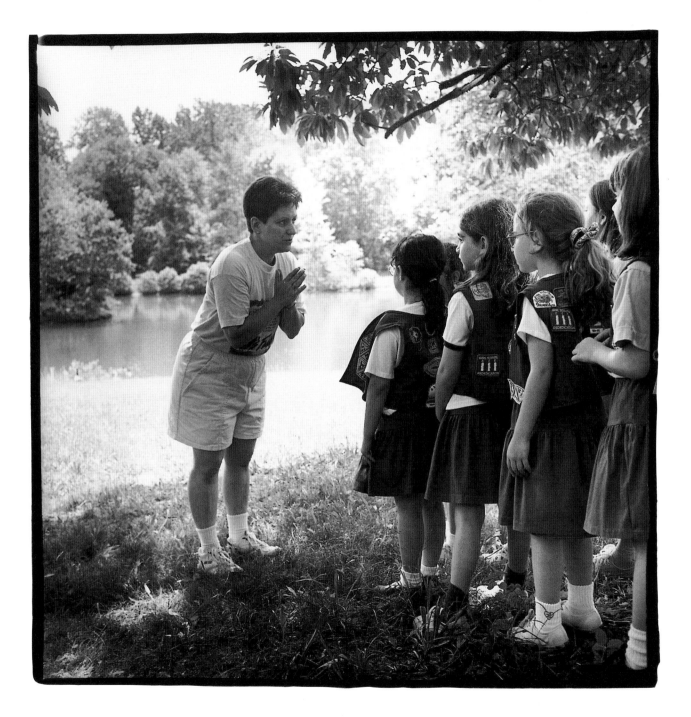

Pamela
Monheimer

In 1998 Pamela Benjamin Monheimer, 40, won one of the

largest employment sexual harassment cases in the state of

Oregon over the issue of breast-feeding. She and her husband,

Paul, and daughter, Noa, live in Portland, Oregon, and belong

to Gesher, an organization for unaffiliated Jews.

During my pregnancy Yitzhak Rabin was assassinated. My husband and I watched his funeral on TV and heard his beautiful granddaughter Noa speaking at the service. I thought she was a wonderful role model with an interesting Hebrew name, and so we named our daughter after her.

I had hoped for natural childbirth but spiked a high fever and had a C-section. Noa was also in distress. She was taken out of me in less than four minutes and rushed to the neonatal intensive care unit. I didn't see her for several minutes, but it seemed like an eternity. Paul followed the doctors to the ICU with our video camera. He came back and showed me Noa by pushing replay. So the first time I saw my baby was on the video.

When Noa was finally brought to me it was love at first sight. She was put to my breast and began nursing immediately. It was amazing. After my return to work I tried to use breast pumps but didn't do well at all. I needed to take Noa with me on my business trips. I was a sales rep for an international company and traveled frequently.

Being a working mother forced me to be incredibly organized. I could nurse, go to the bathroom, and talk on the phone with clients at the same time. I even had a system worked out while I was at conferences. A nanny stayed with Noa in the hotel until I could breast-feed her. I timed how long it would take me to meet my daughter in the hotel bathroom. It took eight minutes.

For a while everything seemed fine. I even had clients telling me to bring Noa along for dinners. Eventually my company was not happy with my image. As a breast-feeding mom I no longer fit the stereotypical company image of the babe in a short skirt. My boss started writing memos about my bathroom breaks, "forbidding" me from breast-feeding. That year my sales were higher than 100 percent of the male representatives.

Although I was written up for breast-feeding, some of the male sales reps took clients to nude dance bars for expensive lunches. The company found this acceptable. In September 1996, I received the breast-feeding memo and filed a sexual harassment and discrimination lawsuit in December of that same year. In January 1997, I was awarded a piece of crystal for being the top national sales rep. I was fired August 1997.

My lawsuit took two years to reach trial. I won the sexual harassment and sexual discrimination portions. The company was forced to pay the jury award and my legal fees. Mine was a precedent-setting case because sexual harassment and discrimination cases are so seldom won. My case helped raise awareness of the issues facing working mothers who breast-feed. We were featured on local televisions news and in *The Oregonian*, the local Portland paper.

I have learned that it is quite a struggle to balance everything in life. As a woman, I enjoy my career. I love spending time with my husband. Above all is my daughter. I want Noa to be kind, generous, well educated, a citizen of the world and aware of her Jewish heritage. She is only three and she has already been on more than one hundred airplane trips with her working mother.

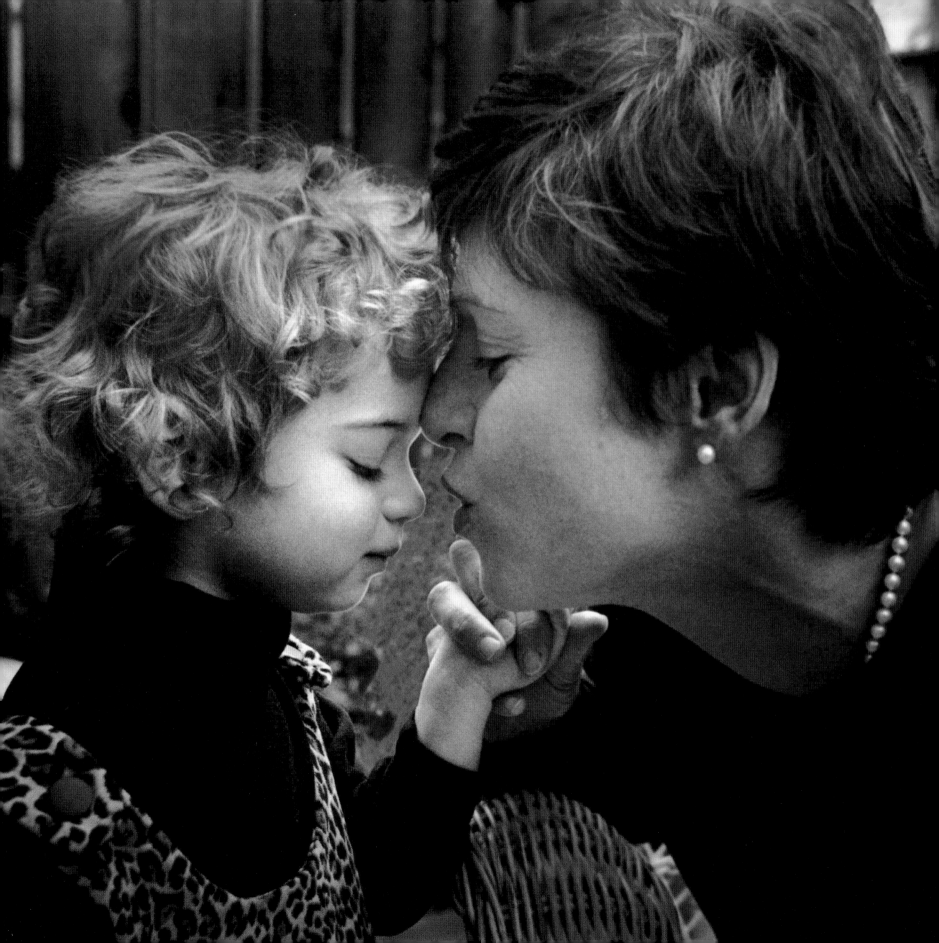

Aida
Wasserstein

Family Court Judge Aida Wasserstein was the first Hispanic to pass the Delaware Bar and designed the first legislation to implement bilingual education in the state. She was born in Cuba and sent alone to America at the age of thirteen when Castro began to nationalize the school system. She was placed in foster care and reunited with her father five years later. Her mother died in Cuba before the family was able to immigrate. Judge Wasserstein is a graduate of Bryn Mawr and the University of Pennsylvania Law School. She is the former chair of the State Human Rights Commission and the 1995 recipient of the National Coalition of Christians and Jews Humanitarian Award. Judge Wasserstein has two daughters.

have a clear memory as a child of sitting in synagogue in Cuba and playing with the fringe on my father's *tallis*. I felt sheltered. We were not wealthy, but life was comfortable. I went to a Jewish day school where we studied half a day in Yiddish and half a day in Spanish.

When Castro came to power the rumor was that he would send the smart kids to school in Russia. My mother's family had fled communism in Russia. My grandfather left Poland just before the Jews in his village were burned to death.

In Torah it says if you save a life you save a whole world. My father knew that at times you must send your child away to preserve the family. So, during the time between the Bay of Pigs and the Cuban Missile Crisis my father sent me to the United States.

I remember crying at the airport, thinking this is the last time I am going to see my home. I was a kid, all alone, unable to speak English.

Through a social worker with Jewish Family Services I was placed in a foster care home in Philadelphia. I felt I didn't belong—I had an accent, spoke Yiddish and Spanish, and came from a very encapsulated Jewish world. I felt conflicted about being Jewish and Hispanic, and also about being female and a Jew.

In Cuba women had defined roles. In America the feminist movement was happening and I was influenced by it. I read *The Feminine Mystique* and did a school paper on it. Yet I felt so confused. One of my Cuban aunts told me that she would cut her heart out and give it to me if I needed it. This was the standard of the women in my family.

When my father finally arrived in Philadelphia I was in college, which he did not approve of. I was the first in my family to go to college and law school.

My father developed a habit of asking men to marry me. Once I had a date and I warned him, "My father might offer to pay you money to marry me, so don't be shocked." My husband still jokes that he never got his dowry.

When I first came to Wilmington I wanted to work with the Spanish-speaking community, so I negotiated with the school district to start a bilingual education program for Hispanic kids. It was an exciting time to practice, applying laws to get positive social action.

As a family court judge the best training for what I do is being a parent. If I am deciding on a case involving neglect, I evaluate if the child is fed, clothed, and also encouraged to do well in school. Without an education, kids do not stand a chance.

My early life experiences have provided insight for judging family cases. I make decisions about people's lives that involve termination of parental rights, domestic violence, juvenile and adult criminal matters. I realize that I am a stranger deciding the fate of a young child, which is a situation I faced myself.

My daughters attend Hebrew school and the oldest one was bat mitzvahed. It touched me at a very deep level. I think it is because of what I went through when I was her age, losing my mother, my family, my culture, my home. That was my bat mitzvah, my passage.

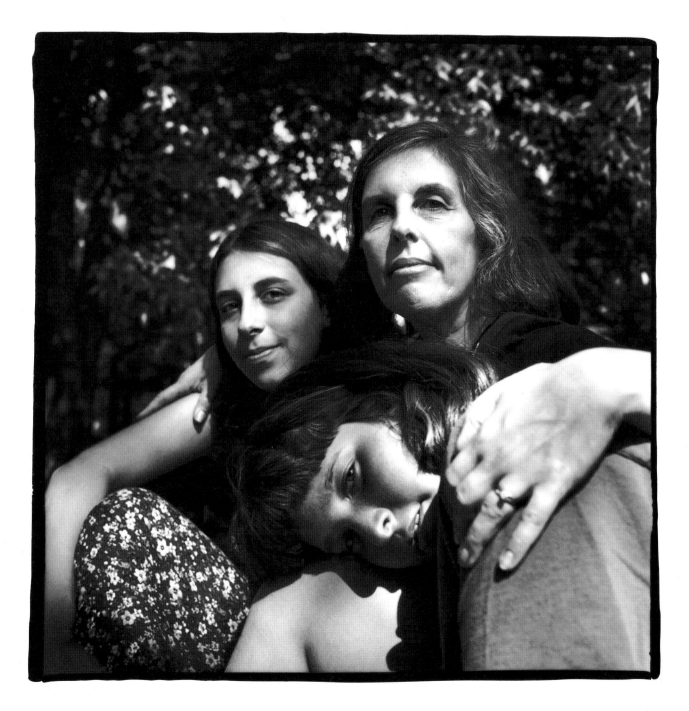

Flory Jagoda
and Lori Jagoda
Lowell

Flory Jagoda, 74, is an internationally known Sephardic musician. Originally from Yugoslavia, she now lives in Falls Church, Virginia, where she raised her four children. Her daughter Lori Jagoda Lowell, 38, a successful fitness gym owner, often performs with Flory and with her own trio, Colors of the Flame.

Flory Jagoda: Before the war my whole family lived in the small Bosnian town of Vlasenica. All these picturesque little villages had Sephardic Jewish communities, descendants of the refugees expelled from Spain's and Portugal's Inquisition in 1492.

Jewish life in Vlasenica was very close knit. In my family the leader was my Nona, my grandmother. She sang beautifully, was a midwife, she knew herbs, her house was always full of women with babies. She was the one to put the first pair of earrings in a baby's ears. She was the teacher of religion in the house. They had lived there for about four centuries. The old peacefully died, the young were born. There was harmony.

Everyone went along peacefully, but in my Nona's family there was a daughter who just couldn't take it. My mother, Rosa, was a rebel. She dreamt of faraway places, read books she was not supposed to read.

Rosa went to the bustling, prosperous city of Sarajevo and married a musician. The family was upset; a nice Sephardic Jewish girl to marry a musician? She found out very early that he played all night, slept all day, and then went out again singing. She right away had a baby, little Florica, which is me.

Rosa then wrote a letter to her father, "I want to come home." The father came to Sarajevo. He took his daughter back to the village and arranged a Jewish divorce.

My grandfather went right away to find a husband for Rosa. Marriages were arranged. They used "los kazamenteros," the matchmakers. They found her a young merchant, Michael Kabilio, and she really liked him.

After the wedding they moved to Zagreb and I stayed with my Nona. I adored that woman. All these feelings I have for Sephardic culture are a gift from her to me. Nona was the most important person in my life. She taught me my music and was a very generous woman. On Friday afternoons we would come home from *shul* and she would have baskets ready for us children to deliver to the poor people.

After two years my mother called for me. Grandfather came in wearing a real hat, not a fez, and I knew he was taking me to the city. My Nona said in Ladino, "Don't ever forget your family," and she gave me a little gold locket.

My stepfather adopted me. He started a necktie business and my mother was in business with him. They were modern and spoke German. We did not speak Ladino and I really missed my life with my Nona.

It was my dream to have an accordion. When Michael Kabilio bought me that little white accordion I fell in love with him. The accordion did it. Mother was very pleased.

In 1941 the war started. Every day we waited in fear for something terrible to happen. First they kicked us out of school. The second day they put yellow badges on us. The next day Jews had to bring their radios in.

My mother saved my life many times. She had a quick, decisive way of doing things. The Ustachi fascists were rounding up Jews and knocked on our door. My mother turned

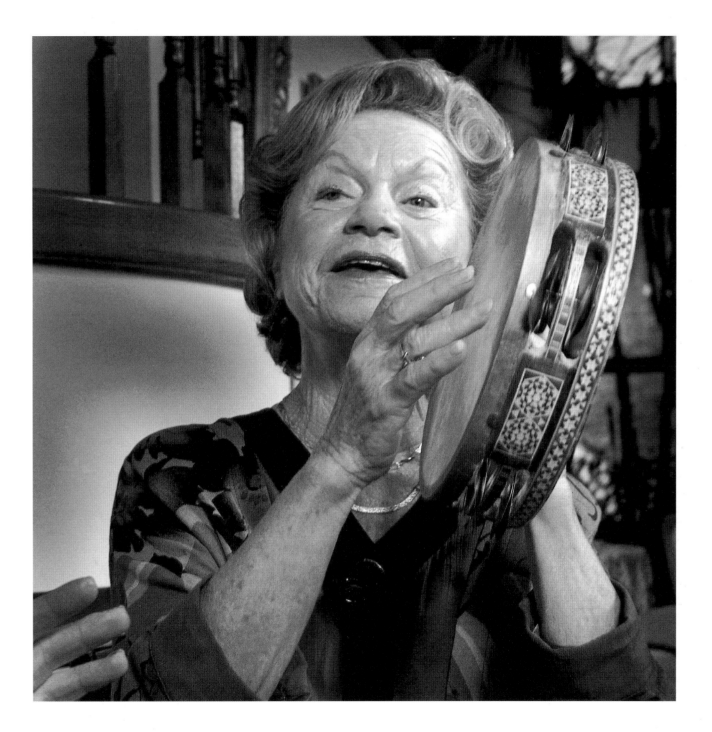

to me and said, "Florica, take this pocketbook to your mother." I understood that she meant for me to run and I did.

A friend of my father's arranged for us to get train tickets with Gentile names so we could get away. I was sent first and then my parents followed. I took my accordion and my Nona's gold locket.

Father said, "The moment you get to your seat, don't talk to anyone. Just play your accordion." I found a seat and we had a party. There were soldiers singing along and the conductor sang too. He never even asked me for my ticket. My accordion saved my life.

The Italians were supposed to send all Jews to Germany but instead sent us to the island of Korchula on the Adriatic Sea. I became a music teacher there. One student was a butcher's daughter so I got a piece of meat, another a baker's daughter, so I got a piece of bread. I had olive oil, bread, cheese. The kids had no worries, but life was tough for our parents. The worst was they were not in contact with the outside world. You couldn't have a radio.

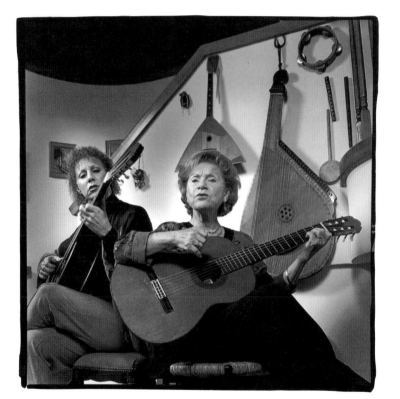

We were there two-and-a-half years. One day my father went to the mainland to buy me a bigger accordion. That same day we got the terrible news that the Germans were retreating, coming though the islands.

Late that night, a stormy, horrible night, we all got on a tugboat and went toward Italy. The weather was bad and you could hear the Germans bombarding everything. After two days at sea we arrived in a promised land. I will never forget the Italian women with big baskets of black grapes for us. We were so hungry.

We were fed by the humanitarian agencies. A new life started. I found myself a job with the American army.

A handsome sergeant worked on the base. His name was Sergeant Harry Jagoda and he was from Youngstown, Ohio. One day he walks over to my desk and asks, "Would you like to go to a dance?" I said I would have to ask my parents.

Harry came to my house with presents, all kinds of good things. It was Rosh Hashanah. My father had a prayerbook, a *machzor,* on the table. Harry saw the book and he couldn't believe it. That was a big excitement because Harry was Jewish, too. So all of us went to the dance together. A nice memory.

Harry and I married on June 24, 1945. He bought a silk parachute to make my gown and all the lingerie. The whole company came to the wedding. Everybody kissed the bride.

When I arrived in America it was almost like closing a book and saying I will never go back. I will start a new life. I fell in love with the country. This was a dream come true. I was able to bring my parents over.

I became an American wife raising American children. I was so into being an American that I named my oldest daughter Betty Lou. She hates that "Lou." To me it was American. I spent forty years just being busy with all the things I love to do, raising children, folk dancing, parties. Maybe I was covering up what I didn't want to think about.

I had to go back and find out what happened to my family. After all the years I just couldn't fight it.

When I went back to Vlasenica we went from house to house. I went to the cemetery and we stopped at a farm. The farmer told us, "I bought this farm in 1956 and one day we had a storm that lasted for three or four days. The ravine filled up with water. The pigs and dogs started walking around with human bones in their mouths. I followed them and saw that the ravine was filled with bodies. That's where your family is."

We just stood there numb, frozen. My husband said *kaddish,* the prayer for the dead. The Ustachi who worked with the Germans used the local Muslims to do the killings. First they took the men and locked them in a barn. Then they took the women, the Nonas, the babies, to the barn and everyone had a great reunion. They had happiness for

one moment. Then each one was killed in front of the other and they were thrown in the ravine.

I had a tough time with religion after the trip. I can't listen to Hebrew sounds. Can't. The worst is when they have *Yizkor*, the memorial service on Yom Kippur. What did those young kids think as they saw everyone being killed? The women screaming for God to help; where was God?

In a way I was glad to finally see with my own eyes and to hear what had happened. I went home and I wrote songs. I just threw myself into music. When I sing my family is in my heart with me. So the trip had a purpose, as horrible as it was.

Survivors have one thing in common. Silence. They do not want to talk about the past, to burden their families with their pain. They want to forget. I was busy for years being a mother, busy with getting the kids through school, with birthdays, weddings, music, but as you get older, you realize that you do not forget. The children grow up, they leave, and you begin to dream, you see terrible images in your mind, faces of your family. You awaken troubled and anxious. Your soul screams.

There must be a reason I did what I did. For forty years I raised an American family. It was very important to me to accomplish that. Let them grow to be happy. All four children are a pride and joy to me. I've accomplished. I've done right.

Lori Jagoda Lowell: As a child I used to watch my mother work in her beautiful rock garden. She would softly hum tunes that sounded very far away. When I was six or seven years old she would come into my bedroom very early in the morning with her guitar or accordion. She would say, "Now, I am going to teach you a song." We would sing it over and over, in Ladino, and that is how I learned my music. Now, I do this with my children.

Most of Sephardic songs are about the traditions in the home since it was really the job of the mother to keep the traditions going. There are songs about everything: love, prayer, even a song about a woman in labor called *"La Parida."*

My children know their heritage and the story of the Inquisition and how their ancestors fled Spain to other parts of Europe. They know many Ladino children's songs. They especially like the song *"Chichi Bunichi,"* which is a finger-counting song that also teaches you respect for the rabbi.

I have learned much from my mother about raising children, including the importance of patience. As a mother I pick my battles, but my biggest battle is to teach them to be nice, to think about the other person's feelings. We are close, we snuggle a lot. I get in bed and read to them all the time.

My mother is known as the "Keeper of the Flame" of Bosnian Sephardic music, and my trio is called the "Colors of the Flame." We are an extension of her music. I have promised her and myself that I will definitely continue this legacy, this incredible gift.

Since there is war again in Bosnia my mother has tried to help by giving benefit concerts. When she was performing at the Croatian Embassy she had a stroke right on stage. The concert was stopped and she was rushed to the hospital. The words to the song *"La Bendision De Madre"* that she was singing when she had the stroke go "Almighty God, In this clear and solemn hour I wish to bless my children. As a mother who feels deeply, please God always be willing to listen in the Heavens above to my prayer and benediction for my children."

The doctors thought that she would never be able to walk or play the guitar again. Seven months later she was playing her guitar and started to give concerts.

My husband says my mother is always just a step away from God.

Ruth Bernards

Rebbetzin Ruth Bernards, 75, is a graduate of the Jewish Theological Seminary. She taught Hebrew school and later was the assistant director of the continuing education department at JTS. She is married to Rabbi Saul Bernards and is the mother of Reena Bernards. Her first child, Joel, died at the age of 20 from a cerebral hemorrhage.

This year has been both joyous and rough. My daughter, Reena, finished breast cancer treatments and seems to have her energy back, just in time for her son's first birthday. My new grandson, Ami, is so delicious.

I wanted a boy first. Joel was an affirmation of joy, so active and loved. Early on though, we knew there were problems. He had kidney stones and was in and out of hospitals. When he learned about kidney transplants, he wanted one. His sister, Reena, was a perfect match. Without hesitation she donated her kidney. After the transplant he blossomed, he started to grow.

Several months later Joel dropped on the street from a cerebral hemorrhage. For ten days he was in a coma. It was a terrible time. I distinctly remember the day we got the call notifying us that Joel died. I remember that the family embraced, and I said to Reena life must go on. I am proud of the way we handled things. My husband and I did not stop Joel from anything he wanted to do.

I hoped that my children would grow up to be happy, respected, thoughtful, and healthy. I wanted them to have a positive Jewish self-image, and be dedicated to the best of Jewish ethics and ideals. We practiced *kashrut*, *Shabbat*, and made several family trips to Israel. The best memorial to Joel is for us to live life to the fullest.

My mother, Hannah, was the crown, the matriarch, of the family. She was beautiful, she had smiling eyes. She came to New York from Russia in 1906, a young bride with her new husband. Her parents and all of her family went to Palestine.

She told stories about her childhood in Russia. She was from a large family that all had beautiful voices, and on Friday nights the family sang Yiddish and Russian songs for *Shabbos*. Peasants would gather round the house—it was the weekly town concert.

My mother was ahead of her time and gave us a great sense of independence. Education was equally important for girls, and I went to Hebrew school at a very early age. She would laugh at the old superstitions and tell us, "If you sew a button, chew a piece of thread so you don't get your mind sewn up, so your mind will not close." I remember my mother used to say in Yiddish, "Be tolerant," one of the values I imparted to Reena.

During the Depression my family moved to Palestine. We lived in Tel Aviv while I went to high school. Little by little, my family returned to New York, but I had to stay on alone to finish exams and graduate. Looking back, it was quite a feather in my mother's cap to let her seventeen-year-old daughter travel alone, from Haifa to Trieste to Paris to Cherbourg to New York. Not once did she express any concern or worry about that trip.

My mother came to live in my household as a widow at the age of sixty-three. I was thirty-one at the time and had a warped perception of old age. I thought that Mom was old, and I was going to have her just sit around and rest. Well, I soon found out that this was just the opposite of what was good for her. She took over most of the household responsibilities and we lit the *Shabbos* candles together. She died at the age of eighty-three. I suspect had she lived longer, she would also have been a peacenik like Reena.

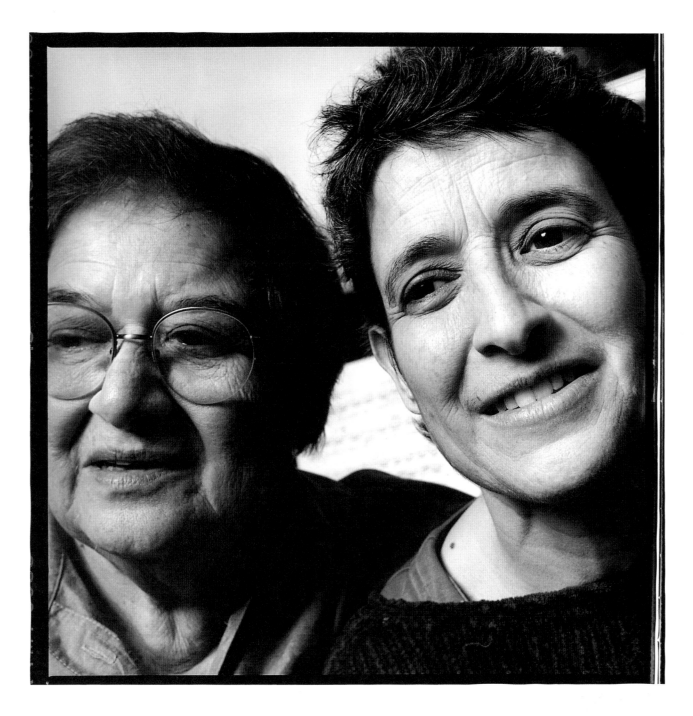

Reena Bernards

Reena Bernards, 44, is a trainer and consultant in conflict resolution and interethnic dialogue. She is the founder and co-coordinator of The Dialogue Project, which brought together mainstream American Jewish and Palestinian women leaders. Ms. Bernards is married to Tom Smerling and has two adopted biracial children, Ami and Talia.

We adopted Ami at birth, and I was in the delivery room when he was born. Three months later I was diagnosed with breast cancer and had chemotherapy and radiation. Ami got me through the year, he was such a piece of joy. No matter what I was feeling, Ami was there.

Ami is a form of Amir, a Hebrew name, which means treetop. It's found in Israeli, Arabic, Pakistani, and Iranian cultures. It is a wonderful symbol for our family because both Tom and I have worked to help facilitate peace through Arab-Jewish dialogue.

Now that I am a mother, I empathize with the Israeli parents who live daily with the fear of terrorist attacks and have children in the military. I have toured the West Bank, Hebron, and Gaza often and know that Palestinian parents share the same fears.

One of the difficulties for Jews in thinking about Middle East peace is not knowing Arabs or understanding Arabic culture. The goal of dialogue is to break down the isolation that exists when you are in your own separate community and listen to only one viewpoint. The many years of dialogue as building blocks culminated in 1993 when Arafat and Rabin shook hands at the White House. It was so exciting for me and other peace activists to witness because we never knew if it would happen in our lifetime.

My values concerning social justice are rooted in my family. Hannah, my grandmother, came to America in 1906. Most of her family emigrated to Palestine. My grandmother lived in my home, so I grew up hearing stories about our Israeli relatives, people who lived through the creation of the state of Israel. There used to be a certificate from a Zionist organization on our wall with a picture of a young girl holding farm tools, a *chalutza*, a pioneer, which is what I wanted to be.

Even though our home followed Conservative *halachah*, I became culturally but not religiously oriented. After graduation from Brandeis I worked as a community organizer, living in low-income ethnic neighborhoods. This was my way to break down white, Jewish, and class boundaries.

It is very moving to me when people from different cultures come into contact with each other and realize that we are all part of humanity. I hope for my children that they grow up confident of themselves and accepting of others' differences. They will be raised with lots of Jewish holidays as well as celebrations that affirm their African-American identity. I want to find an inclusive and welcoming Jewish community for our family.

At Talia's baby-naming we wrapped both children in our *chuppah*. Talia means the dew of heaven. And that's just how she came to us. One day we were at the beach and we got a call from her birthmother. The next day she was born. It felt as though this wonderful being fell into our laps.

It feels like such important work to raise my children. It is funny, but mediating conflict and mothering both require the ability to listen, to problem-solve, to comfort, and to have enormous patience.

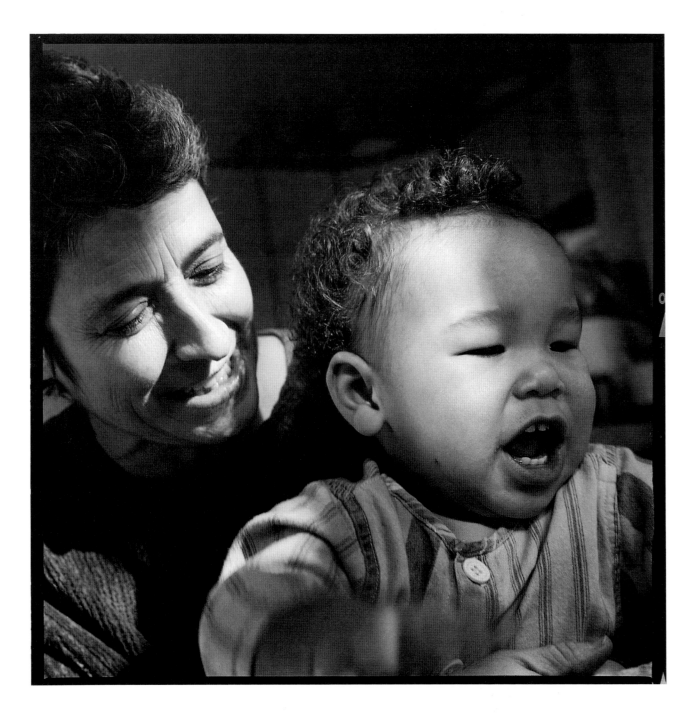

Jennifer Breger

Jennifer Breger, 50, is a writer and expert on women's devotional prayers, and collects Judaica with particular interest in women's prayer books. She contributed to the recently published Jewish Women in America: An Historical Encyclopedia. *She appraises Jewish books and objects and has curated museum exhibits. A native of London, England, Jennifer holds bachelor's and master's degrees from St. Hilda's College, Oxford, and has a master's from Hebrew University in Jerusalem. She emigrated to the United States in 1976 after her marriage to lawyer Marshall Breger. She is the mother of two daughters, Sarah and Esther.*

Books have always been very important to me. It is perhaps a silly way to say it, but even as a child, books spoke to me. My father was a rabbi, and on Friday nights I can remember being in my father's study, and he would ask me to bring him a certain book. Even when there was no light, I knew where every volume was.

Often I would wander through our library and take books off the shelves almost randomly. I would look where the books were printed and who printed them, even before I could read the English or Hebrew texts themselves. Now I collect books, particularly those relating to Jewish women—books written by them, for them, and about them, and also books printed by Jewish women. I love the words in the margins written by former readers, the signatures of previous owners, the introductions, the endorsements, and the dedications. All of these are windows into the lives of Jewish women of the past and help to re-create the texture and variety of their experiences.

Although I spend my time writing about many different topics relating to Jewish culture, my dream is really to devote myself to the history of the Jewish book in general—how the books were printed, distributed, and transported, who read them, who paid for them, who subscribed to them, books as objects, and how they related to the whole pattern of Jewish literacy and history.

For my daughter Sarah's bat mitzvah, my husband and I designed a book of prayers, stories, and poetry. Part of it was about famous "Sarahs" in Jewish history. It is believed, for example, that our biblical foremother, Sarah, had a great gift of prophecy, as God instructed her husband, Avraham, "Everything that Sarah tells you hearken to her voice." We included in the book materials about the seven prophetesses grouped together in the Midrash and Talmud beginning with Sarah and ending with Esther.

For our youngest daughter's bat mitzvah I plan to make a similar book. We have spent a lot of time talking about her namesake, the biblical Esther, and her leadership role in becoming the national savior of the Jewish people. How Jewish women have made a difference in the past is something I always stress to my daughters.

I feel it is very important that my girls learn about Jewish women's history, and one way of doing this is through my book collection, in particular the books of Jewish prayers coming from a wide period of Jewish history and from many different places. This way they can learn about women's prayers from both an intellectual and religious standpoint, and understand how important prayer was in the lives of Jewish women in the past.

Women's prayers were first written in the sixteenth-century Jewish communities in Western and Eastern Europe. There are hundreds of these prayers called *tkhines,* which comes from the Hebrew word meaning "supplication." They are far more personal and intimate in tone than prayers used by men. There are prayers for conception, stages of pregnancy, days of the month, the new moon and for many other occasions—for taking a child to *cheder* for the first time, or for not smothering a child sleeping in one's bed.

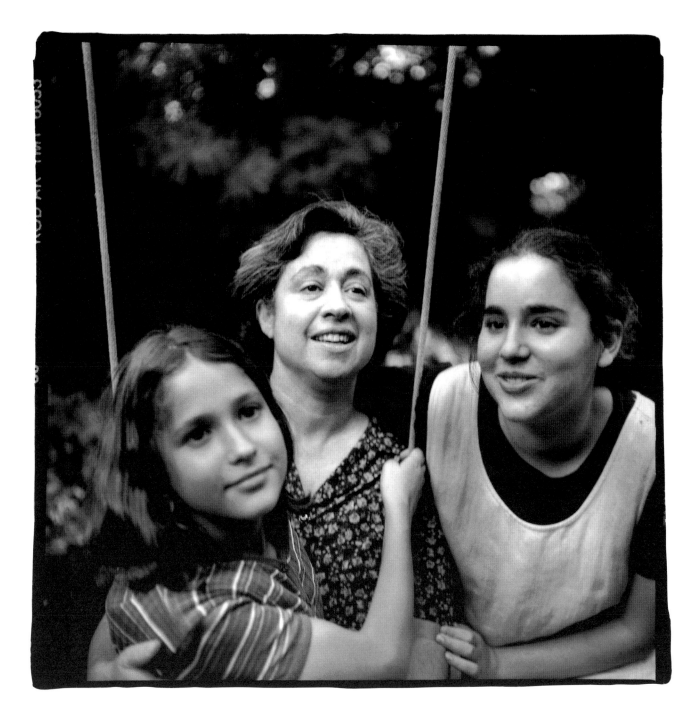

In past generations a woman was only fulfilled in marriage and in mothering. In today's world women don't want to be relegated only to the experience of their bodies, yet our bodies are a serious part of our experience. Jewish women's prayers reflect this. One thing we have to realize is that childbirth used to be very unsafe. Many women and children died. These prayers reflect the very texture of women's lives.

The majority of prayers for Jewish women were actually written by men, but there were some women who wrote prayers. One whom I often speak about in my courses was Sara Rebbekah Rachel Leah Horowitz, who wrote *"Tkhine Imohos"* or the *"Tkhine of the Matriarchs."* She lived in eighteenth-century Poland, wrote in Hebrew, Aramaic, and Yiddish and was very advanced in her beliefs. She talked about the importance of women's prayers in bringing the redemption and felt that women should go to synagogue twice a day. She advocated the study of Torah by women and spoke about the power of women's tears: women's tears in prayer open up the gates of heaven.

One of my most vivid memories is of going into my grandmother's room every morning to bring her a cup of tea and finding her *davening* and saying *tehillim* (psalms). Nothing took precedence for her over that.

There are, I believe, two views of human nature in Judaism. One is that you are a noble vessel created by God, and the other is that you are a broken spirit and that God should have mercy: "I am nothing and have no merit." Most of the women's prayers are of the second variety, but if you read between the lines there is a sense that the woman has the ear of the Almighty. She is absolutely confident that God is listening to her. When she lights her candles, takes *challah* when baking bread, or fulfills laws of family purity, she is doing work for God. The woman lighting candles confidently compares herself to the High Priest in the Temple of old.

Many Jewish feminists are now seeking information about women's prayers and the strong Jewish women in the Bible. One of them is Hannah, who according to the rabbis gave us the model for prayer, in particular for the *Amidah.* The rabbis learn a lot from the story of Hannah who goes to Shiloh to pray for conception. While she is praying, the priest Eli thinks that she is drunk, but then realizes that she is very sincere. From the story of Hannah, we derive many rules including how to petition God in prayer by silently moving our lips.

When my children were little I told them that during services we are actually talking to God right now and that this is very important.

I stressed that you can't run in and out of the synagogue and have an intermittent prayer or conversation with God. I wanted them even when they were very little to take their religion very seriously and very happily. My mother used to tell me that God's listening to our prayers is a tremendous gift, and that we cannot waste it.

A hundred years ago one tried to be just a man or woman in the street and a Jew at home. Today we feel confident with our Judaism and see no special need to hide it. My husband was Special Assistant to President Reagan with responsibility for Jewish and Academic Affairs. Among many other things he did, Marshall helped institute Chanukah parties at the White House. So we have photos of our daughter Esther playing draydle with Vice President Quayle. Of course she knew that the correct thing to do was to let him win. We were excited to bring the religion we live to the White House itself.

Now that my children are older I tell them that religious law helps us to achieve integration within life, to live one's life as a whole. They attend Jewish day schools and we live in a very traditional neighborhood. *Shabbat* is a positive time spent together as a family. We don't dwell on the things we can't do. The year after my father died the girls and I studied together every *Shabbat* in his memory. Every Friday afternoon, however short the day in winter, I take the girls to the library before *Shabbat* as my mother used to take me. It is part of our ritual.

Judaism is God's gift to us. I truly believe God gave us the commandments as a gift for us to make sense of ourselves and to bring us closer to Him. I also believe that all service to God should be done with joy. We also have a responsibility of knowing as much as possible about our Judaism, about Jewish culture and Jewish history. I pray that my daughters will continue to study and learn all their lives and gain pleasure and satisfaction from their studies as they become educated Jewish women.

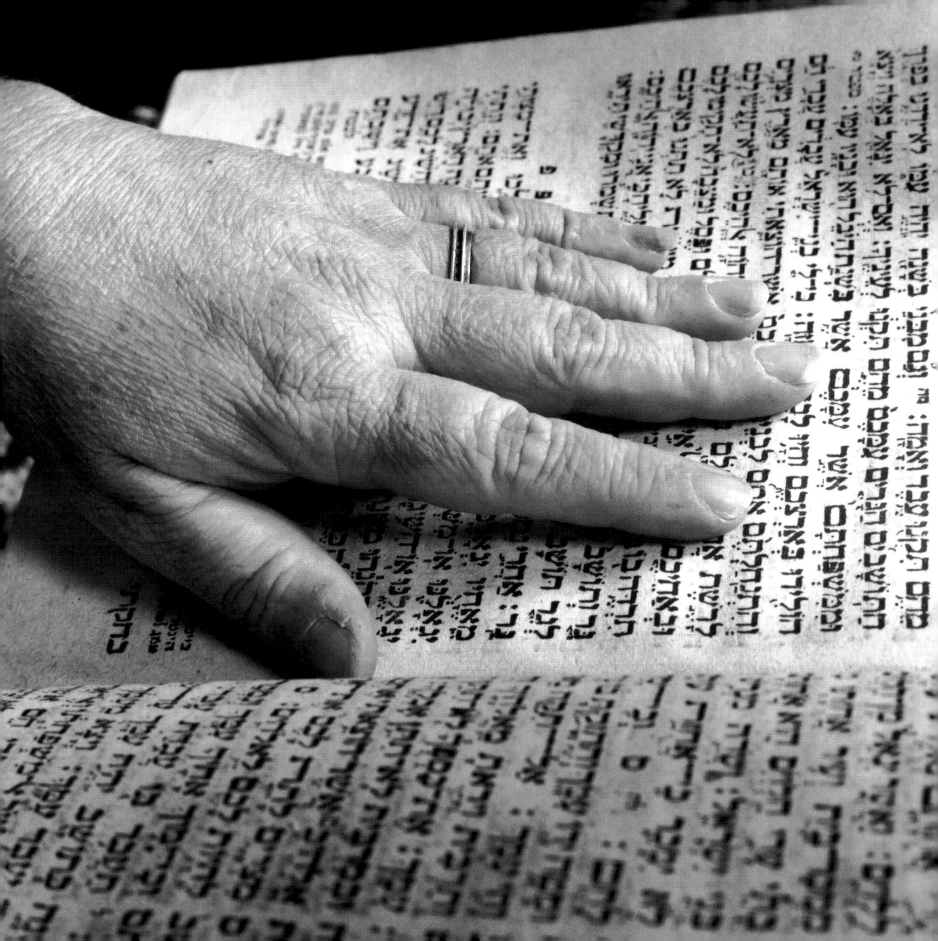

Lisa Beltz

Lisa Beltz, 34, is a bal teshuvah, *one who returns to Orthodox practice. Widowed at a young age, she is currently working as a consultant on conservation issues and living in Nairobi, Kenya, with her son, Brendan.*

have had a couple of life dreams. One of them was to get married and have lots of kids, the other was to travel. When I became widowed early in my marriage I decided to backpack around the world with my son and pursue this other dream. I wanted to see nature, wildlife, and live up-country with indigenous peoples before it was all gone.

We traveled to Kenya, Uganda, Madagascar, Singapore, and Thailand, and spent six months in Malaysia and Indonesia. Brendan was eight years old at the time. We hiked mountains and jungles, took boats and buses, and walked across borders. My agreement with Brendan was that he would eat whatever I set in front of him. I put Brendan in charge of knowing the geography and, of course, the monetary exchange rates.

We went to wild and crazy places but managed to remember *Shabbat* and light candles. For Passover I had my mother send us *matzah*. We were stuck on this faraway tiny island and I was frantic to find another Jew to have a seder.

When Brendan and I returned from this adventure to Arlington, Virginia, we moved in with my sister's family. I became a single parent working all day with little time in the evening for quality parenting. I went looking for a Jewish life and found a very hypocritical community not in tune with spirituality. I met a lot of people who were glorifying their Judaism through clothing, song, and food. And I was looking for God. You can be a passive Jew in America, somebody will organize things for you, you can get invited to a seder, attend a lecture, and have a rich cultural life. So I left. I volunteered to do wildlife conservation in Africa and went back to Kenya. I wanted small-town life.

I am raising my son in Africa to give him a quality Jewish life. Life is much simpler in Kenya than in the United States. There are fewer demands on your time and everything is family oriented. We belong to the Nairobi Hebrew Congregation where Brendan is a very important part of the *minyan*. He gets an *aliyah* almost every week. When my son needed a bar mitzvah, the entire community pulled together to help me organize, study, and prepare. This was a godsend because I had not been raised religiously and had attended only one bar mitzvah. I come from an absolutely nontraditional background.

My parents dropped out in the '60s. When I was seven the family took a bus trip around the country for a year, looking into alternative lifestyles. My father was a child psychologist seeking an ideal society. We lived in ashrams, communes, and nudist colonies. My parents were searching for the right way to live but took the wrong path. I would say my parents got caught in the "if it feels good, do it" mode.

When I was ten my mother took a great step and rejected what was going on. She moved us to Virginia and attempted a stable lifestyle. Yet she was still connected to broadminded approaches for raising children, letting us make our own decisions, so I had a lot of hands-off parenting.

As I reached my teen years I was encouraged not to have inhibitions. The adults I knew did not teach or convey that sex is a sacred act. Eventually my parents' marriage broke up before I turned fifteen. I moved into my own basement apartment when I reached tenth

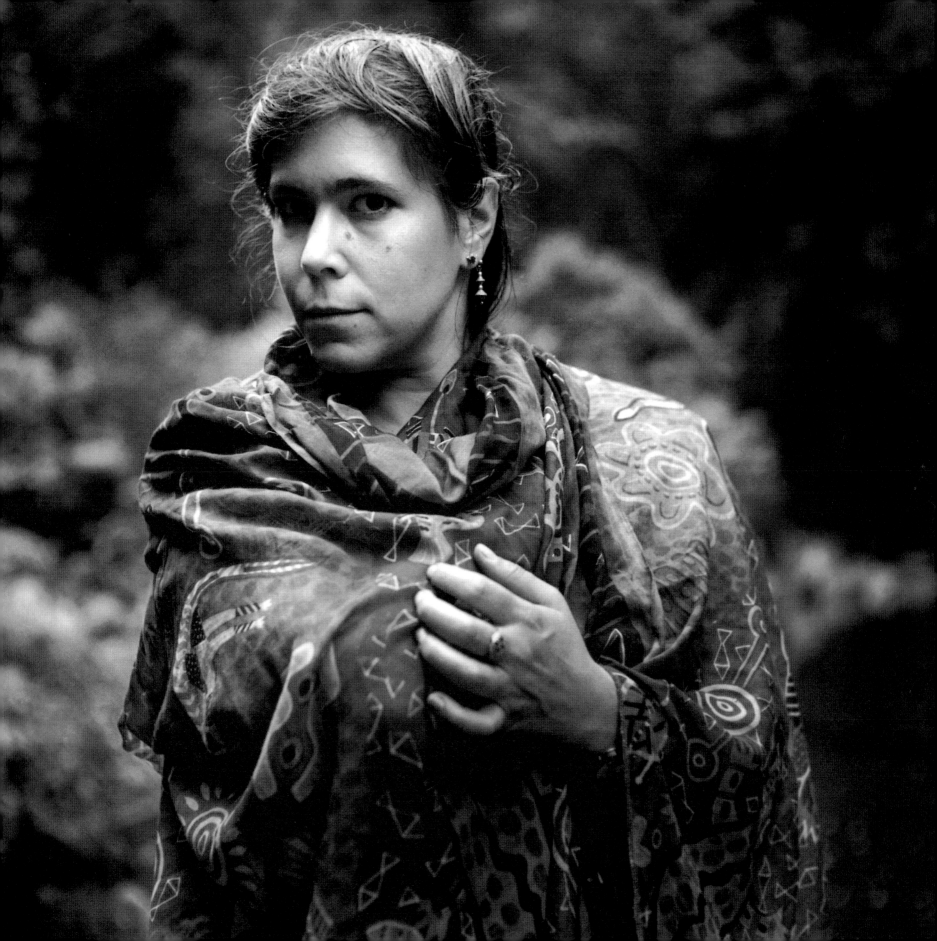

grade. That was the end of parenting from my mother, and I worked my way through high school.

I believe my parents' search for a utopian community was well intended, but they became lost. Since I have become religious, *bal teshuvah,* I have found the truth. Judaism is perfection. That's why I have chosen to raise my son as a Jew. I can do this much better in Kenya than in America, because our children are supervised and my son's school is free of drugs or violence.

What we have in Nairobi is a unique community that you do not find in the United States or in Israel. We are a few Jews living in a foreign country and we need each other. It is a loyal community of Jews from Britain who came down and took an active role supporting Jewish

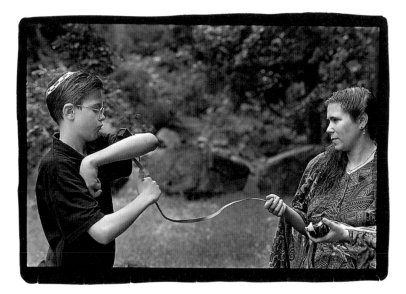

refugees from Poland and Eastern Europe. There is a lot of heart in the founders and patrons of this community. We are an international group composed of embassy staff, Israeli businessmen, Jewish relief and development workers. I am always picking up Jewish visitors and taking people home for *Shabbat.* Every Jew is valuable in Kenya and doing a *mitzvah* for one another is very easy. This fills me up with joy.

As a new member of an international but tiny Jewish community, I had to do things for myself. I studied Torah and it affected me like nothing else. I became religious, *kashered* my house, and one day just stopped using electricity on *Shabbat.* I just couldn't pick up the phone. It felt wrong to me. I became very pro-active to provide my son with a Jewish education.

For the last two years Brendan and I have studied Torah together and began preparing for his bar mitzvah. I know everything there is to know about keeping a Jewish home, how to *kasher* for the holidays, but not how to be a Jewish man. I hadn't a clue and I went looking for help. A wonderful Lubavitch man came through Nairobi, selling Sprint, and when I told him our situation he jumped on the ball and took care of everything. The first thing that needed to happen was to get Brendan circumcised. This did not happen when he was born because his father was not Jewish and I was not religious at the time. Our Lubavitch friend made sure I had *tefillin* for Brendan and arranged for the circumcision to take place in Israel. With all the Russian doctors in Israel, they now know how to circumcise older boys.

It is hard to become *bal teshuvah* when you have a teenage son, but I take each step with Brendan slowly, and my strategy for bringing Judaism into the home has been through positive energy and joy. My son believes in God and is embracing his Jewish identity. In our synagogue he has a role to play and is valued. This makes him feel wonderful. In the United States Brendan would be just another fourteen-year-old boy, sitting in the back of a *shul* with no one paying special attention to him. In Nairobi he is needed and welcomed for the daily *minyan.* Even though his responsibilities have increased, so has his joy. My son's soul was given to him as a gift from God and there is only so much that I have control over. This will sound like a cliché, but as a mother my biggest responsibility is to be a good example. It is not what I say but what I do. If I want my son to be kind, I must be kind. If I want him to deal with his anger appropriately, I must deal with my anger appropriately. If I want him to find joy in Judaism, I have to find joy in Judaism.

For his bar mitzvah he chose the name "Baruch," which means blessed. Taking my son to the point of bar mitzvah and having him circumcised in Israel is my commitment to God. It was accepting the yoke of the commandments and saying that I am going to live a righteous life.

Nancy Helman-Shneiderman

Nancy Helman-Shneiderman, ILCSW, 54, of Washington, D.C., has practiced psychotherapy for over twenty-five years, and is the founder of the Women's Coping Center. She has created a midlife ceremony for women who have undergone hysterectomy. An award-winning songwriter and actress, she is the mother of two daughters.

One morning before the hysterectomy I woke up with a start. Horrified, I had a vision of my womb in the hospital trash with other undifferentiated body parts. I wasn't going to just throw away my womb, the seed of my soul. A Jew has a blessing for everything. I wanted to make a covenant for this transition. I started doing research. I wanted to do this Jewishly. I wanted to have a ceremony, a sacred ritual joined to tradition. I spoke with Orthodox rabbis who reminded me there is a tradition for burying amputated limbs. I visited a Kabbalist healer in Jerusalem and a rabbi in Safed. I tried to link my ideas for a midlife covenant ritual to prayers already in existence. I called Europe and Canada. What I found had nothing to do with my essence, nothing that moved this process back to the garden, the place I knew my womb belonged. I called Rabbi Zalman Schachter and he actually got it. He said plant it under a pear tree. The womb even looks like a pear. I then called Rabbi Laura Geller in Los Angeles. The lock opened when I learned from her that after a *bris* the foreskin is often planted, giving my vision a Jewish balance. It became easy. I would plant my womb in the garden.

People began to say, "Will the hospital let you have it?" I spoke with a rebbetzin in Canada with a similar situation who had wanted her womb returned and was unsuccessful. She said, "Do this for me, for us, and for everybody." I thought to myself, "Who am I to create a midlife covenant for Jewish women?" At first, I wanted somebody else to do the ceremony. Finally I realized I was in a better position to create this than women rabbis and those working for institutions. As a psychotherapist I have a certain independence and understanding of healing.

A covenant is a contract between you and the Divine; it is a commitment involving body, heart, mind, and soul. No commitment comes without sacrifice. I wanted things to change. I wanted to create a *midrash* with my life. Nobody had heard of anything like this. It would be planted, which is a feminine image. My womb would be composted, not buried in a little casket. This was about recycling energy, about the Sacred Mother. It is important to raise consciousness, blessing the Source of life.

My ceremony took place in my backyard. My daughters participated. Anna began the ceremony by playing a *niggun* on her violin. A *minyan* of women encircled me in the garden. I blew the *shofar*. Friends shared prayer, poetry, and song. My daughter Sara helped cover my womb with earth, stating, "For everything there is a season. In choosing to do this, I help my mother move on. She has given me life, has helped me grow and will continue her help as I move through the life cycle."

Things changed fast. When I first created this ceremony in 1989, I was told it wasn't Jewish. These days I travel, lecture, and sing. People everywhere tell me they have heard of someone doing a related ceremony.

I say the *motzi* blessing, "*Baruch atah adonai eloheinu melekh ha-olam, ha-motzi lekhem min ha-aretz.* . . . and don't forget Minnie Horowitz." Let's remember the older women. They are all of us.

Joan Nathan

Joan Nathan, Jewish cookbook author, is the host and executive producer of the public television series Jewish Cooking in America with Joan Nathan. *Her books include* The Jewish Holiday Kitchen, The Children's Jewish Holiday Kitchen, *and* Jewish Cooking in America. *She is currently working on a book on the foods of modern Israel. She lives in Washington, D.C., and is the mother of three children.*

Food has become a way for me to learn about Jewish history and culture. I believe Jewish rituals, the laws of *kashrut,* and a history of poverty have influenced the importance of food in our culture. I also think that the poorer the people are the more important food is, not just for survival, but as a way to bring people together. My mother-in-law was a Holocaust survivor, and when people came to visit she would have incredible amounts of food to serve others.

I believe the act of cooking alone helps keep people alive. Some of the elderly cooks I have interviewed live the richest lives. They become invigorated by sharing recipes. One ninety-three-year-old lady we put on our television program wouldn't trust our gefilte fish so she brought her own from Cleveland. When a cookbook author asks for a recipe it often gives the elderly cook a new lease on life, even a sense of immortality.

I have never actually said this to my children, but I believe that we owe it to history to stay Jewish. As Jews we have gone through a lot, and I would hate to see us losing it in one generation. You can't just tell your kids they are Jewish, you have got to do it, show it, and be it with joy. If children enjoy Jewish culture then they will enjoy being who they are.

One of the values of my parents is to be decent to other people. Over the door to our family synagogue it said, "Do justice, love mercy and walk humbly with thy God."

I have always felt that "the cream rises." If you have a good idea and do a good job, you can do anything in life. That is what my mother taught me. I think in my work and by example, I have shown my kids that anything is really possible.

My mother is eighty-five years old and spends much of her time cooking for friends. Like many Jewish women of her generation my mother learned to cook from *The Settlement Cookbook*. I can still smell my mother's stew, which was rich with potatoes, carrots, and huge chunks of meat. My mother insists on making homemade chicken soup, which my kids would love.

In the 1920s somebody called chicken soup the "Jewish penicillin." Just smelling chicken soup and breathing it in soothes you. Studies have even been done about this. Chicken soup is still the first thing I make when one of my kids is sick. I like my chicken soup spiced with dill, rich in color, with lots of vegetables.

I use my family to test recipes, so there is a lot of cultural input in what we eat. For my oldest daughter's bat mitzvah I did the very best of Jewish foods from around the world. I schlepped the Lower East Side for bialys. We had spanakopitas, Moroccan salads, and the chef at the French Embassy made grouper couscous. For my other children's bar and bat mitzvahs we did Greek and Hungarian menus. My children baked their own *challah*.

Cooking with one's children is a great way to get them to talk to you. I used to think that being around kids when they are little was important, but now I know it is just as important to be with the older ones. Often we are in the kitchen together, the conversation flows easily, and they have me as their sounding board.

Roni Toporovsky

Roni Toporovsky, a graphic artist, lives in Virginia and has four children—Daniel and triplets Hannah, Esther, and Naomi. During the early years of family life they lived in an intentional community where the children attended a private alternative school. Roni and her husband, Jerry, are co-owners of a holistic health center and two massage-therapy schools.

Jerry and I married in 1974. We lived on a dollar a day in Europe, Asia, India, and Iran. When I became pregnant with Danny we headed back to the States.

I knew I did not want to raise a family in the city, so we moved to Claymont, an organized community in West Virginia. We were all very respectful of one another's heritage and used to have huge Passover seders. My son's *bris* was the first one that took place in Claymont.

I gave birth to Danny at home with the help of my husband, a midwife, and my friend Deborah. When I was in my second pregnancy, I naturally figured I would have the baby at home again. Well, I was getting very big very quickly and my physician was locating heartbeats all over the place! I had a sonogram done and was told we were having twins. When the time came it was off to the local hospital.

My doctor whistled as first Hannah and then Naomi were born. My stomach was still hard so she took a look and said, "There is one more sac in there." Out came Esther!

Danny was only two when the triplets arrived and naturally they got all the attention. Just walking down the street became a circus for us. I have always been appreciative of people who acknowledged him for being "the big brother" and my helper.

My children had the almost perfect childhood while living within the Claymont community. When they walked out our front door I did not have to worry. They had 400 acres of woods to roam. We paid attention to the whole child: mind, body, and spirit.

Once everyone started having children, people began to get jobs outside the community. Jerry became a massage therapist and was encouraged to teach. At first we ran a real mom-and-pop operation. The business expanded at the same time our children outgrew the community school so we decided to move to our own home.

A love of Judaism and our heritage has always had a strong presence in our family. We celebrated both bar and bat mitzvahs at our house after traditional ceremonies. Danny climbed a mountain the day before to contemplate his life. The evening before the girls' bat mitzvahs we had a women's circle where we told stories and gave advice to the girls.

I have been very open with my kids. They always knew they could come to me about anything and they have. They've grown into fine young adults. My relationship with my children is in sharp contrast to the one I had with my mother.

It is hard to talk about my mother because she is deceased and I want to honor her memory. She did not make the best choices for herself in life and was quite anxious, probably very unhappy. She worked hard at home, watched soaps on TV, and was very superstitious. When I got my first period I was in the bathroom and called my mother. When I told her she slapped me hard in the face. I was stunned. She never explained why and just said it was tradition. I did not carry this "tradition" over to my daughters.

My mother was of another generation and she had trouble understanding me. However, I knew that she loved me, and that is really all you have to do as a parent, simply love your children, listen and give them space to find themselves.

Lee Wolf

Lee Wolf, 71, a docent at the Smithsonian Institution, was a city

planner and a state board member of the League of Women

Voters. An avid world traveler and opera fan, she lives in Falls

Church, Virginia, with her husband, Eric, and has two sons,

Lloyd and Dean.

My mother died when I was eleven. Back then children were not allowed in hospitals to visit so I sneaked in. During one visit I finally realized how sick Mom was. One Saturday my brother and I were called out of a movie and taken home. No one explained why, and they took us to the home of an aunt. Our relatives were assembled and some idiot came over to me and said, "You poor child. Your mother is dead." I was furious.

I remember my mom as a very warm, loving person who took me on walks to the zoo and hugged me before I went to bed. The scar that has remained for me is not about her death, but about waiting. Waiting always means bad news.

Luckily, my father was a terrific man. When I listen to psychologists discuss parenting skills, I realize my father came by them naturally.

Both my parents were from Galicia, in Austro-Hungary. I grew up hearing them say, "If I had liked the old country, I wouldn't have left." I was brought up to take one look at the Statue of Liberty and kiss the ground.

I received a four-year Regents Scholarship and chose to go to Brooklyn College. I majored in U.S. history and political science. My real major was Eric.

The way we met is kind of romantic. My best friend and I were at the Metropolitan Museum of Art. We walked into a gallery and Eric was there. We wandered around the museum and then the Central Park Zoo. He told me, "Elephants have kind eyes." After he left, I turned to my friend and said, "I am going to marry him."

We were married in 1949 and had two sons. I was fortunate and had an easy time during my pregnancies. It was great being the mother of two boys, lots of fun.

We were really close to our neighbors. One of their kids, who was studying for his First Communion, told everyone what he was learning. Lloyd, about five at the time, began talking about Jesus. The boy's mother said, "Hey, you are a nice Jewish family. Will you please send your boy to Hebrew school so he can be brought up properly?"

My sons did well in school. They didn't get into the long-hair, grubby phase until they went to college. My father once said about kids, "If they are not doing anything immoral, illegal, or harmful to their health, leave them alone and they will outgrow it." I am very proud of my sons; they grew up to be decent, honorable men.

I believe that there are misconceptions about women in the 1950s. I didn't know anyone who did housework while wearing a dress and high heels. Most of the women I knew were active in volunteer work. When the children were established in school, many women got jobs working.

The best thing about motherhood is becoming a grandmother. I don't have to be responsible for the children. If they want cookies before dinner I give it to them. I hope my granddaughters grow up to be kind, decent people and achieve what they want in life. I really enjoy life and wouldn't change it for the world, but I'd still like to be on the Supreme Court.

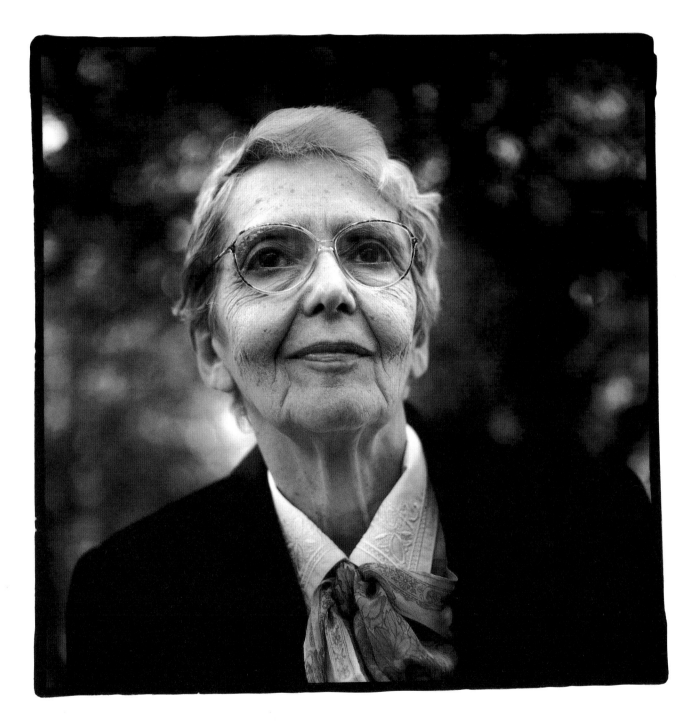

Rhoda Shea
Wolfson

Rhoda Shea Wolfson, 74, is an award-winning Jewish commu-

nity center worker and social activist. She was a Vietnam War

draft counselor, facilitated support groups in women's shelters,

and consulted with police on domestic abuse cases. She is the

mother of Joe, Ellen, and Paula, and the grandmother of Maria.

She lives in Napa, California, with her partner, Lilyan Frank.

I became politically radicalized as a student at Erasmus High School in Brooklyn. My mother must have really trusted me because I was out every night at meetings and she never questioned what I was doing. It would not have mattered, I was just so ardent.

World War II and the Holocaust were the most significant influences on my identity. I considered myself a humanitarian, and during the war I gave blood as much as I could, visited the wounded, and raised money for bonds. After the war I met my husband, Harry, in the union movement, my ideal of a working-class man. We left our honeymoon early to demonstrate at the UN in support of the creation of the State of Israel.

During my first pregnancy Harry and I were so thrilled that we were necking in the hospital. I loved every smile, gesture, and new stage in my babies' lives. At Joe's *bris* I got a surprise when the man in black at the door turned out not to be the rabbi, but an FBI agent! He was investigating my mother's signature on a petition to ban the A-bomb.

My youngest daughter was born at the beginning of the McCarthy period. I named her Paula Ethel after Paul Robeson and Ethel Rosenberg. Robeson was a great Black activist and artist who represented everything I believed in. I was pregnant with Paula the year Ethel and Julius Rosenberg were executed for being spies. I was in a train car with Ethel Rosenberg's mother going to Washington, D.C., hoping to stay the execution. Mrs. Rosenberg spit on a photo of Judge Kaufman, who presided at the trial. I will never forget it.

Eventually my husband and I left the movement, disillusioned. Our union was smashed. We decided to move to California. In Long Beach we went from not having a pot to pee in to owning a tract home with a garage and a backyard. When school busing started there, I was glad. It was the first time I had lived in an all-white community and I didn't want my children to grow up in a lily-white world.

In 1960 the Long Beach Jewish Center opened and became our second home. I was employed there for twenty-five years and think my experiences as a youth worker helped me become a better parent. I learned not to get upset over kids' hair or clothes styles.

Once the kids left the home my marriage became shaky. The women's movement had kicked in. My husband and I had communication issues. After twenty-eight good years my marriage ended, but we share a legacy of having raised decent and caring children.

What is devastating for me now is that my son, Joe, a champion surfer, has terminal lung cancer and tried to commit suicide. He swallowed sleeping pills, took a midnight swim, and tied himself to a buoy. He was found at sunrise by a surfing instructor, unconscious and hypothermic.

When my sister Harriet died of brain cancer my mother said that the worst experience a mother can have is to outlive her child. Recently I have joined a cancer family support group and for the first time in my life, a synagogue. I have told the rabbi about my son's cancer, so she calls to provide comfort and healing. I am learning that it is a Judaic concept to take good care of oneself.

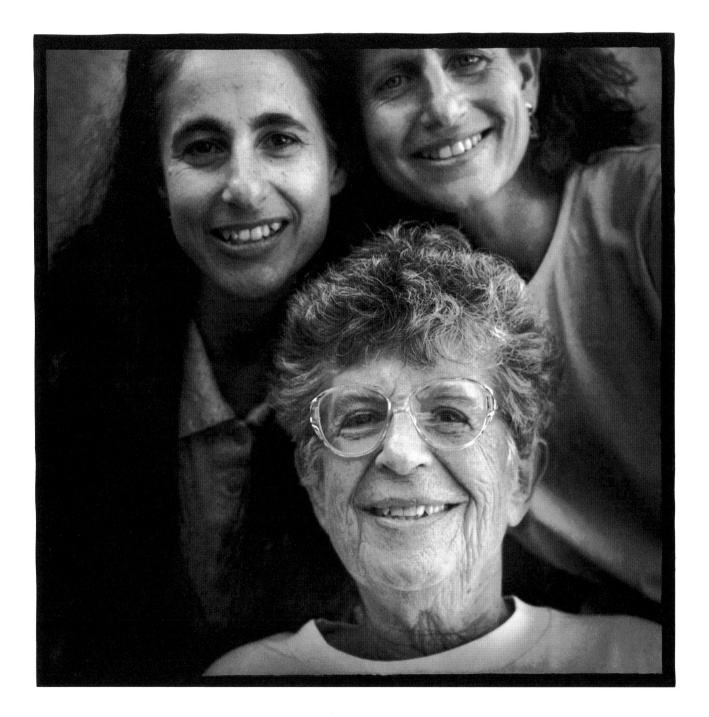

Glossary

Agunah - A woman who cannot remarry because her husband is missing or refuses to grant her a divorce.

Aliyah (pl. Aliyot) - Being called up to read from the Torah. "Making aliyah" refers to a return to Israel.

Amidah - Lit. "standing." The principal Jewish prayer.

Ashkenazi - Northern and Eastern European Jews.

Baal Shem Tov - The founder of Chasidism.

Baleboosta - Capable and industrious woman, "boss."

Baruch HaShem - "Praised be the Name (of God)."

Bet Din - Rabbinic court.

Bichur Cholim - Visiting the sick.

Bimah - The raised dais in a synagogue's sanctuary.

Birkat HaMazon - Blessing after meals.

Bracha - A blessing.

Bris - Circumcision.

Brit Milah - Ritual circumcision ceremony.

Bubbe - Grandmother (Yiddish).

Bucher - Student (Yiddish).

Chabad - The organization of the Lubavitch Chasidim.

Challah - Braided egg bread.

Chasidism - A religious revival movement founded in Polish Galicia. Followers are called Chasidim.

Chavurah - An independent, nondenominational Jewish congregation.

Cheder - A small traditional school.

Chuppah - Wedding canopy.

Chusidl - A young boy.

Daven - The act of prayer.

Eishet Chayil - "Woman of Valor," a Sabbath song.

Frum - Observant of religious law.

Get - Religious Jewish divorce decree.

Haftorah - Readings from the prophets after the Torah.

Haggadah - The Passover prayerbook.

HaKodesh Baruch hu - The Holy One, Praised Be He.

Halachah - Jewish religious law.

Halutz - "Pioneer" early settlers of the State of Israel.

HaMotzi - Blessing over bread or a meal.

Havdalah - Ceremony at the end of Sabbath.

Haymish - Homey, full of warmth and comfort (Yiddish).

Kabbalah - Jewish mystical texts.

Kaddish - Prayer recited in memory of the deceased.

Kallah - Bride.

Kashrut - Jewish dietary law.

Kavanah - The inner intention during prayer.

Kedushah - Holiness.

Ketubah - Marriage contract.

Kiddush - Blessing over wine.

Kippah - Skullcap.

Klezmer - Traditional Eastern European Jewish music.

Kosher - Food made according to Jewish dietary law.

Kvell - Pride mixed with joy (Yiddish).

Ladino - Judeo-Spanish, the language of many Sephardic Jews.

L'dor V'dor - From generation to generation.

Leyn - To chant from the Torah.

Loshan Hara - Evil or malicious speech, slander.

Lubavitch - A major Chasidic sect.

Machzor - Jewish holiday prayerbook.

Matza(h) - Unleavened bread eaten at Passover in commemoration of the exodus from Egypt.

Mechitzah - The divider between men's and women's sections in orthodox synagogues.

Mentsch/mensch - A decent, honorable person (Yiddish).

Menschlikheit - The quality of being a mentsch.

Mezuzah - Small prayerbox placed on doors.

Midrash - Rabbinic commentary on the Torah.

Mikveh - Ritual bath.

Minyan - A quorum of ten for Jewish public prayer.

Mitzvah - A biblical commandment; also a "good deed."

Mohel/ot - A man/woman who performs circumcision.

Motzi - Blessing over bread or a meal.

Naches - Special joy, a feeling of pride and pleasure (especially from one's children).

Neshama - Soul.

Niddah - Status of a woman during her menses until her ritual immersion in a *mikveh*.

Niggun - Melody.

Nona - Grandmother (Ladino).

Olim - Immigrants.

Passover - Eight-day observance of Exodus from Egypt.

Pesach - Passover.

Pesachdik - Food appropriate for Passover use.

Purim - A carnival holiday commemorating the survival of the Jews of ancient Persia.

Rebbetzin - Wife of a rabbi.

Rosh Hashana(h) - Jewish New Year.

Rosh Hodesh - Monthly celebration of the new moon.

Schmaltz - Rendered goose or chicken fat (Yiddish).

Seder - The Passover Feast.

Sefer - Book.

Sephardi(m) - Jews of Spanish or oriental descent.

Shabbat - (Hebrew) *Shabbos* (Yiddish) - Sabbath.

Shaitl - Wig.

Shammes - Ritual director in a synagogue.

Shande (shonda) - Scandal, shame (Yiddish).

Shavuos/t - The Festival of Weeks.

Shechinah - The Divine Presence, the feminine principle of God.

Shiva - The seven days of mourning.

Sh'lom bayit - A peaceful home.

Shluchim - Leaders.

Shochet - Ritual slaughterer for kosher meat.

Shofar - Trumpet made from a ram's horn.

Shtetl - Village (Yiddish).

Shul - Synagogue (Yiddish).

Siddur - Jewish prayerbook.

Sofer - Scribe.

Sukkah/Sukkot - Harvest shelter; the harvest festival.

Taharat HaMishpachah - Laws governing Orthodox marital relations.

Tallis (tallit) - Prayer shawl.

Talmud - "Study" - books containing commentary on Jewish law and life.

Techines (tkhines) - Prayers of supplication.

Tefillah - Prayer.

Tefillin - Phylacteries; the ritual boxes (containing sections of the Torah) and leather cords worn by observant Jews during morning prayer.

Tehillim - Psalms.

Tikkun Olam - To heal or repair the world.

Torah - The Five Books of Moses.

Tzaddik - Righteous person.

Tzedakah - Charity.

Tzeniut - Modesty.

Yahrzeit - Anniversary of a date of death (Yiddish).

Yarmulke - Skullcap.

Yeshivah - Religious school.

Yiddish - Judeo-German, language of Ashkenazi Jews.

Yiddishkeit - Judaism, Jewishness (Yiddish).

Yizkor - Memorial service.

Yom Kippur - Day of Atonement.